ANIMAL KINGDOM

Design with Animal Aesthetics

SendPoints

ANIMAL KINGDOM - Design with Animal Aesthetics

© SendPoints Publishing Co., Ltd.

SendPoints

EDITED & PUBLISHED BY SendPoints Publishing Co., Ltd.

PUBLISHER: Lin Gengli

PUBLISHING DIRECTOR: Lin Shijian

EDITORIAL DIRECTOR: Sundae Li

EXECUTIVE EDITOR: Casey Kwan, Elly Ho, samsam

ART DIRECTOR: He Wanling

EXECUTIVE ART EDITOR: WangXue, He Wanling

PROOFREADING: Sundae Li, Heart Fensch

ADDRESS: Room 15A Block 9 Tsui Chuk Garden, Wong Tai Sin, Kowloon, Hong Kong

TEL: +852-35832323 / **FAX:** +852-35832448

EMAIL: info@sendpoints.cn

DISTRIBUTED BY Guangzhou SendPoints Book Co., Ltd.

SALES MANAGER: Zhang Juan (China), Sissi (International)

GUANGZHOU: +86-20-89095121

BEIJING: +86-10-84139071

SHANGHAI: +86-21-63523469

EMAIL: overseas01@sendpoints.cn

WEBSITE: www.SendPoints.cn

ISBN 978-988-13834-5-7

Printed and bound in China

Animal Kingdom focuses on the artistic shape of the animals, and their application and psychological value in modern design.

CONTENTS

-DIGITAL ORIGAMI TIGERS-

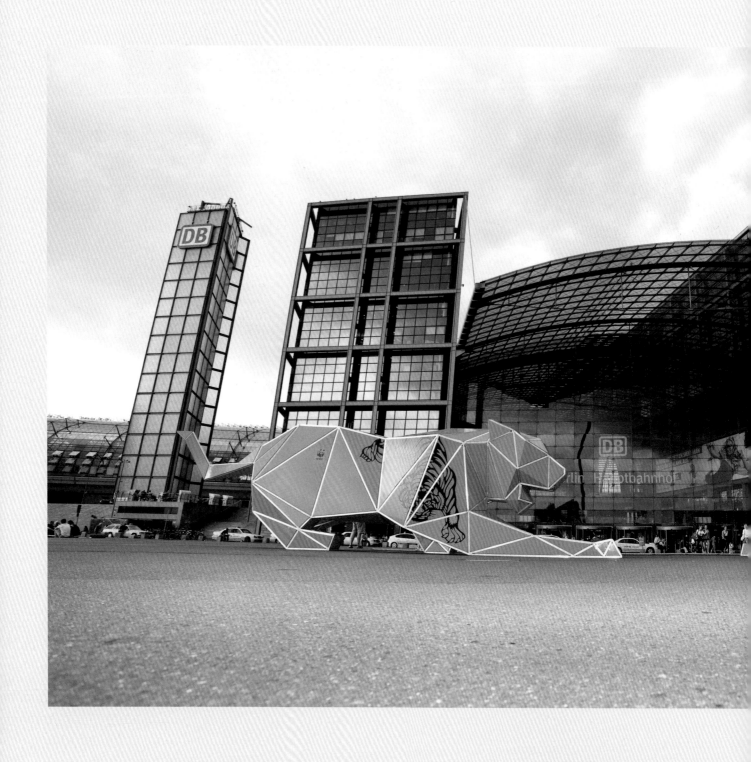

Two "Digital Origami Tigers" started their world travel in 2010 by playfully celebrating Chinese New Year in Sydney. Then they went to Kuala Lumpur as part of KL Design Week, to Berlin for the WWF awareness campaign, then Singapore as part of the i-Light Marina Bay Festival and finally to the US.

These "crouching digital tigers" combine ancient lantern making methods with digital design and

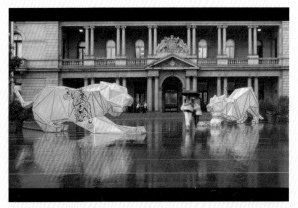

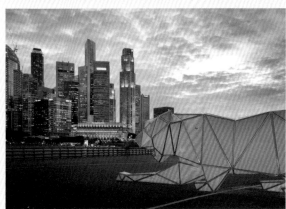

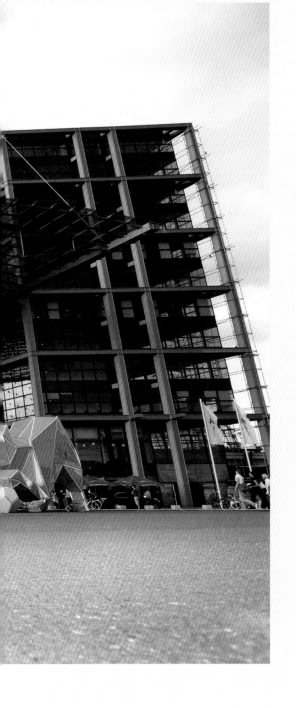

fabrication technology, bringing East and West together through tradition and innovation. These special big cats were a collaboration between LAVA and Customs House to mark the lunar year of the tiger and raise awareness about the endangered status of tigers. The tigers are inspired by "zhezhi", a Chinese term for paper folding, more popularly known by its Japanese name "origami."

"The tiger is such an incredibly designed animal – its feline structure, its patterns, coloring, shape and texture. We also wanted to use one and so the tigers played football to kick off the FIFA world cup held that year. Pulsating low energy LED lighting brings the sculptures to life", says Chris Bosse.

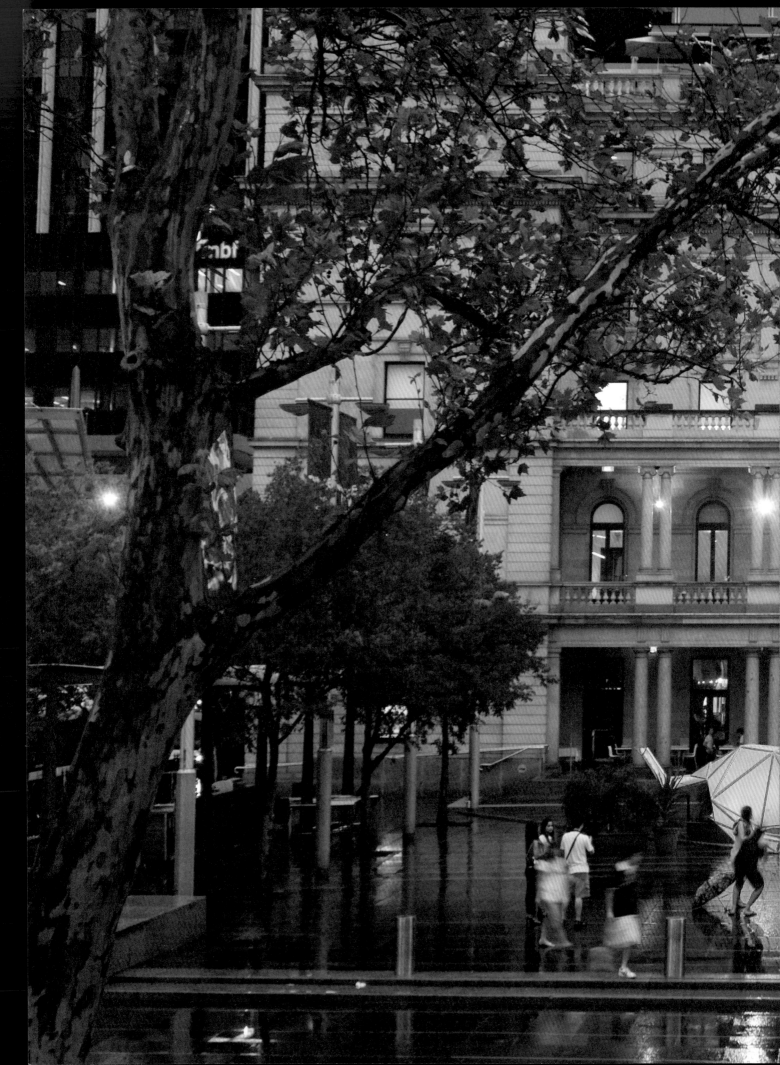

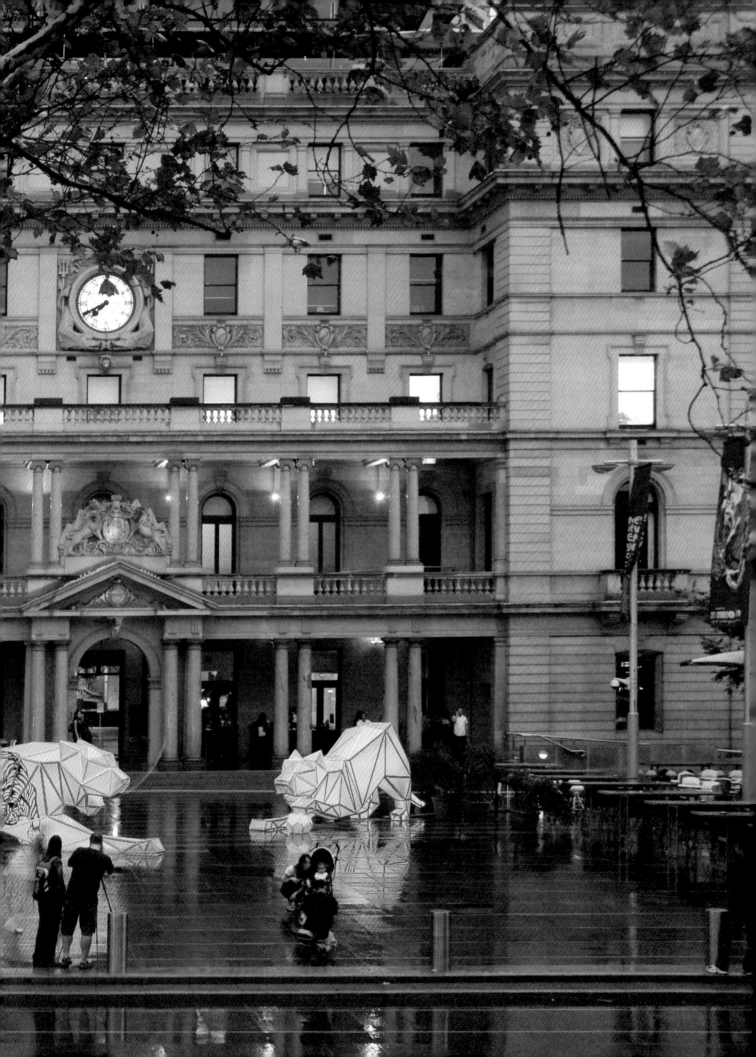

Thinking about Animal Aesthetics

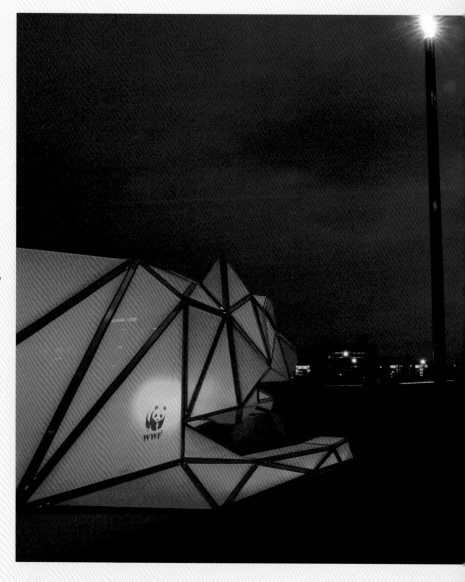

"The installation fuses tradition and innovation, bringing East and West together", Bosse emphasizes. "The design concept for the giant tigers evolved from "digital origami Tasmanian tigers" that we developed with architecture students. The digital tigers project grew out of an exploration of the molecular geometry of the soap bubble, the structural system used in the design of the Watercube (Beijing Aquatic Centre) which I worked on with PTW architects." The tigers are 2.5metres high and 7 meters long yet weigh only 200kgs. They use fully recyclable materials, aluminum and Barissol, a new light weight reusable stretch material. Pulsating low energy LED lighting brings the sculptures to life. The project continues LAVA's special aim of building "more with less." Fabrication was done by Sydney Stretch Ceilings using Barissol.

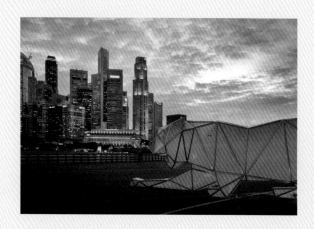

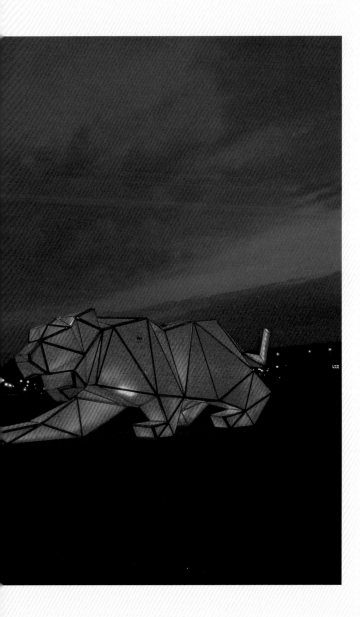

This project was awarded the 2011 Australian Interior Design Awards Commendation in the category of installation design. Bosse explained that the cultural orientation was based on Year of the Tiger. "Yes we were really pleased about the level of public and media interest they attracted around the globe. They successfully combined artistic, visual, ecological, and educational values. With only 3,200 tigers remaining in wild today, they generated invaluable support and awareness for the endangerment of the species.

Stefan Ziegler, WWF tiger expert stated: "The giant origami tigers are a powerful eye catcher. WWF is very pleased that they raise public awareness for tiger conservation." In the industry today, lots of design projects will use animals as design element including the shapes of animals, textures and colors, etc. Bosse believes that animals are a great source of design: their shapes, colours, patterns are all amazing. But ultimately it is not so much about style as performance. Ultimately the architecture of the future is not about the shape but about the intelligence of the system. The intelligence of the smallest unit results in the intelligence of the overall system. The designers from LAVA consider that combining the patterns of organization found in nature with the latest technologies (like the tiger project mentioned) will result in a smarter, friendlier, more socially and environmentally responsible future. And they do this through the potential for naturally evolving systems, such as bubbles, spider webs and corals, to create new building typologies and structures - these geometric shapes found in nature create both efficiency and beauty.

PRACTICE CREDITS
LAVA -- Chris Bosse, Tobias Wallisser, Alexander Rieck
Concept: Jennifer Kwok and Chris Bosse
Fabrication: Sydney Stretch Ceilings
Photos: Peter Murphy; David Biene; Patrick Bingham
Hall;Tim Griffith

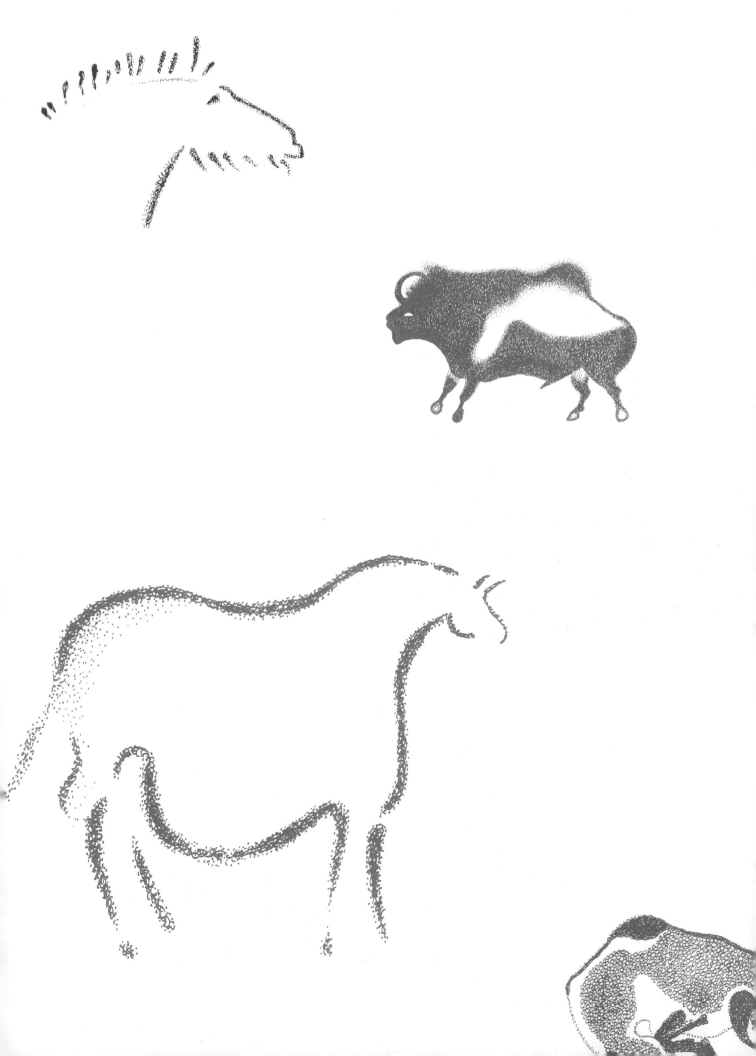

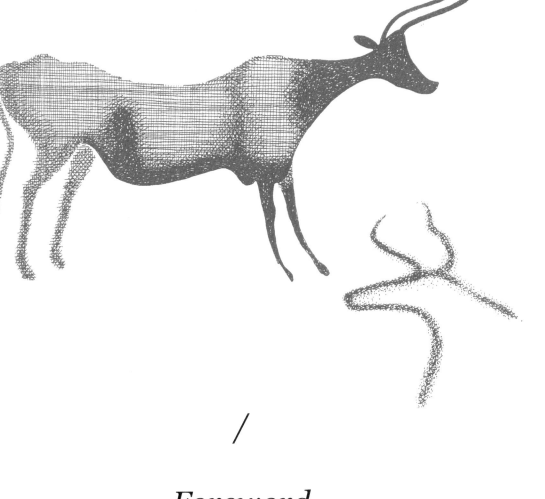

/

Foreword

/

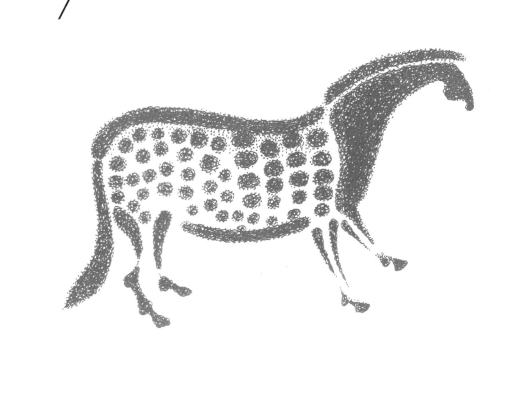

In 2014 scientists found frescos from ancient times in the Maros area of Indonesia. In addition to depictions of humans, there are drawings of wild animals that were living on the island. Based on dating methods, these frescos are at least 39,900 years old. Frescos of nature are one of the primary images created by human beings. For decades scientists believed that human art was born in Western Europe, where ancient rock paintings were found in Spain and the south of France. However, according to Professor Chris Stringer from the natural history museum of London, these Indonesian frescos from a similar period might change previous ideas.

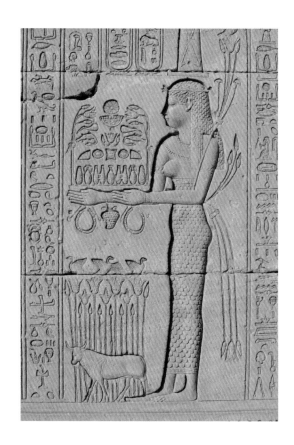

The understanding and documentation of the world is connected with the beginning of modern human wisdom. Artistic creation and abstract thinking are crucial characteristics that make humans different from animals. These are the abilities that led us to the use of fire, invention of wheels and other tools and techniques which have led to the prosperity of mankind.

Humans have never stopped depicting animals throughout the history of human civilization. Even without using language, our ancestors made records of what they knew and what they saw in the world with rough paintings on rocks or grottos. Along with the development of civilization and understanding of nature, the depictions of animal were used for spiritual and totemic purposes. Because ancient people were so much weaker than animals in stamina, speed and strength, the worship and deification of animals may seem natural. As humans have taken a dominant position in the modern world and scientific development has progressed, animals are not as mysterious and deified. While the beauty of animals may not be religious, they can still be artistic, exaggerated, adorable, delightful, and scary.

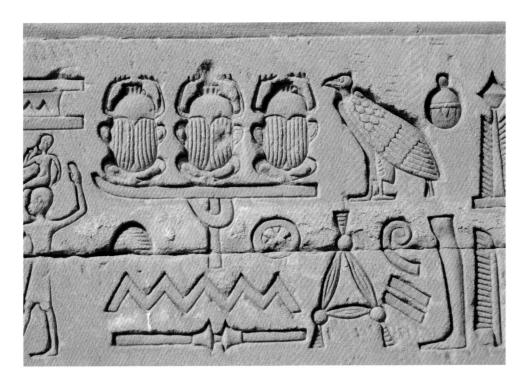

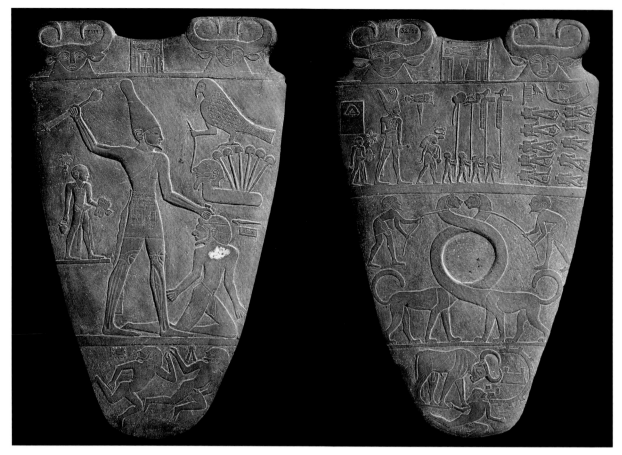

Narmer palette

The manifestation and expectation of animal aesthetics differ in different historical periods and cultures.

The ancient Egyptian frescos are a tremendous historical example, as well as a life-like visual feast. They feature a typical three-segment painting style. The human body parts were eccentrically twisted together – head, arms and legs were presented in profile, while shoulders and chest shown from the front. These illustrations of animals combined different angles and can be found on multiple stone craving and tomb frescos, like the Narmer palette. Ancient Egyptians wished to present the animal images in the most fascinating way, so they had accurately included the most important things in one graphic representation. This principle was never doubted and had lasted for almost three thousand years.

The ancient Orient was rich in the aesthetic depictions of animals with related psychological connotations and needs. Chinese people combined different body parts of animals into a special creature named dragon, the legendary totem of Huaxia. Other animals were also featured. The depiction of those animals had become more intricate and precise as history proceeded. The theme of their exploration in aesthetics - the fusion of physical appearance and spirit, the pursuit of artistic conception and vigor - is reflected in the unpainted part, animals, people, mountains and waters in ink painting.

In Europe, the expression of animal aesthetics had always been focused on figurative and decorative art before the 19th century. Ensuing art styles such as impressionism, brutalism, cubism, abstract art, surrealism, etc., have enhanced this expression.

In modern social context, to appreciate animal aesthetics contributes to the higher pursuit of an artistic life which in the professional level can achieve an impressive visual presentation of art and human imagination.

/

Projects

/

Borna&Fils

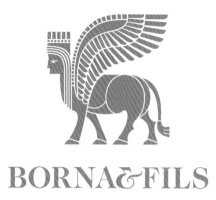

BORNA&FILS

PARIS DEPUIS 2011

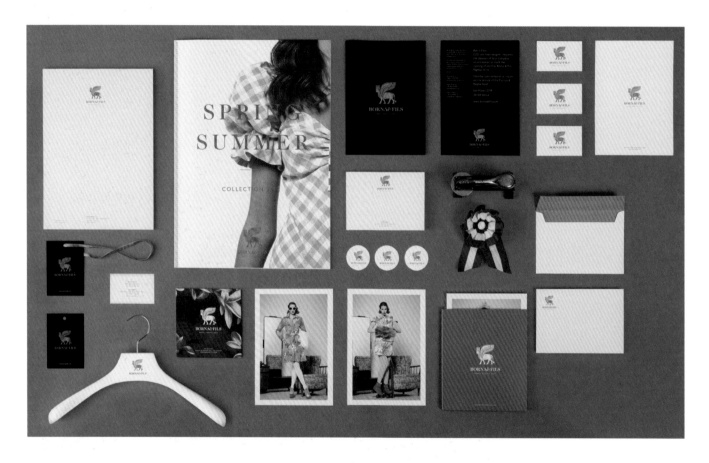

Croatia

Design Agency
Bunch

Creative Director
Denis Kovac

Client
Borna&Fils

Borna&Fils is a French fashion house whose creations embody the brand's vibrant spirit, polished aesthetics and imaginative thinking. Bunch was in charge of designing the brand and its applications, with logotype designed as a custom version of an Apsasu, a female version of Lamassu, usually associated as a symbol of power with the ancient Assyrians. This theme was used on everything from stationery, bags, lookbooks, custom tags, labels, billboards and website to launch event graphics signage and various in-store applications.

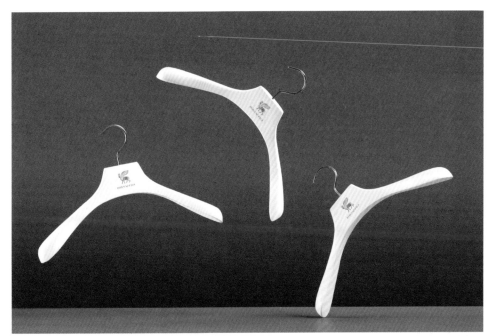

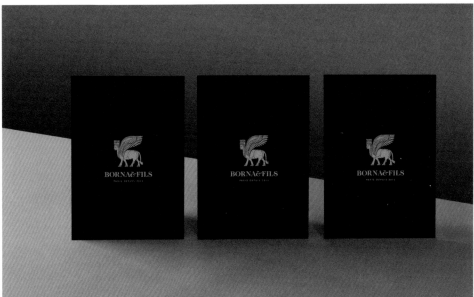

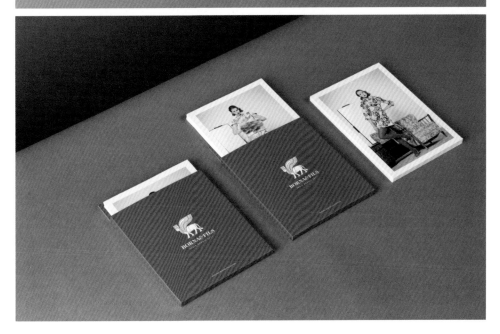

Jude of James

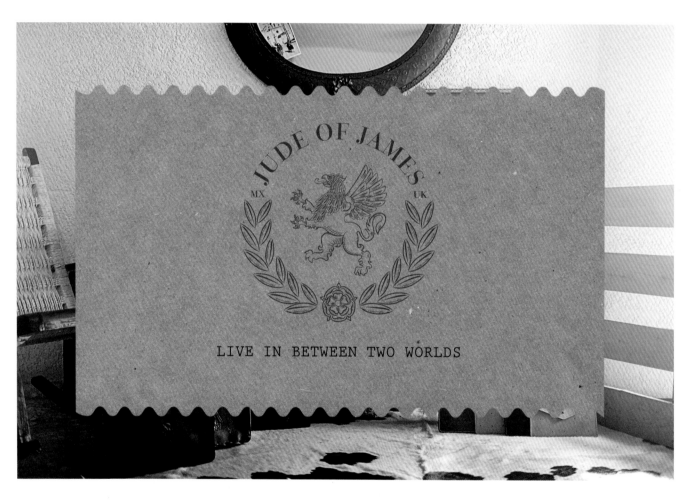

Mexico

Designers
Airamzul Alfano
Marcela Sousa Contreras
Ivette Torres Tristán

"Jude of James" is a brand by an English fashion designer who focuses her business on selling leather accessories, including totes, clutches, make-up bags and more. All were created featuring simultaneously the characteristic of being an English fashion label and at the same time Mexican craftsmanship, hand-made by artisans. Through their research, designers came up with the concept of mixing both cultures, and the way the designer chose to convey that was through heraldry. They took the Mexican eagle and the English lion, both well-known as national emblems of the respective countries and came up with a griffin. The reason is that this mythological creature represents power and mysticism, which they placed inside a laurel wreath with a Tudor rose.

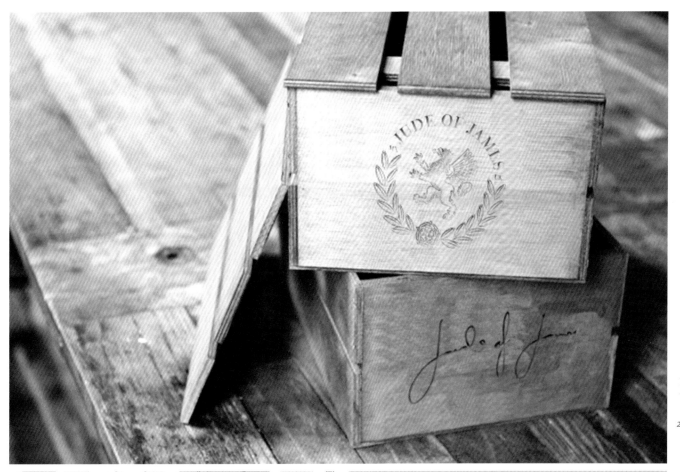

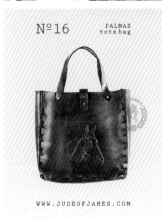

Nº16 PALMAS
tote bag

Nº17 TRINIDAD
make up bag

Nº09 FRESNO
tote bag

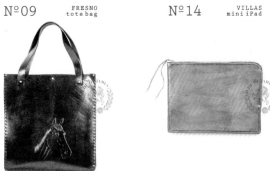

Nº14 VILLAS
mini iPad

Kamatanakarokugo

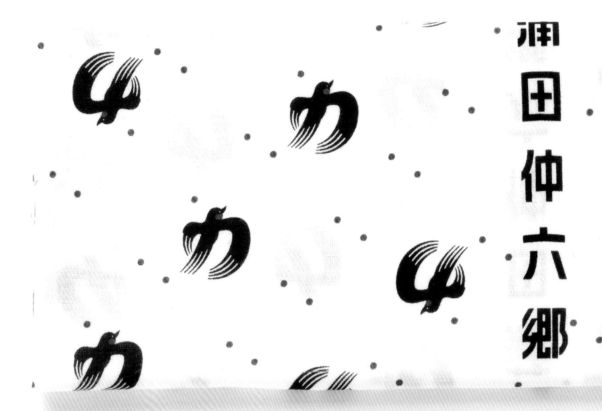

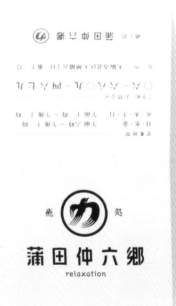

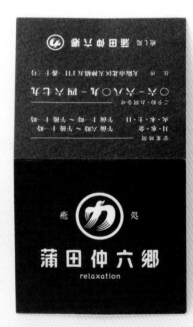

Japan

Design Agency
ANONIWA

Designer
Naoto Kitaguchi

Client
Sharaku

The designer drew inspiration from a swallow's nest which was found at the entrance of the salon. Inspired by the characteristics of hard working swallows, the designer combined the swallow motif and Kanji (力 or "chikara") to symbolize strength on the logo design, showcase the salon's ambition to bring a healthy life to human.

癒 力 処

蒲田仲六郷
relaxation

癒 力 処

蒲田仲六郷
relaxation

マネージャー
山崎 祐也

大阪府大阪市
北区天神橋五丁目一番十三号
電話〇六-六八〇九-四六七九

癒し処 蒲田仲六郷 力

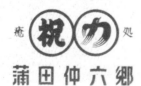

努 勤 励 力
勇 勁 助 労
勢 劾 勘 加
務 功 効 勉
勝 勤 動 勲

癒 祝 力 処

蒲田仲六郷
relaxation

POST CARD

料金別納郵便
力

五月十七日（金）午前十一時〜 開店

拝啓 春陽の候、皆様におかれましては
益々ご健勝のこととお存じます。
また、平素は格別のお引き立てを賜り厚く
御礼申し上げます。

さて、このたび私はリラクゼーションサロン
「癒し処 蒲田仲六郷」を下記の通り開店する
運びとなりました。

これもひとえに皆様のご支援の賜物と
感謝しております。

是非日々のお疲れを癒しに一度いらしてください。

まずは書中を持ちましてご挨拶申し上げます。

わいん＆串カツダイニング shariraku オーナー 山崎 祐也

癒し処
蒲田仲六郷 大阪市北区天神橋五丁目一番十三号 ☎〇六-六八〇九-四六七九

Seattle Urban Honey Brand Identity

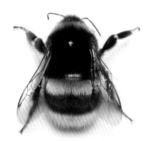 + 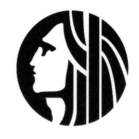 =

Seattle Urban
HONEY

Bee Seattle Flag

United States

Art Director
Joe Post

Creative Director
Shakir Dzheyranov

Client
Seattle Urban Honey

Seattle Urban Honey is a seattle-based company that produces raw honey. The task was to create a simple yet memorable symbol, which represents Seattle's history and the same time modern urban feeling. Many honey-making companies use cute, childish bee icons for their businesses. Seattle Urban Honey wanted something different than that. So the designers decided to learn more about the history of the city and finally came to the decision to combine the honey bee with Chief Seattle, the most famous person in the history of Seattle. They used the same elements and curves as in Seattle's flag.

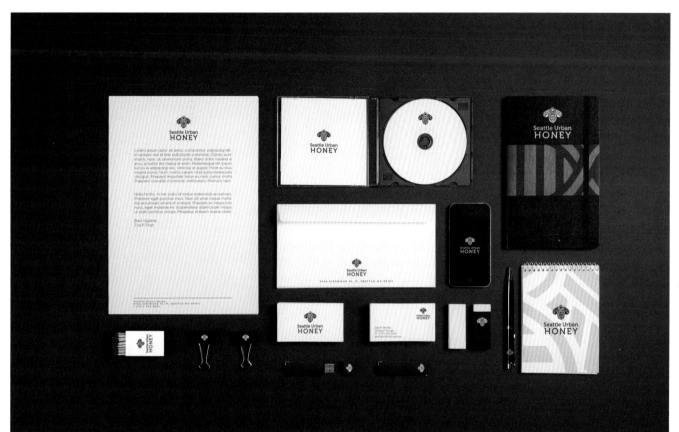

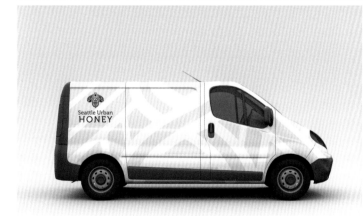

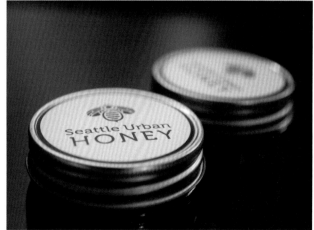

Elepago Branding

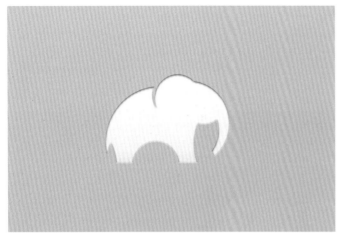

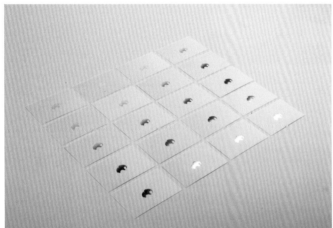

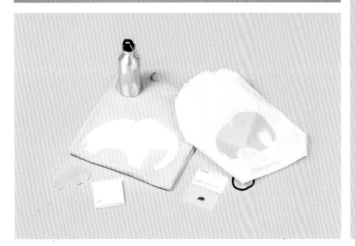

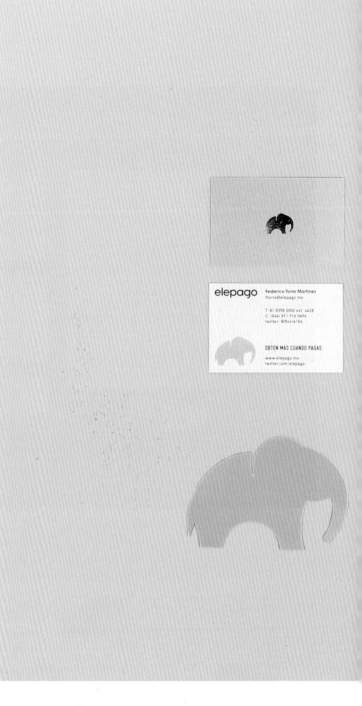

Mexico

Design Agency
Firmalt

Creative Director
Manuel Llaguno

Art Director
Francisco Puente

Client
Elepago

Elepago is a company that offers value-added mobile payments. An elephant was chosen as the icon because of the characteristics they represent. Elephants are known for their incredible loyalty and memory. Careful attention was brought to the construction of the icon, using a circle-centric approach. The result is a clean icon that is instantly recognizable and represents the reliability and honesty of their service.

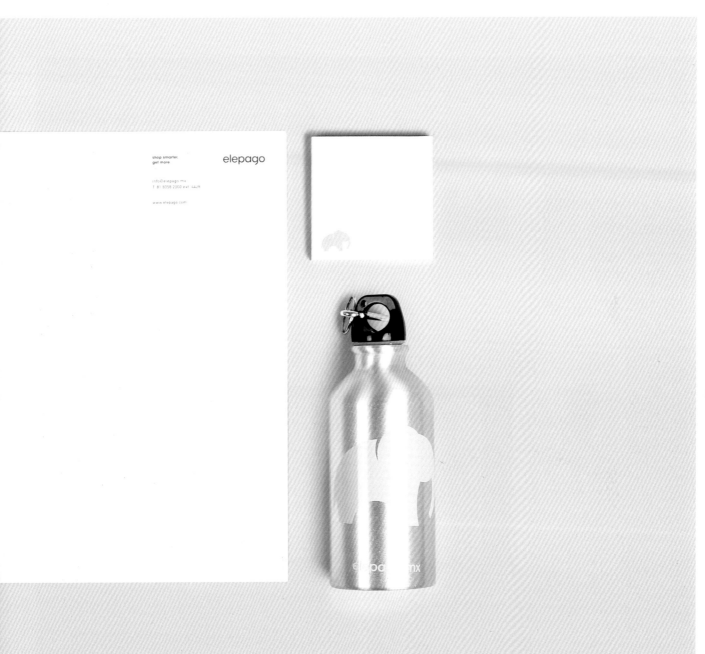

The Birth of Abel

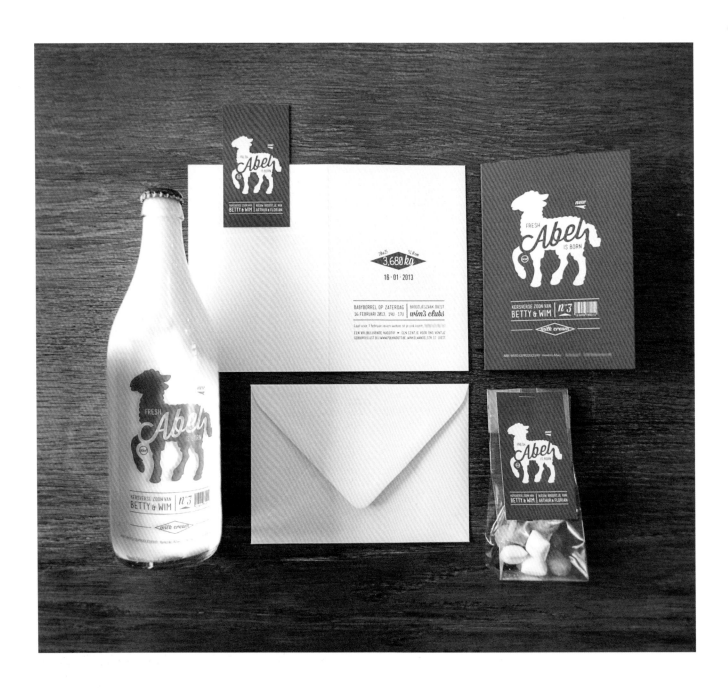

Belgium

Designer
Jacques Maes, Lise Braekers

Client
Wim & Betty

This project was designed to celebrate the birth of the client's son Abel. The designer used a silhouette of a little lamb as the symbol of innocence, playfulness, and the beginning of a new life. An old fashioned milk bottle with special typography was delivered to each doorstep on the day of Abel's birth, as a way of sharing this cheerful message.

Personal Business Card

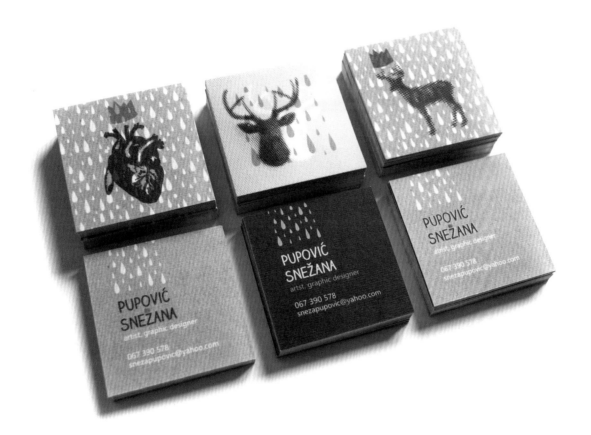

Montenegro

Designer
Snežana Pupović

These business cards are inspired by the naturally aesthetic shape of deer. The project takes a very artistic approach, especially with the horns which look like a drawing of tree branches. With their graceful and wonderful horns, the deer seem to come from an amazing fantasy world.

Low Brau

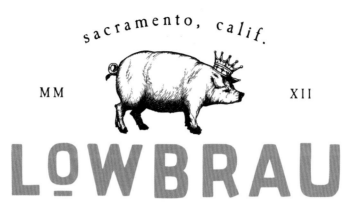

sacramento, calif.

MM XII

LOWBRAU

bierhalle

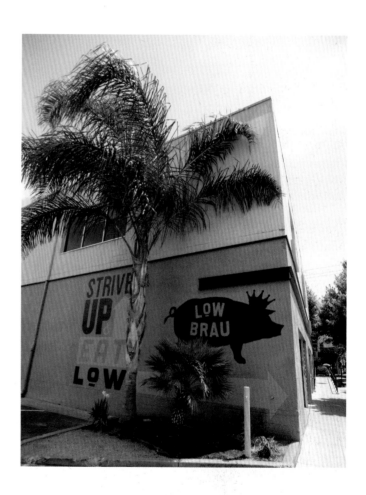

United States

Design Agency
Band

In Germany, the "beirhalle" (beer hall) is a communal gathering place where people can enjoy time with friends and family. "Lowbrau" puts a modern spin on the traditional German Bierhalle. Located in the heart of Sacramento's midtown, Lowbrau features community tables, beers from the old country and sausage to go with it. Band aimed to give Lowbrau a sense of heart and could not have been more thrilled with how it turned out.

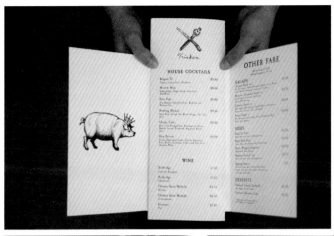

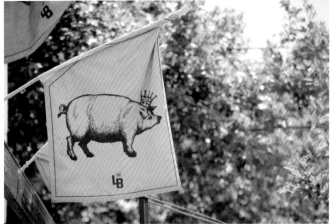

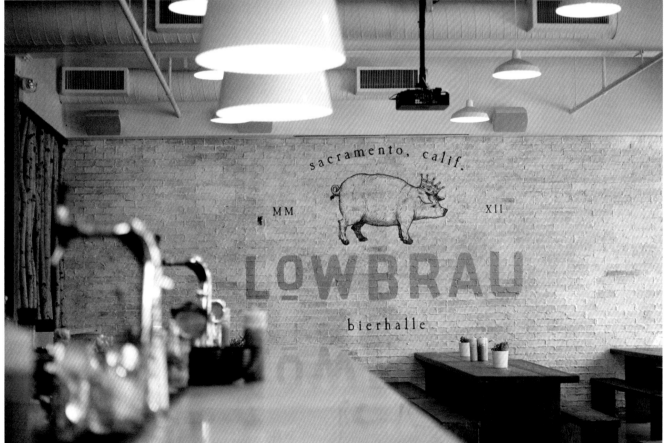

Boksem Bende

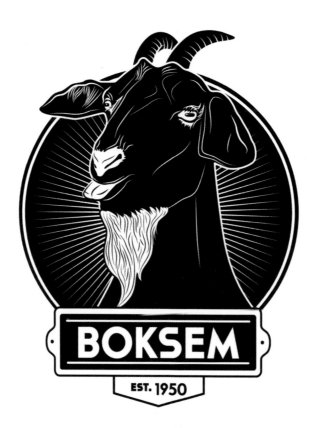

South Africa

Designer
Janus Badenhorst

The project brief was to design a new South African craft beer brand. Janus had to use the word "Bok" in the name, which is the Afrikaans word for goat. The inspiration of this project comes from a legendary South African story: "Trompie en die Boksem bende." The story is about 4 boys and the adventures that they experienced. The "Boksem" brand focuses mostly on Afrikaans speaking males, using nostalgia and a "boys will be boys" prankish approach for the tone of the message, as well as the look and feel.

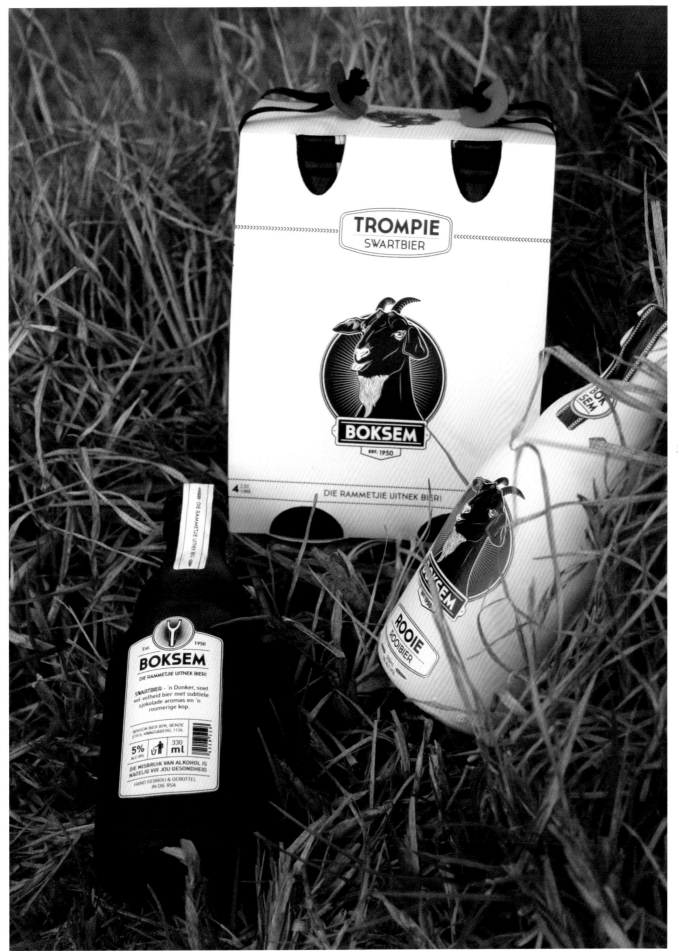

38 *Mitsubachi Hachimitsu*

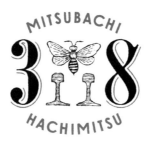

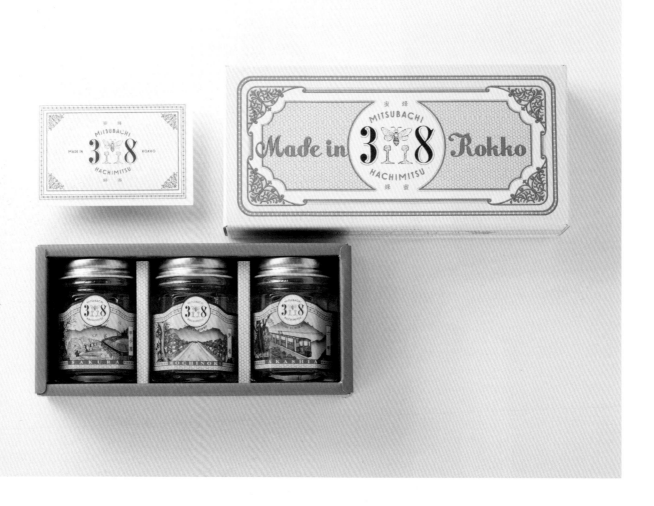

Japan

Design Agency
ANONIWA

Designer
Naoto Kitaguchi

Client
Mt. Rokko Cablecar & Tourism Company

This packaging was created for a new range of products released by a railway company. Ever since it was founded, the railway has carried passengers reliably, day in and day out, like bees carrying nectar from flowers back to the hive. This abstract connection between bees and railway rail led to the creation of a logo that communicates the commitment of the railway company to its passengers, a commitment which has remained unchanged since the first train departed.

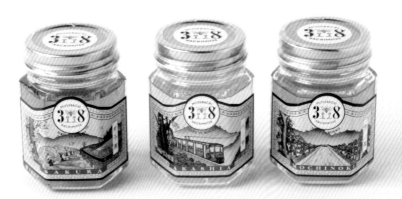

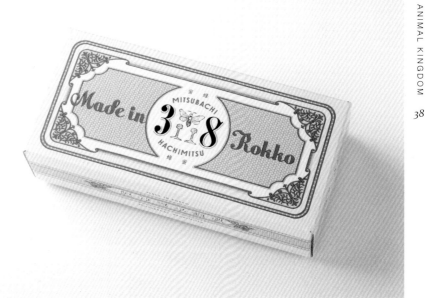

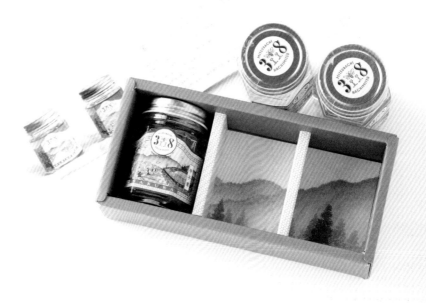

ChillsDeli Branding Development

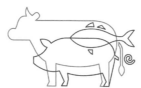

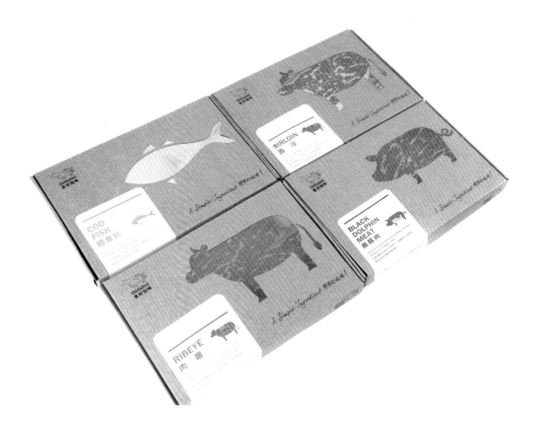

Hong Kong (P.R.C)

Design Agency
The Box Brand Design Ltd.

Creative Director
Joey Lo

Art Director
Yvonne Chung

Designer
Sibyl Yan

Client
ChillsDeli

"ChillsDeli" uses high-quality, imported cooking ingredients. In order to express this simple marketing concept, three images which look like a fish, cow and pig are used in the logo and branding element. Fish, beef and pork are basic ingredients in the human diet. The brand message is delivered to the customers using the graphic design and interior design in the brand's retail shops.

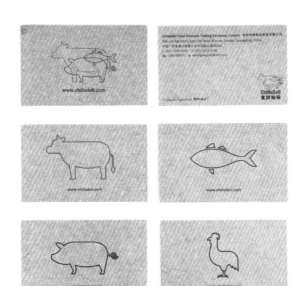

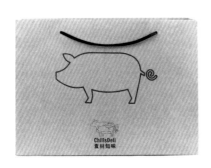

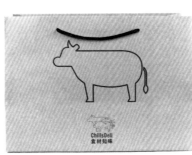

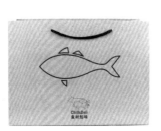

Ibra

Tulio Tucano.

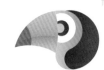

ibra
Instituto Brasil Ambiental

RGB: 230/51/56
CMYK: 0/90/75/0

RGB: 240/190/0
CMYK: 10/25/100/0

RGB: 21/50/82
CMYK: 100/80/40/35

RGB: 120/204/244
CMYK: 53/0/0/0

RGB: 232/78/27
CMYK: 0/80/95/0

RGB: 239/125/23
CMYK: 0/60/95/0

RGB: 0/90/55
CMYK: 85/0/75/60

RGB: 172/201/14
CMYK: 40/0/100/0

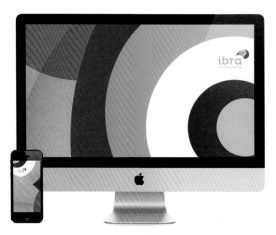
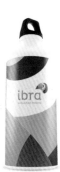

Brazil

Designer
Manoel Andreis Fernandes

Client
IBRA

Notable for its colorful plumage, Tucano is a very beautiful bird in Brazil. The idea was to create an icon that people could love and feel comfortable with. The tucano serves as an easily recognized symbol for all ages, especially children.

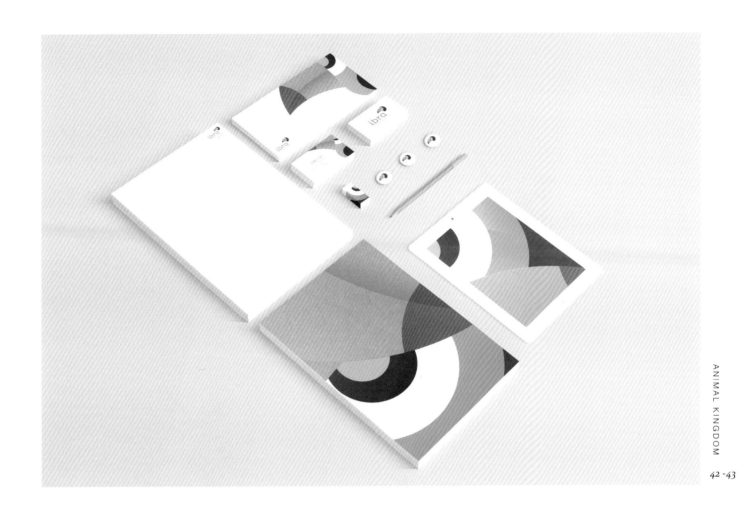

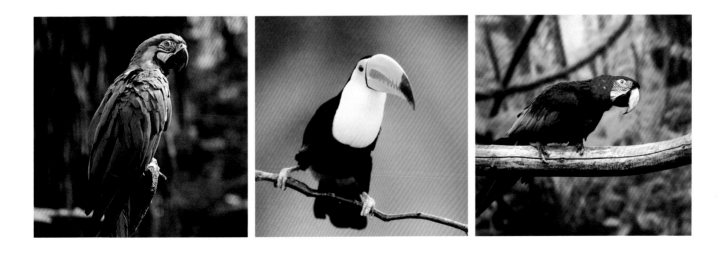

Jealous Sweets

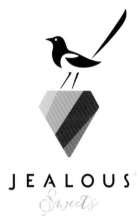

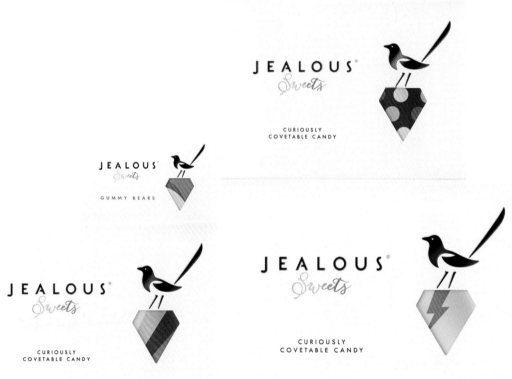

United Kingdom

Design Agency
B&B studio

Creative Director
Shaun Bowen

Designer
Claudia Morris

Client
Jealous Sweets

Jealous Sweets was looking to bring credibility to candy with its range of delicious and high-quality sweets for grown-ups. So the rebranding project adopted the intelligent magpie to showcase its brand character. The magpie is famed for its longing for all things shiny and precious. It was blessed with a sweet-tooth instead of sparkly eyes, and would surely be spellbound by Jealous' uniquely covetable sweets, sweets destined to be desired by those who insist on the best.

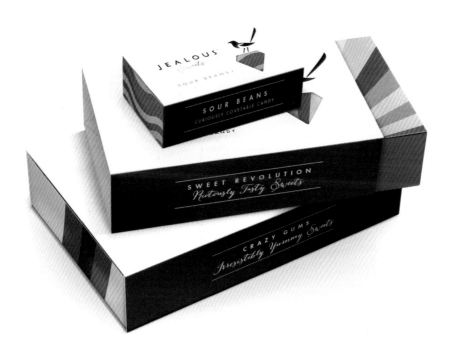

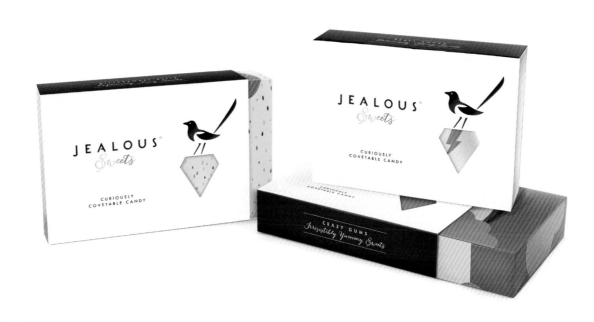

John White Shoes

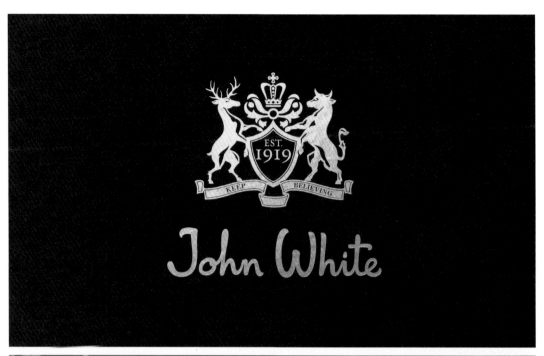

United Kingdom

Design Agency
Yawn Creative

Designer
Joe George, Harry Fowler, Charlie Wild

Client
John White Shoes

John White is a traditional English men's shoemaker which was established in 1919. In order to get the company back in touch with its roots and its founder, John White, the rebranding project has decided to create a traditional coat of arms with a contemporary feel. The bull is a symbol for strength and durability and the white hart elegance and style. Combined they offer the perfect symbol for John White shoes.

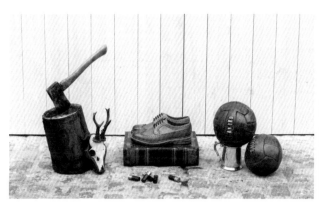

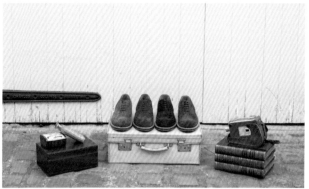

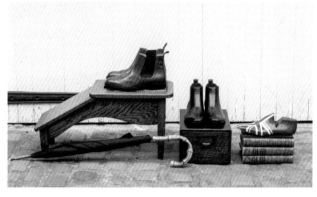

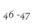

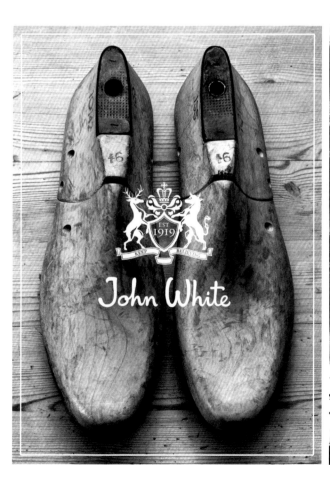

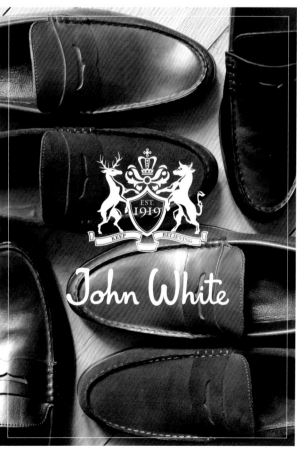

Oriental Films New identity 2012

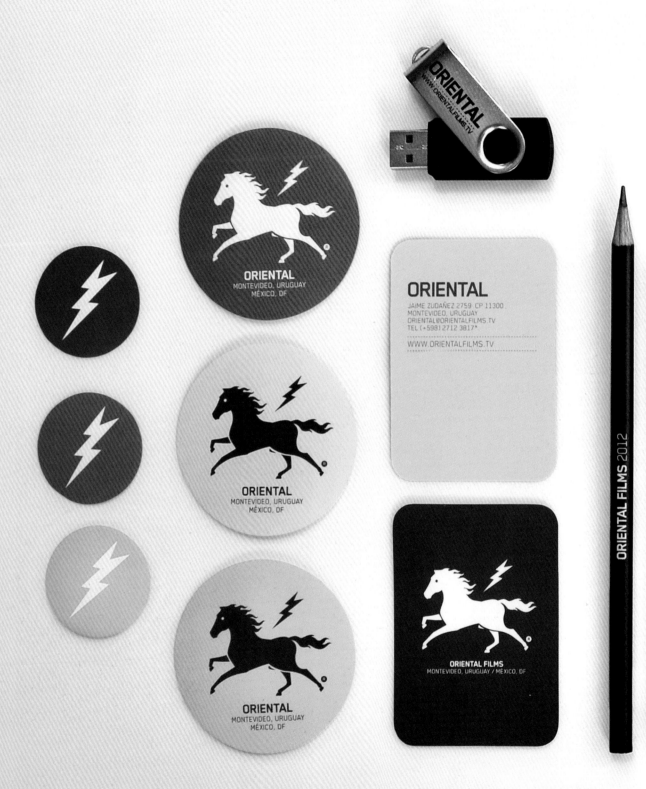

Uruguay

Designer
Gutiérrez

Client
Oriental Films

Oriental Films is an important production house in Uruguay which has been seen around the world. A horse symbolizes elegance, strength and freedom (as well as being the national animal of Uruguary) and is used as the main graphic element in the new corporate identity.

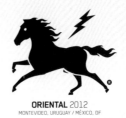

ORIENTAL 2012
MONTEVIDEO, URUGUAY / MÉXICO, DF

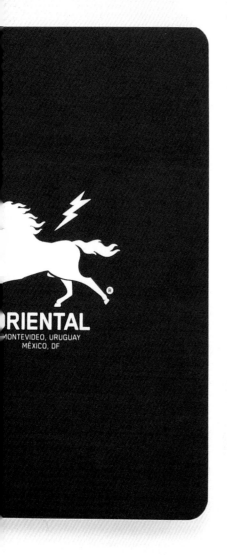

ORIENTAL
MONTEVIDEO, URUGUAY
MÉXICO, DF

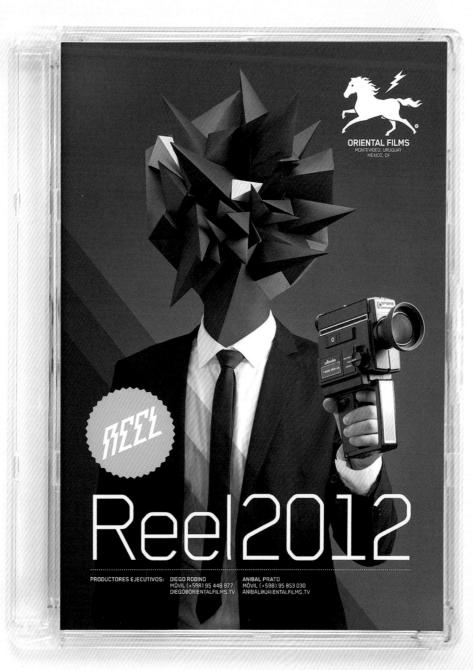

ORIENTAL FILMS
MONTEVIDEO, URUGUAY
MÉXICO, DF

REEL

Reel2012

PRODUCTORES EJECUTIVOS: DIEGO ROBINO ANIBAL PRATO
 MÓVIL (+598) 95 448 877 MÓVIL (+598) 95 853 030
 DIEGO@ORIENTALFILMS.TV ANIBAL@ORIENTALFILMS.TV

Personal Identity

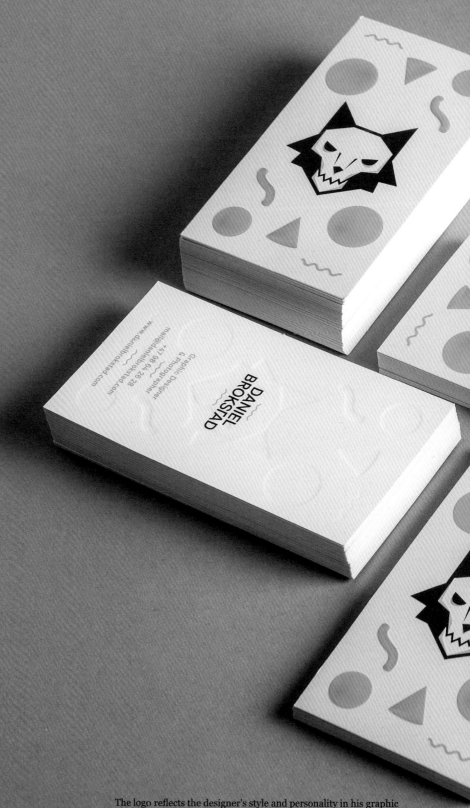

Norway

Designer
Daniel Brokstad

The logo reflects the designer's style and personality in his graphic design work. The update creates a more defined look, sharper edges and a more contemporary feel. The business cards are embossed with the design elements to create an interesting contrast on the otherwise clean information side.

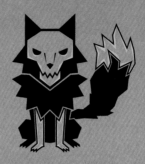

DANIEL
BROKSTAD

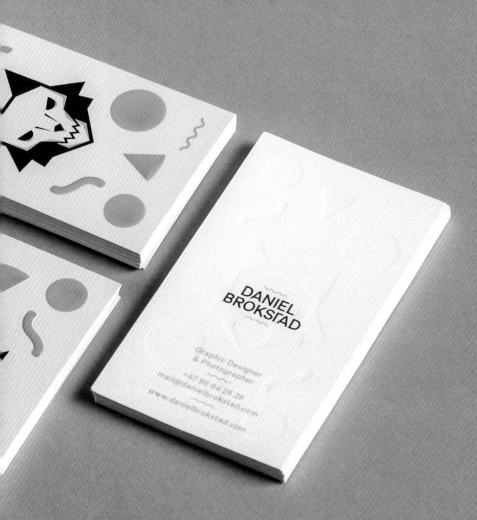

DANIEL
BROKSTAD

Graphic Designer
& Photographer
+47 98 64 26 26
mail@danielbrokstad.com
www.danielbrokstad.com

Plant & Pollinate

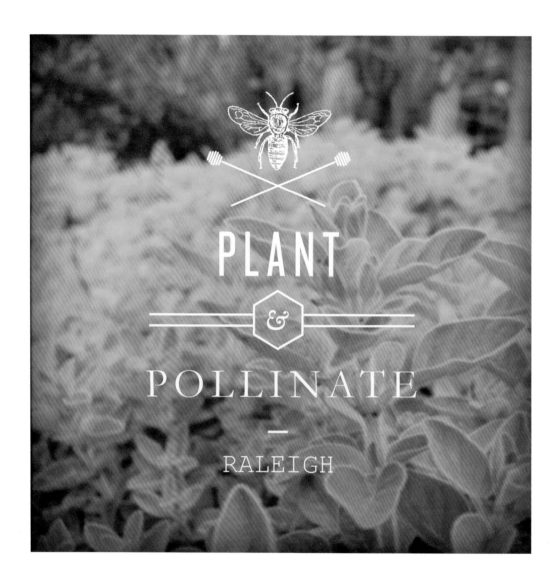

United States

Designer
Chelsea Amato

Plant & Pollinate is a honey bee advocacy campaign based on agricultural solutions which can be supported by all Americans in both urban and rural settings. The herbal pollinator toolkits include an herbal compendium, seeds, starter pots, plant care cards, and urban garden guide, and plant labels. In addition, pollinator totes, t-shirts, and posters are available.

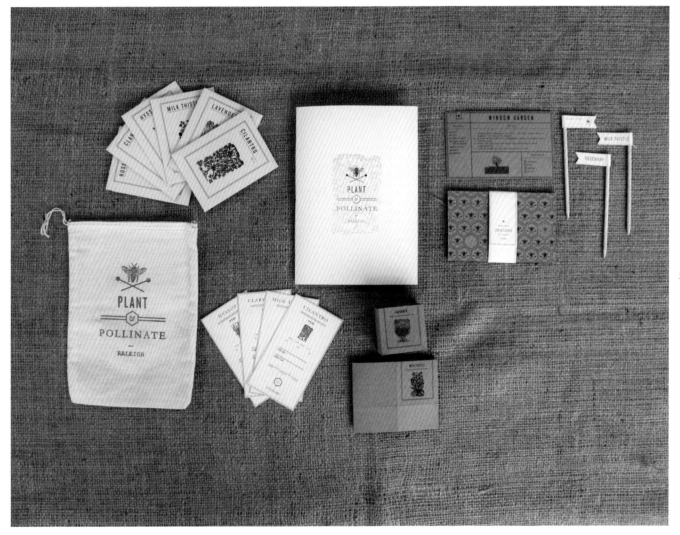

Sauce Restaurant

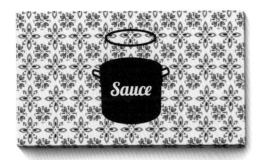

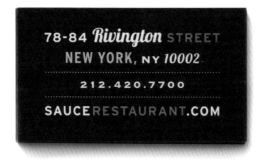

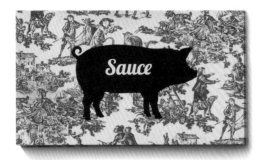

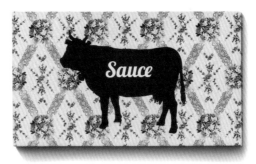

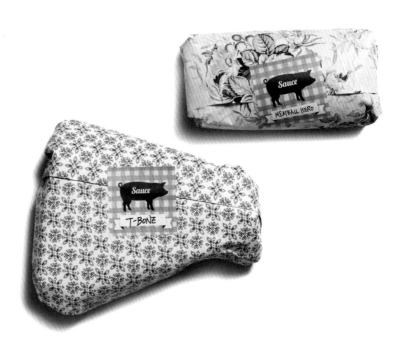

United States

Design Agency
Marty Weiss and Friends

Creative Director
Marty Weiss

Art Director
Andrea D'Aquino

Designer
Eulie Lee

Client
Sauce Restaurant

Sauce is the 4th restaurant run by Chef Frank Prisinzano having previously managed Frank, Lil' Frankies and Supper. It is warm and authentic, with an almost "undesigned" design esthetic. The identity, featuring pots, pigs and cows hovering over grandmotherly wallpaper, mixes the old world vision of Frank and partner Rob DeFlorio with a quirky modern spin. The whole identity included the storefront signage, shopping bags, menus, cups, butcher wrap and wallpaper.

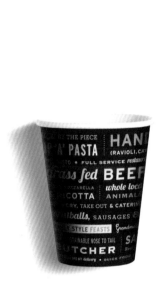

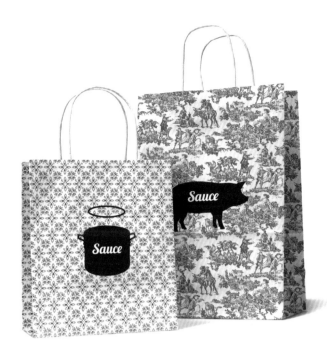

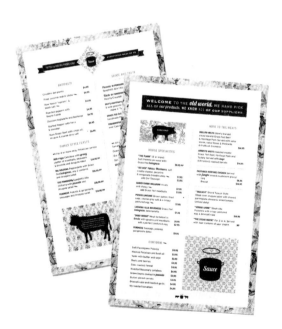

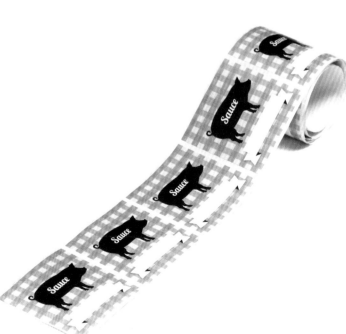

Café Fou

Argentina

Design Agency
Los Caballos

Creative Director
Nicolas Di Filippo, Sebastian Fuks

Client
Café Fou

Café Fou is a homemade, black coffee house. The designers wanted to reflect the strength of the product by featuring its main characteristics: an energizing, strong, black coffee that can keep you as alert as a cat at night.

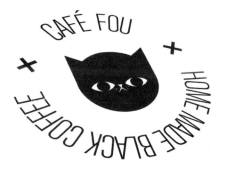

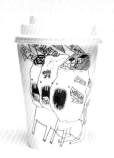

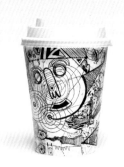

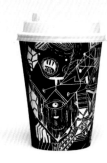

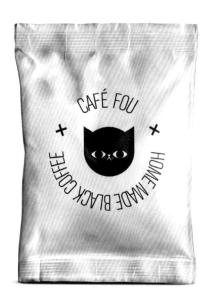

Bear Clothing UK

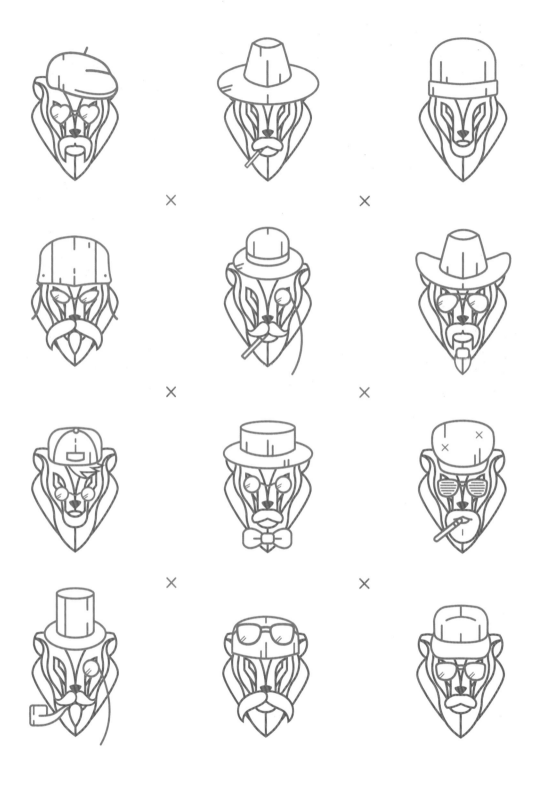

Portugal

Designer
Tiago Machado

Client
Bear Clothing UK

Bear Clothing UK is a new fashion apparel brand in the United Kingdom, presenting as a manly brand. Under the requirement of an image of bear, the designer aimed to create a new visual identity that could be sophisticated, humorous and minimalistic. The bear has been personalized with some apparel accessories such as a hat or a scarf, and even a mustache.

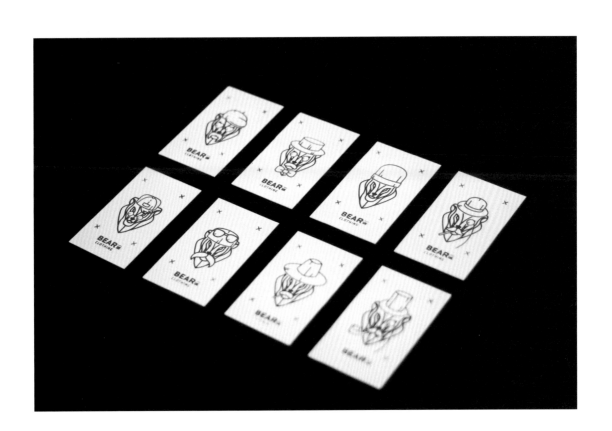

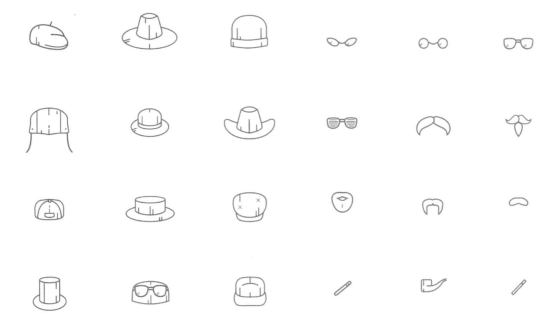

Be Yourself

Brazil

Designer
Marmota vs Milky

The animals featured in this project have wonderful and memorable features. They have striking personalities that can inspire the viewer to be someone better.

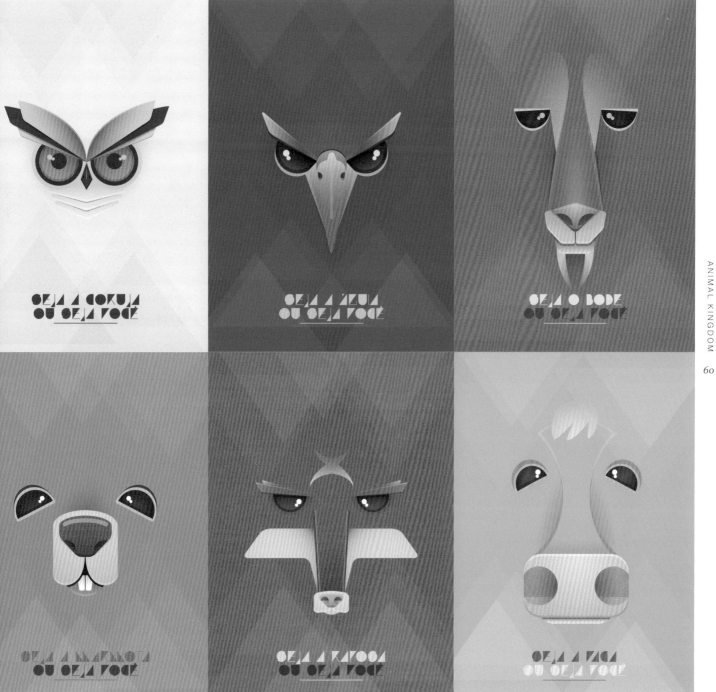

Narcizo NYC

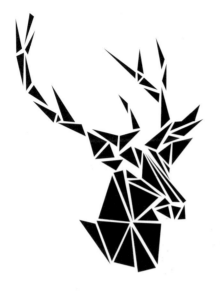

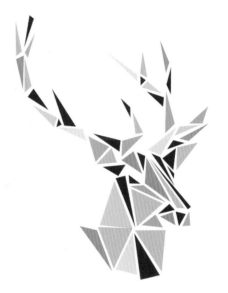

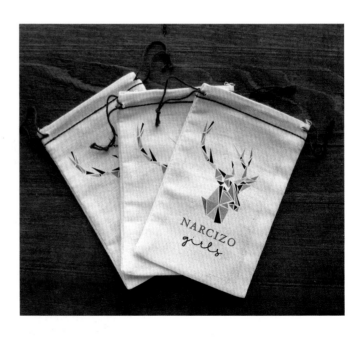

United States

Design Agency
Bardo Industries, LLC

Creative Director
Lau Giraudo

Designers
Lau Giraudo, Roberto Bernasconi

Photographer
Celeste Martearena Godoy

Model
Lore Olalla

Make up artist
Candelaria Carballo

Client
Cucu Fuentes, Narcizo NY

The concept behind the project is that every product has its own soul, and the sum of all the souls becomes this one amazing animal soul. Narcizo NYC branding is represented by a deer. The deer is in the forest, surrounded by nature and in harmony with other species. Narcizo is a unique brand that combines organic materials with the talent of the jewelry designer Cucu Fuentes.

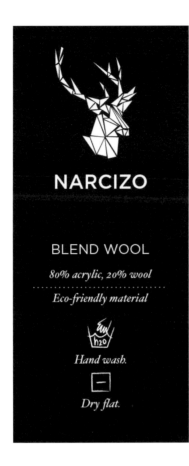

NARCIZO

BLEND WOOL

80% acrylic, 20% wool

Eco-friendly material

Hand wash.

Dry flat.

MADE IN NYC
www.narcizo.net

material

material

material

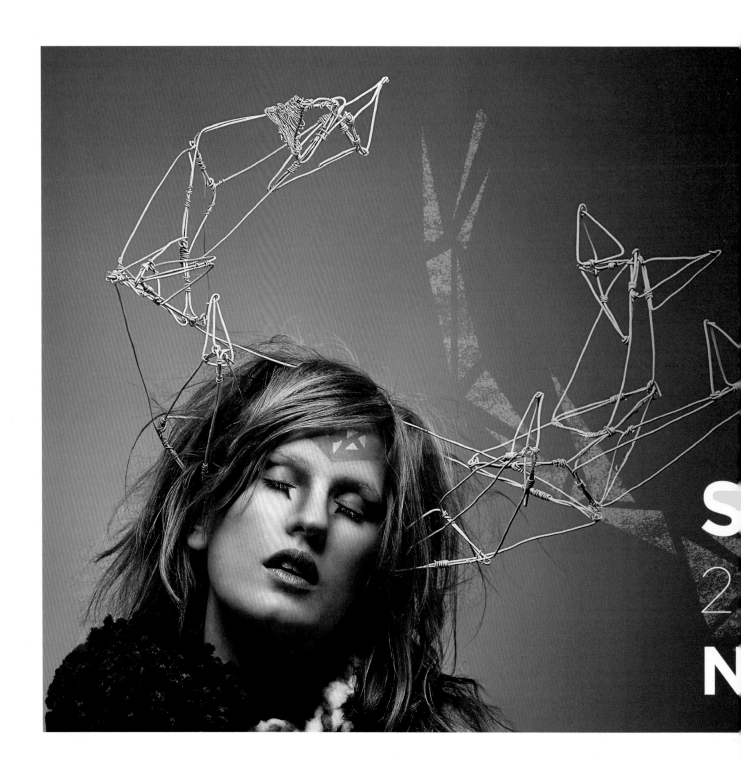

ASON
/ 2012
RCIZO

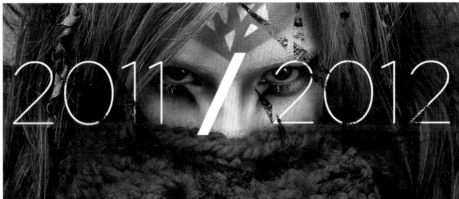

2011 / 2012

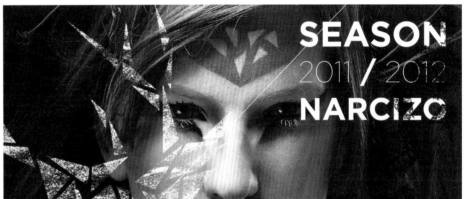

SEASON
2011 / 2012
NARCIZO

SPRING
SUMMER
2012

Sweets Packaging

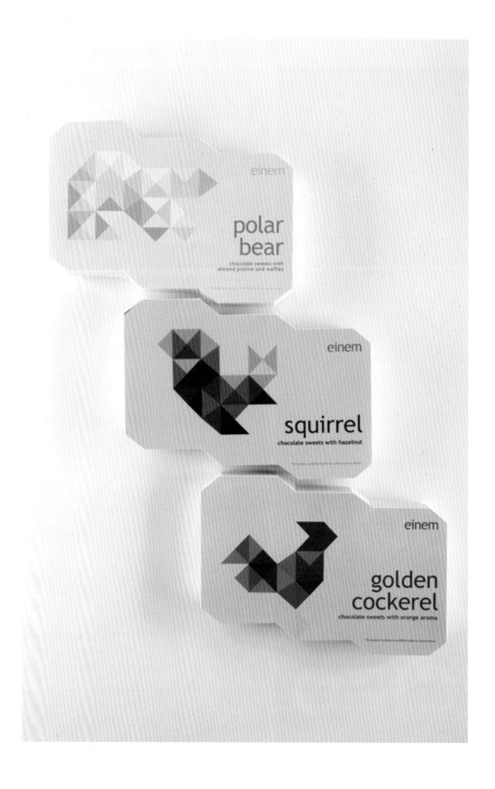

Russia

Designer
Anna-Maria Bushtueva

This sweets packaging box in the specific shape contains 15 sweets in each box. The graphics on the outer packaging are a squirrel, polar beer and golden cockerel with gentle colors that reminded people of their childhood.

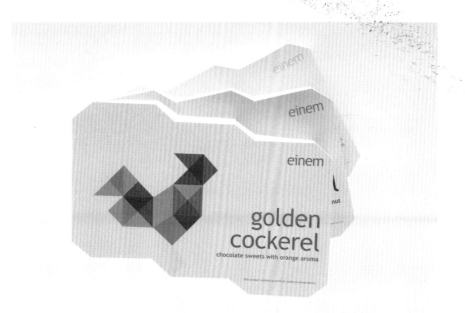

einem
einem
einem

nut

golden
cockerel
chocolate sweets with orange aroma

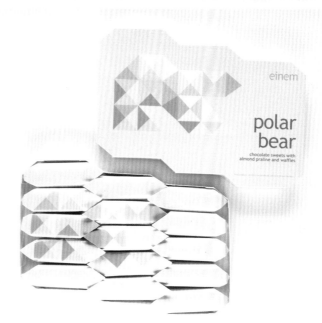

einem

polar
bear
chocolate sweets with
almond praline and waffles

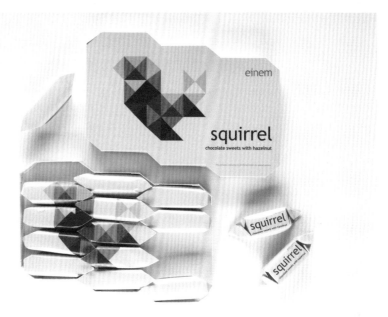

einem

squirrel
chocolate sweets with hazelnut

squirrel

squirrel

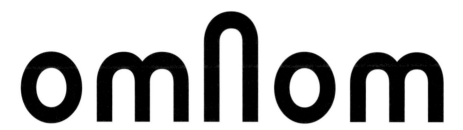

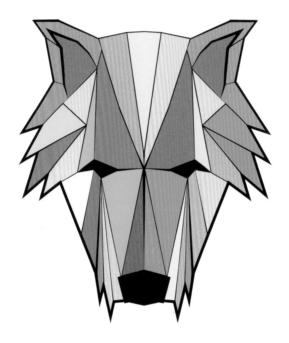

HAND CRAFTED CHOCOLATE

r e y k j a v í k

Iceland

Design Agency
The North South Studio

Designer
André Úlfur Visage

Client
Omnom

The box design for this project represents a secret chest of happiness. Instead of a throw away wrapper, the process of opening it up and the option of closing it again was important. It doubles as a tray while sharing and enjoying omnom and it is also a safety chest to protect any uneaten chocolate safely and neatly. The illustrated characters were inspired by living and traveling in Iceland.

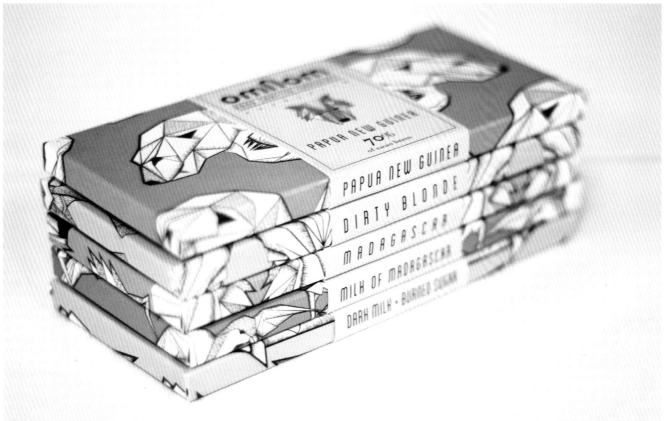

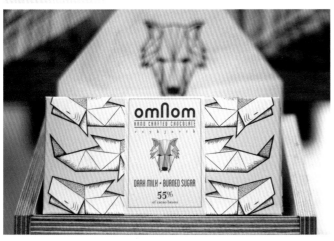

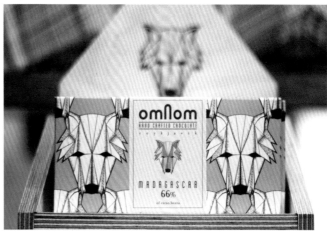

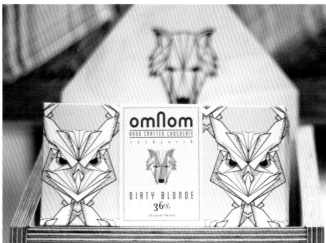

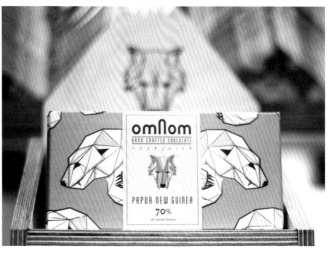

Tranimals

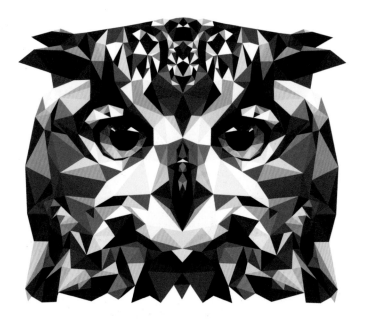

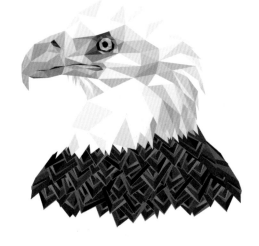

Canada

Designer
Hope Little

The "Tranimal" series contains a variety of animals from tigers and cheetahs to owls and dogs. This series was inspired by the variety of shapes and color palettes that each unique animal has. Using a geometric approach for the visuals each animal was constructed intricately with hundreds of vibrant colored vector triangles.

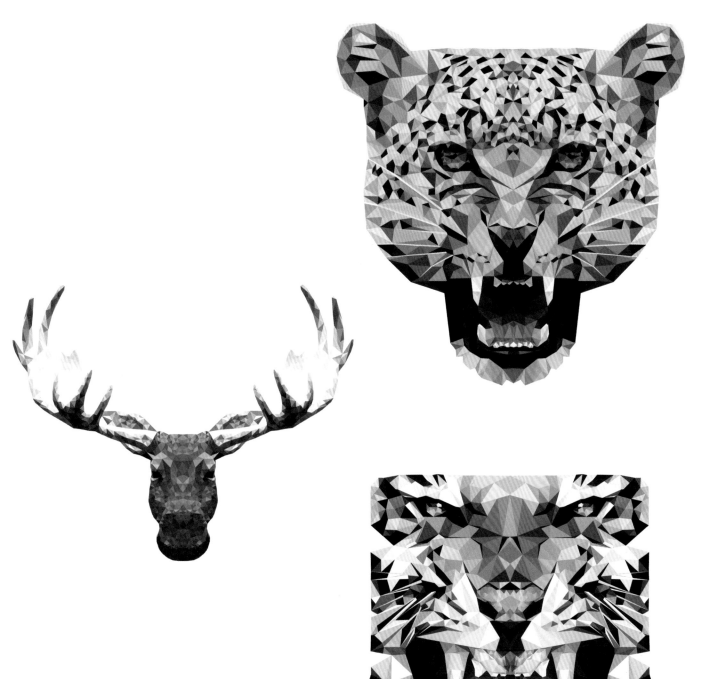

Word Animals

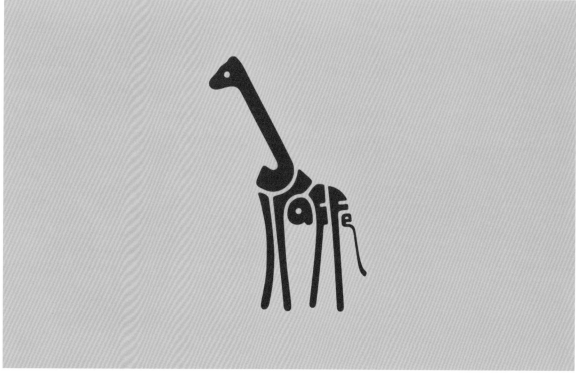

United Kingdom

Designer
Dan Fleming

"Word Animals" are illustrations of animals created using the letters in their name. It is a collection of 20 colorful typographic designs exploring the relationship between words and images.

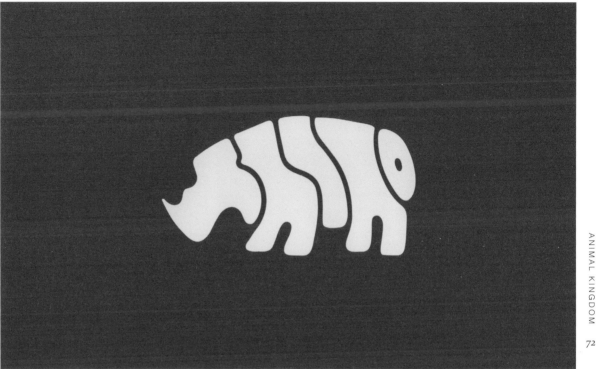

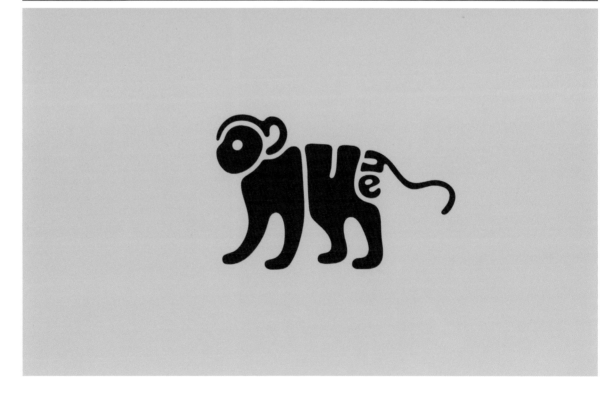

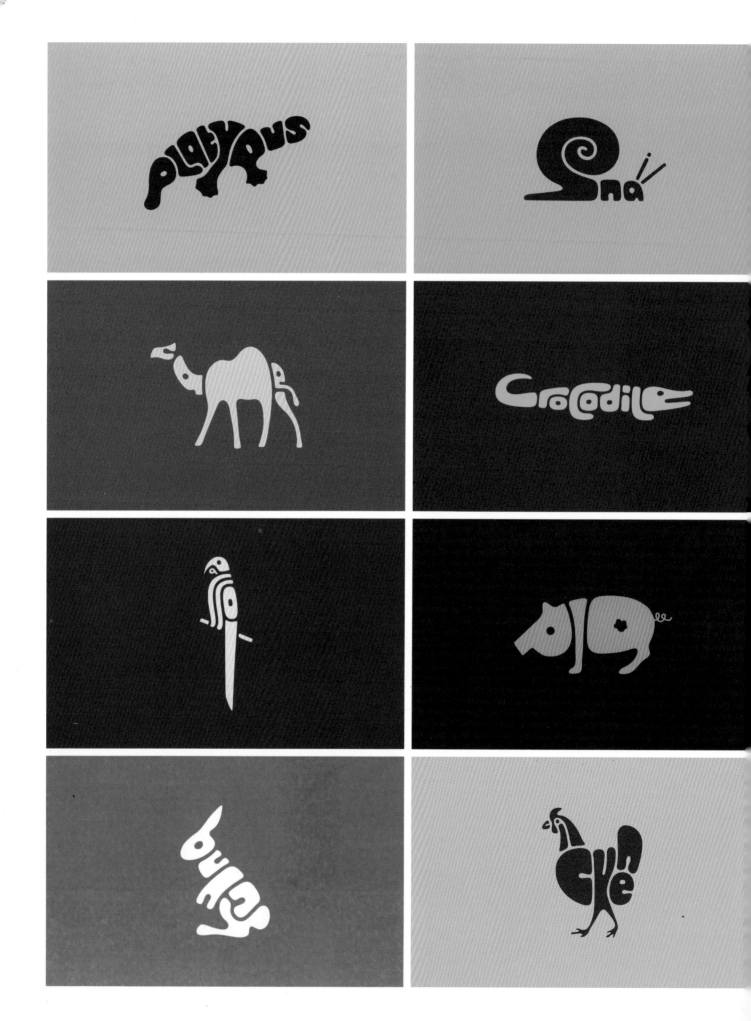

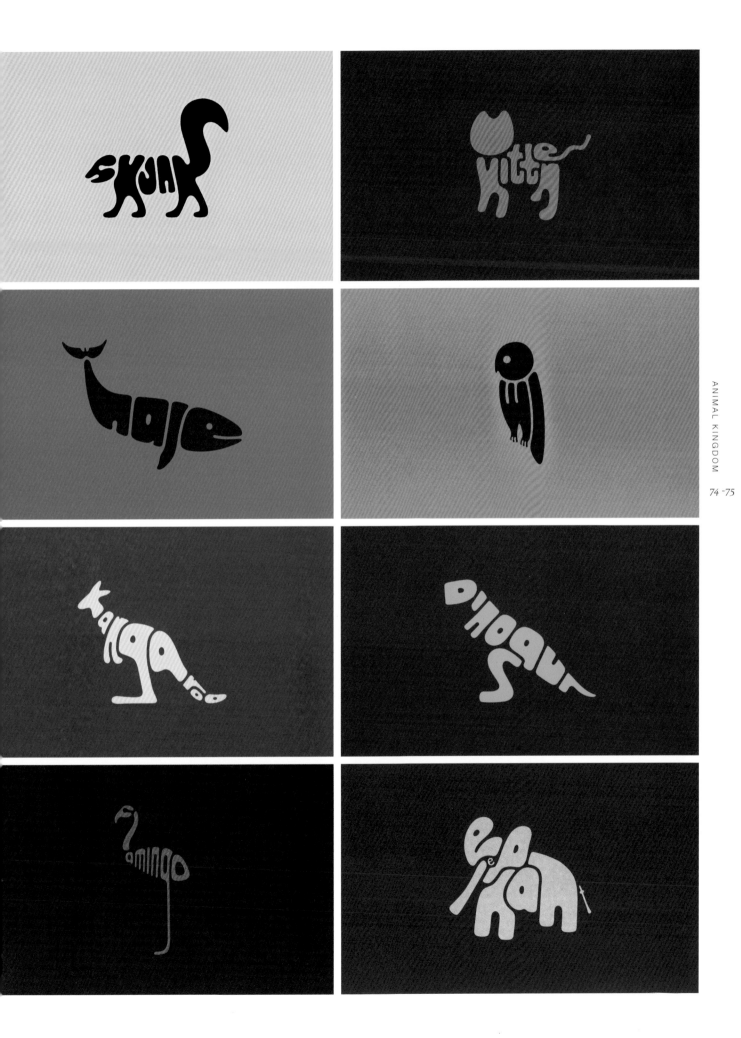

Børk

Iceland

Designer
Thorleifur Gunnar Gíslason

This project includes the naming of the company, logo and other graphical elements, packaging, website, stationery and business-card design. The designer used animals in Scandinavian style to liven up the whole graphic.

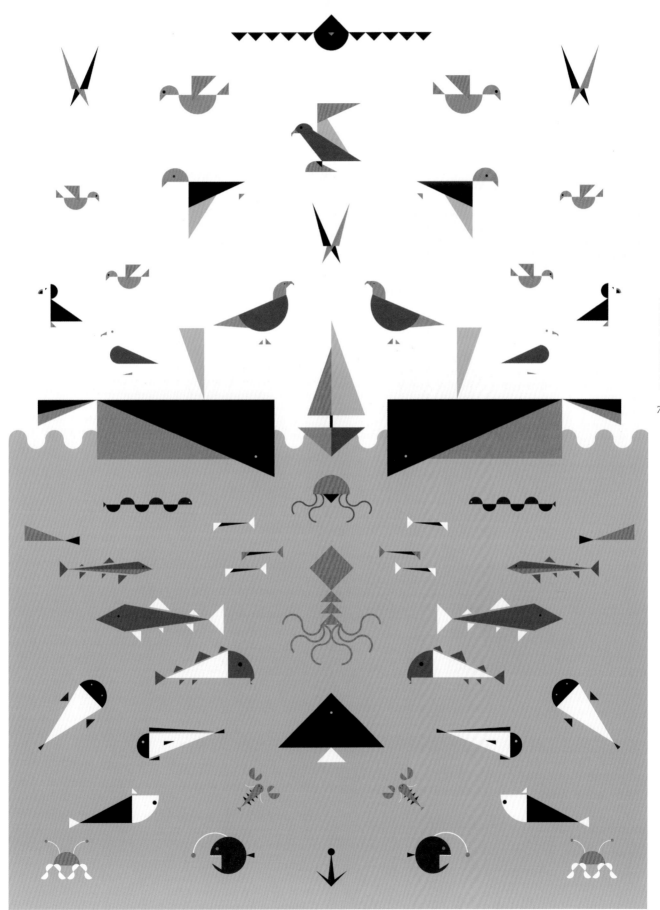

Belvoir Branding

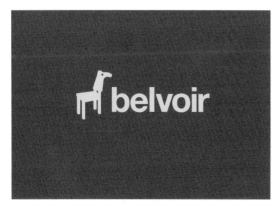

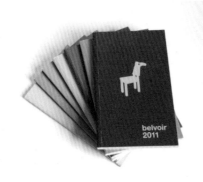

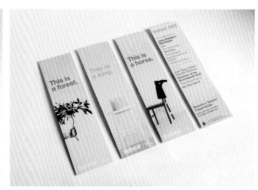

Australia

Design Agency
Alphabet Studio

Creative Director
Tim Kliendienst, Paul Clark

Design Consultant
Pim van Nunen

Designer
Lara Juriansz, Ashleigh Steel

Client
Belvoir Theatre

The concept behind the logo is about the theatre experience where the audience is an active participant in the telling of the story. In a film, a real horse would play the horse. In a theatre, a real horse would not only be impractical on stage, but also unnecessary since the audience will "see" a horse when they see a chair. Likewise with the logo, the viewer is asked to become a creative player and fill in the gaps.

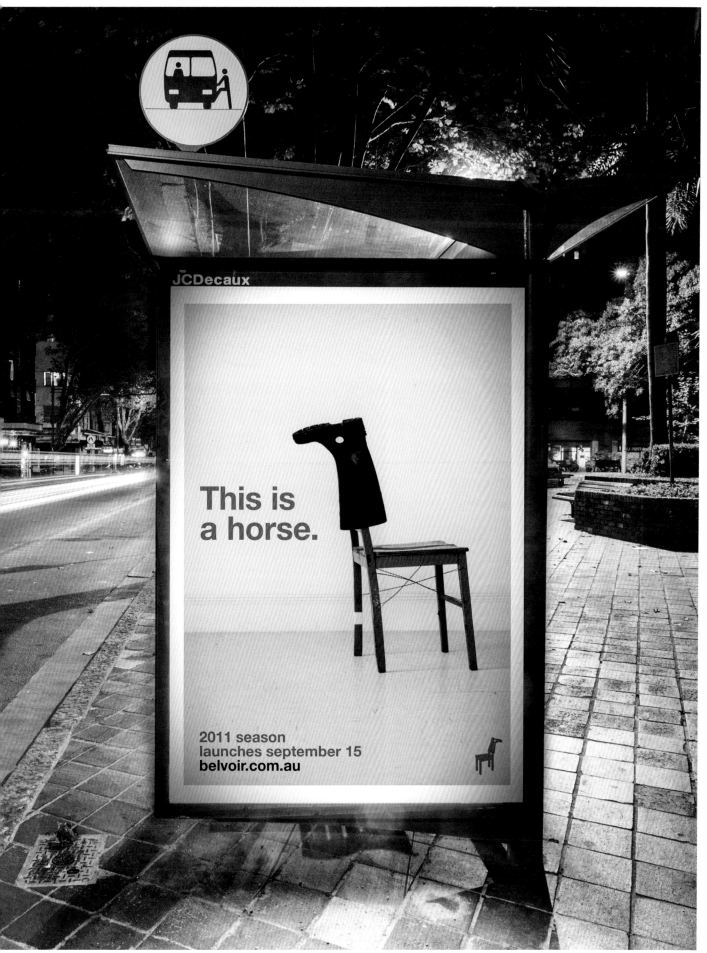

ColdMoth

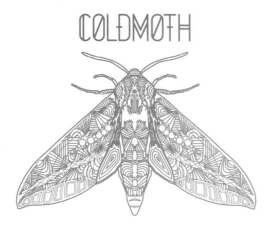

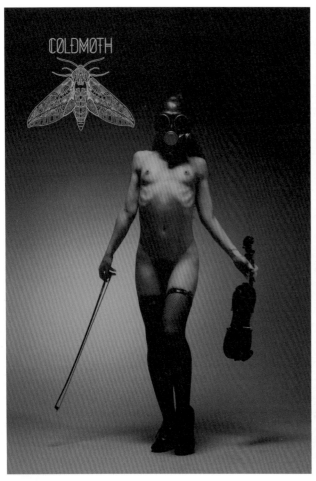

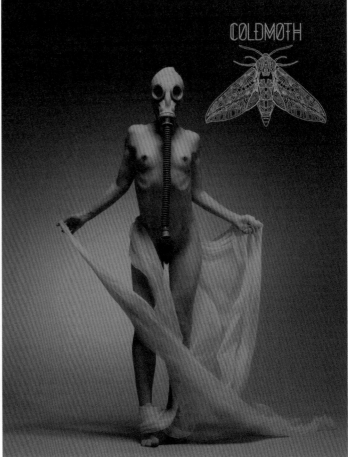

Canada

Designer
Tom Ralston

Client
ColdMoth

The design brief was to create an identity that was original, imaginative and passionate, creating a sense of mystery and intrigue. After various experiments it was decided that a literal approach to the logo was most suitable. The moth is a mysterious animal by its very nature - the dark, nocturnal counterpart to its cousin the butterfly.

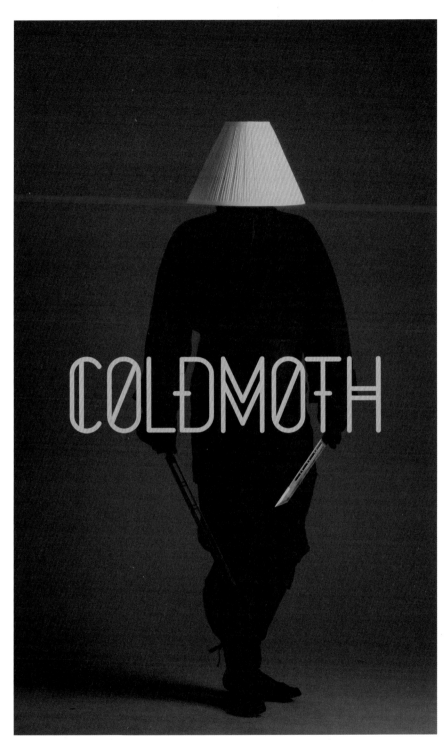

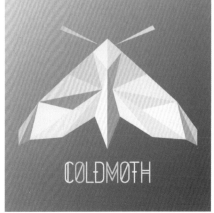

Koi

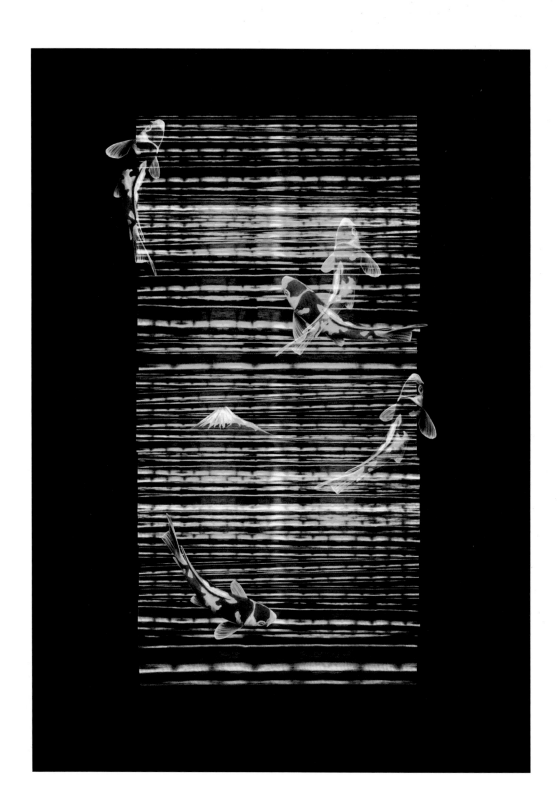

Finland

Designer
Emil Bertell & Kea Bertell

Client
AAVE Festival

This project was made to illustrate Oishii – Japanese for "food delicacies". It is one of the series created for AAVE festival (Alternative Audio Visual Event).

Die Bremer Stadtmusikanten

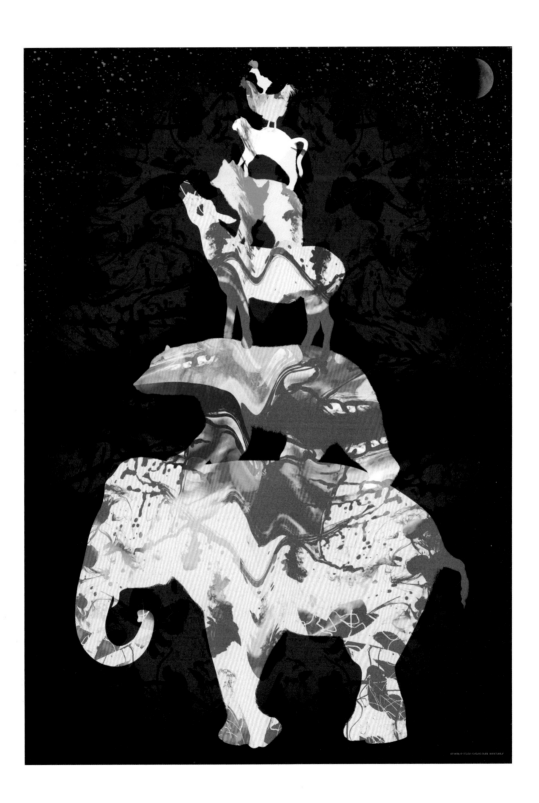

Japan

Design Agency
Ouwn

Designer
Atsushi Ihisguro

"Die Bremer Stadtmusikanten" means "the town musicians of Bremen" in German. The motif in this project drew inspiration from it and depicted many kinds of large and small animals together.

Bugs

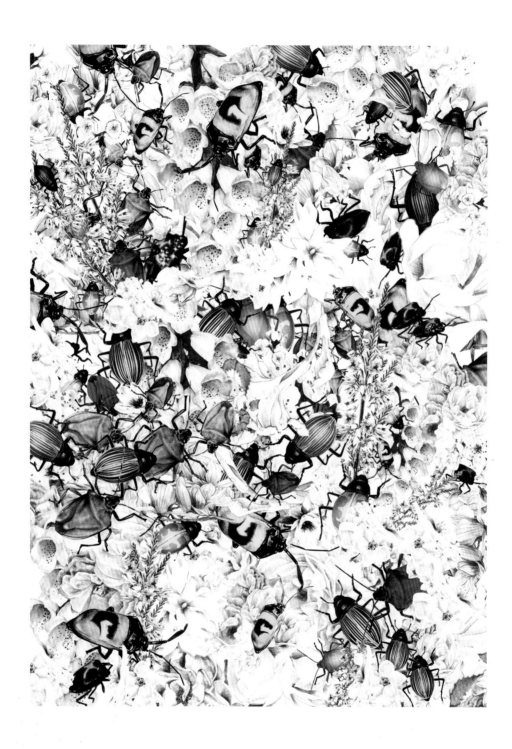

Finland

Designer
Emil Bertell & Kea Bertell

Client
Agent Pekka

This piece of work was made for the Amsterdam office launching exhibition of Agent Pekka, an agency dedicated to promoting original and well-crafted illustrations.

BESTIARIO

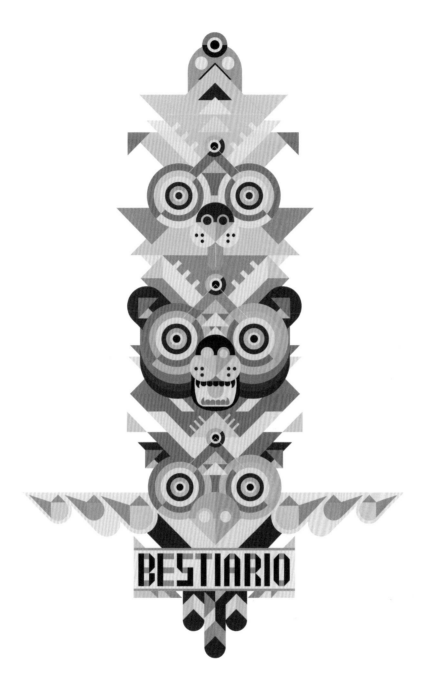

Uruguay

Designer
Gutiërrez

Bestiario Music Festival brought together three rock bands from Montevideo, Uruguay: Los Hermanos Láser, Boomerang and Eté & los Problems. The intention was to create an animal character to represent each of them in the poster.

Down To Earth

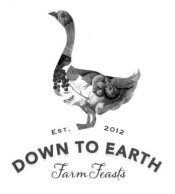

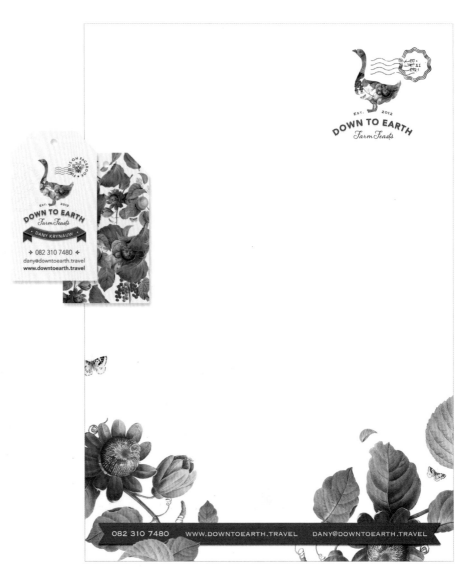

South Africa

Creative Director & Graphic Designer
Bia van Deventer

Client
Down To Earth

"Down To Earth" features two friends and their mobile kitchen. The fun and classic logo represents the "real food experience" as the central theme, which consists of two images: the primary duck logo and a secondary bee icon.

The duck symbolizes the farm-like dining venues with carefully selected food that represents the produce available. The flower, peach, red currant berries and lemon blossoms represent the diversity of flavor and color. The bee icon can be used in conjunction with the primary logo or cleverly incorporated as embossed or stamped elements. The bee also symbolizes "Down To Earth" moving from location to location, introducing people to local produce which they wouldn't otherwise have been aware of, "cross-pollinating" communities by connecting the people and the producers in their local area.

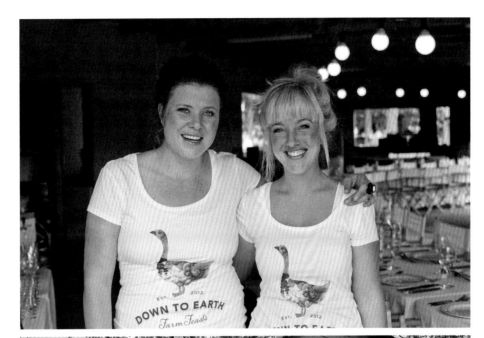

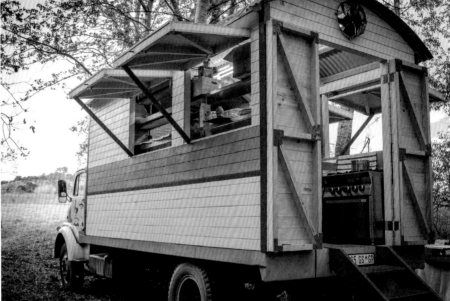

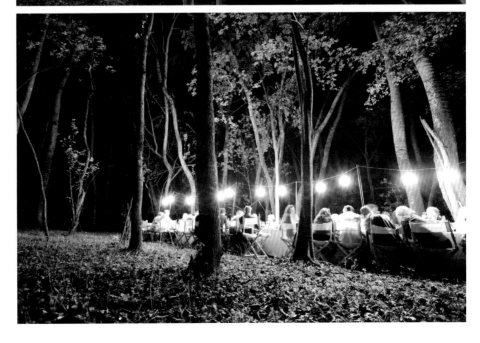

Ekies Aesop Fables

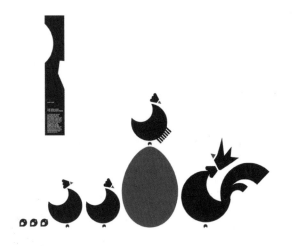

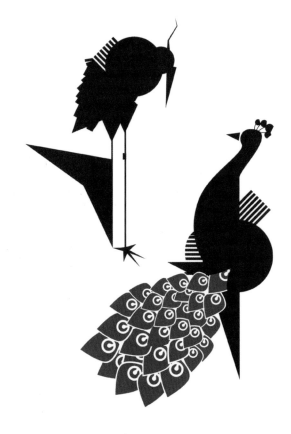

Greece

Design Agency
BeetRoot Design Group

Client
Ekies All Senses Resort

These vector based shapes were cut out on plexiglass and mounted on the walls. Each installation features one of Aesop's Fables. The illustrations were applied as well in other applications of the visual identity of the resort such as a giveaway calendar.

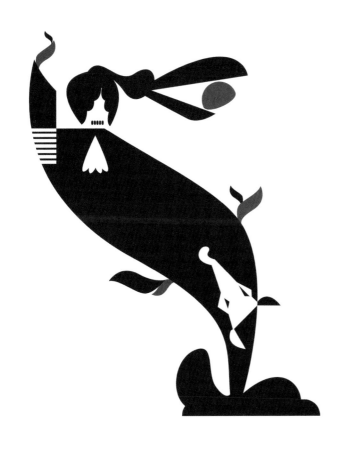

Ekies Identity

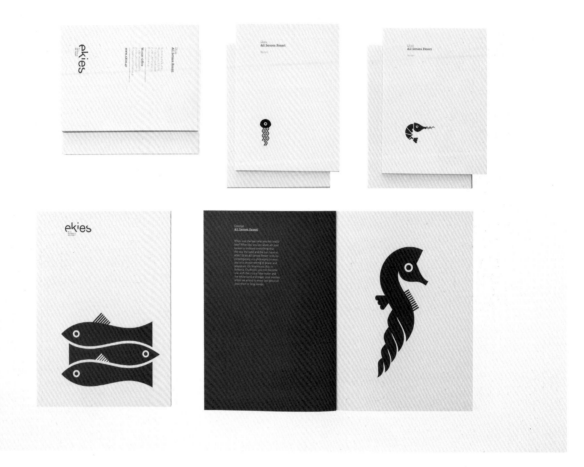

Greece

Design Agency
BeetRoot Design Group

Client
Ekies All Senses Resort

In order to communicate Ekies All Senses Resort's natural Greek environment, the designers chose to use illustrations of animals found in the local area. The illustrations had to be simple, pleasant and welcoming. The hotel's multiple needs were met with the variety of local animals plus some other illustrations created with the same technique. Eco friendly materials, discreet typography and sometimes photography were the elements of the corporate identity.

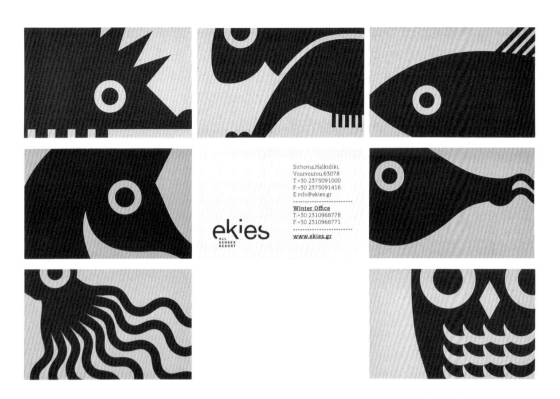

ekies
ALL
SENSES
RESORT

Sithonia,Halkidiki,
Vourvourou,63078
T.+30 2375091000
F.+30 2375091416
E.info@ekies.gr

Winter Office
T.+30 2310968778
F.+30 2310968771

www.ekies.gr

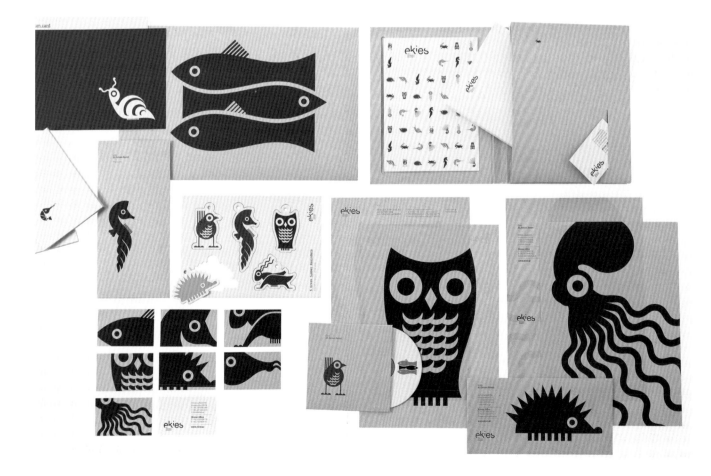

Trata OnIce Packaging

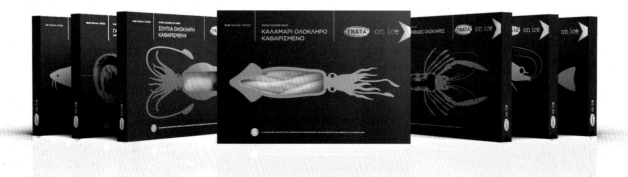

Greece

Design Agency
BeetRoot Design Group

Client
KONVA Canning Factory of North Aegean

The tail of a fish is one of the main visual elements that were used on these frozen seafood packaging series. It was used both on the design of the logo and the structure of the packages. It is a very strong element of the brand since it makes the products recognizable from any viewing angle. The black background, the subtle typography and the seafood illustrations were used to highlight the quality of the product and to give it a "delicatessen" feeling. People can see the product through the holes on the illustrations that highlight the part of the seafood that is included inside the package.

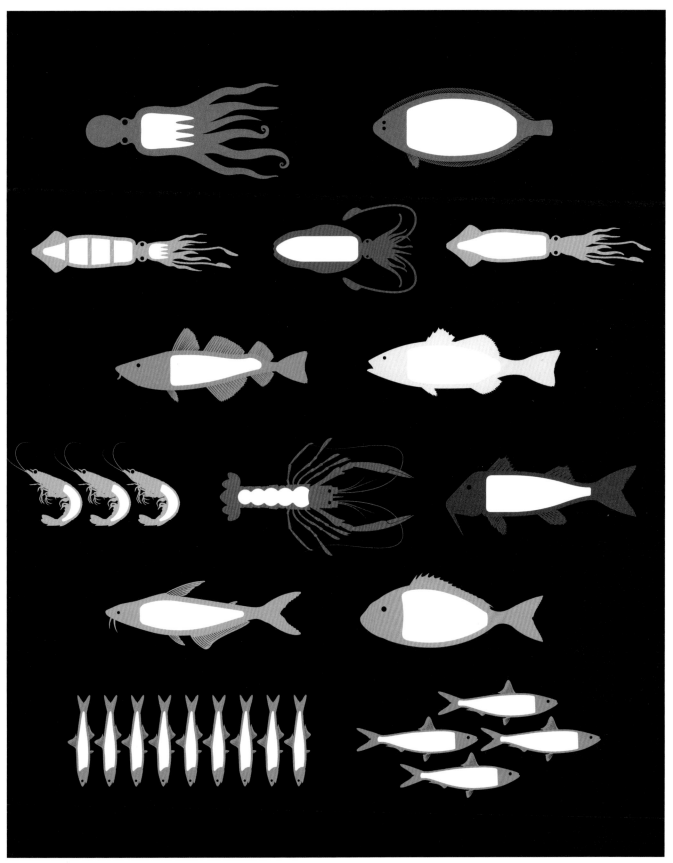

Windfest

Canada

Designer
Lily Li

Windfest is a kite festival held in Toronto every year. For this year's festival mascot, a bird was chosen to represent the childhood joy of kite-flying. The image of a bird is widely known as a symbol of freedom and adventure. Its presence throughout the festival branding intensifies the yearning to go on an imaginative journey.

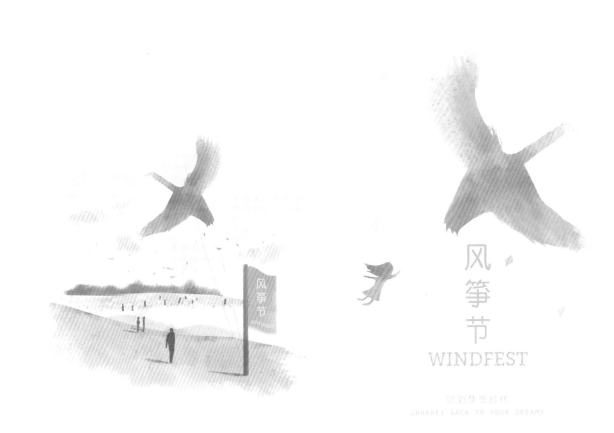

Onassis Cultural Centre

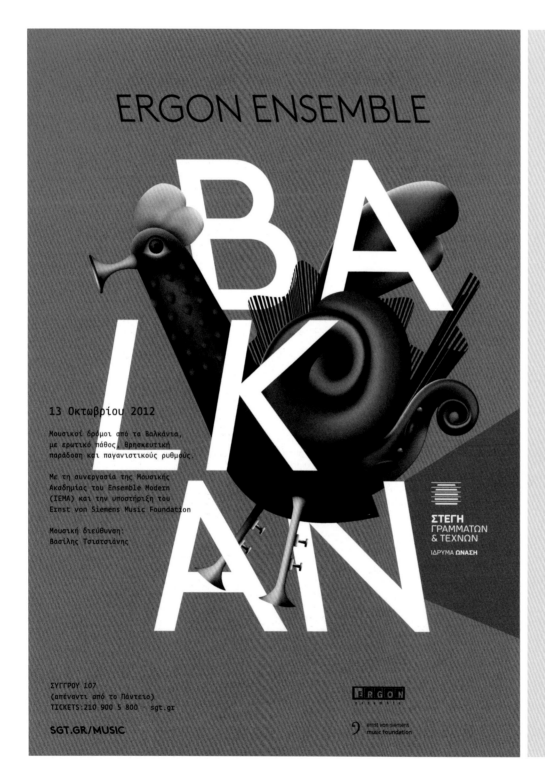

Greece

Design Agency
BeetRoot Design Group

Client
Onassis Cultural Centre

These illustrations featured clean-cut, single or two-color gradient colored shapes as well as black geometric graphic elements (including lines and patterns) that were heavily focused on the themes and imagery of each individual show. In many cases the anthropomorphic element was stretched when using abstract forms, but pushed back when using descriptive ones, so that the overall feel of structure and composition would be maintained. The illustration style became an easily recognizable and praised feature in the Onassis Cultural Centre's posters and visual communication.

ΟΣΕΙΣ ΙΙ

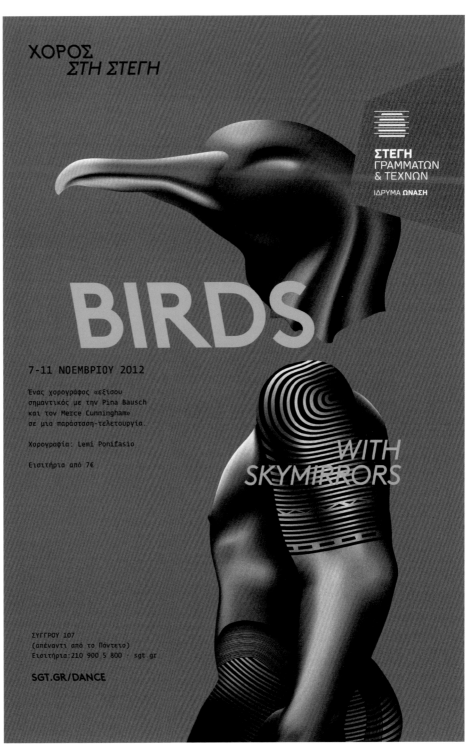

ΧΟΡΟΣ
ΣΤΗ ΣΤΕΓΗ

ΣΤΕΓΗ
ΓΡΑΜΜΑΤΩΝ
& ΤΕΧΝΩΝ
ΙΔΡΥΜΑ ΩΝΑΣΗ

BIRDS

7-11 ΝΟΕΜΒΡΙΟΥ 2012

Ένας χορογράφος «εξίσου
σημαντικός με την Pina Bausch
και τον Merce Cunningham»
σε μια παράσταση-τελετουργία.

Χορογραφία: Lemi Ponifasio

Εισιτήρια από 7€

WITH
SKYMIRRORS

ΣΥΓΓΡΟΥ 107
(απέναντι από το Πάντειο)
Εισιτήρια:210 900 5 800 · sgt.gr

SGT.GR/DANCE

Drosophila Melanogaster

Spain

Design Agency
NastPlas

Creative Director
Natalia Molinos

Art Director
Drfranken

Geneticists began breeding the fruit fly soon after the turn of the century, and since 1910 when the first mutation was reported, some 3000 mutations have been identified. In this project fruit fly is used as a symbol of mystery to reflect the combination of art and technology.

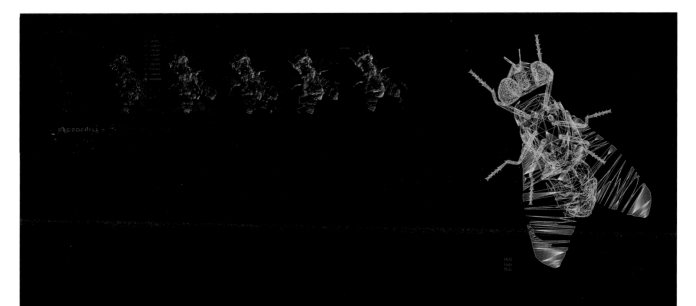

•

Geneticists began breeding the fruit fly soon after the turn of
 the century, and since 1910 when the first mutation was reported,
some 3000 mutations have been identified.
The definition of the final size and shape of an organ largely
depends on processes such as cell proliferation and differentiation.

•

Drosophila Melanogaster
evolutive sequence
by NastPlas

•

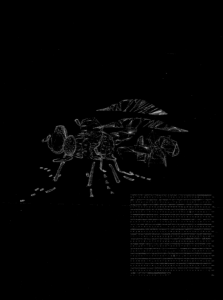

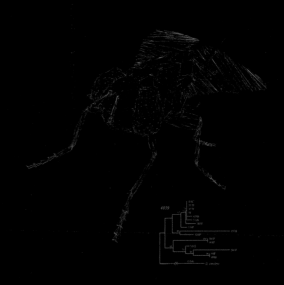

Noir

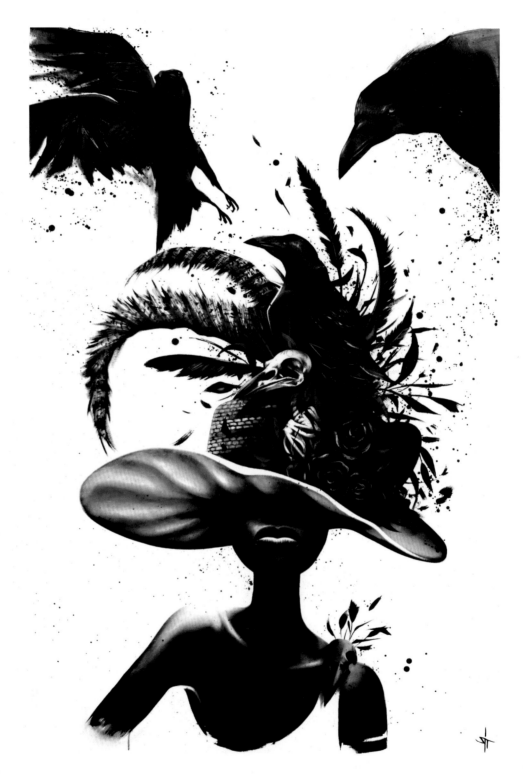

This bold, black and white work examines the troubled relationship between the animal kingdom and mankind, focusing on the magnificent beauty of the beast and the way it has been used to serve the vanity that is associated with humanity. The result is a haunting series that is simultaneously sexy and morbid. The sensual textures of fur and feathers are juxtaposed with pale animal skulls and soft female curves to illustrate what the artist sees as a blackness gnawing the edges of our sense of beauty.

The Netherlands

Artist
SIT

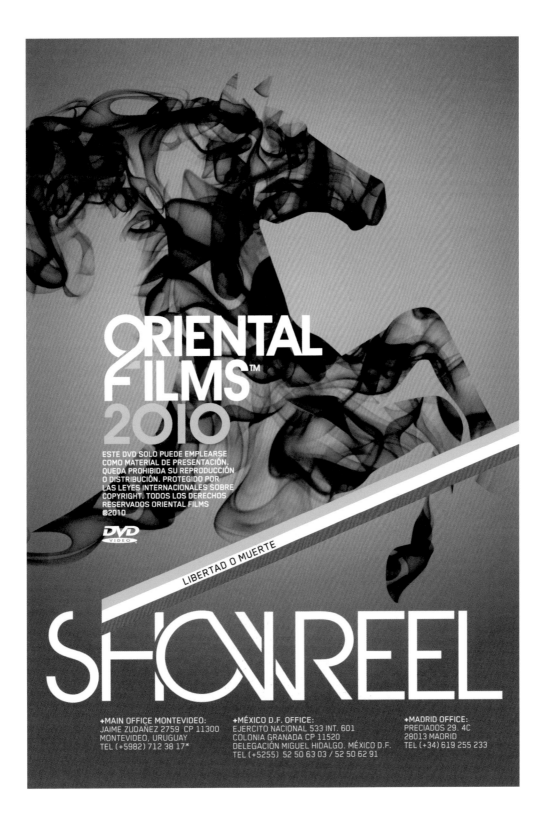

Uruguay

Designer
Gutiërrez

Client
Oriental Films

This timeless DVD Showreel cover was designed for Oriental Films 2010.

Vögele Fall Campaign 2012

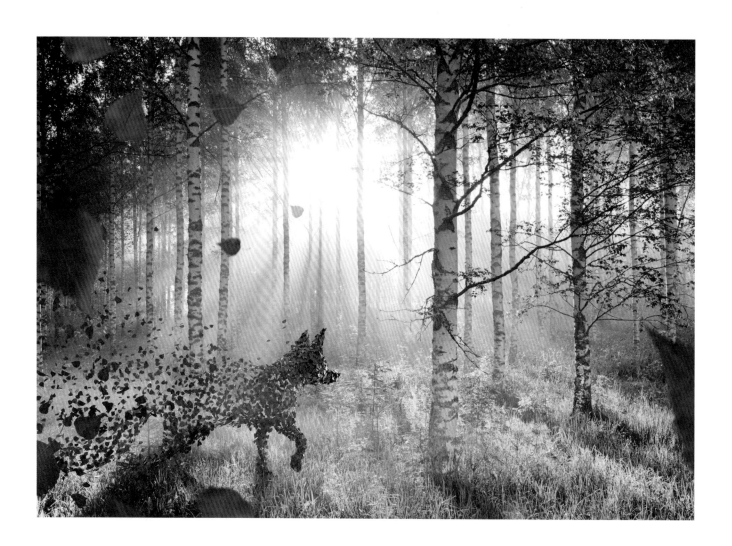

Germany

Design Agency
Viaframe

Client
Charles Vögele

Creative Director
Steffen Kirschner, Sebastian Mildenberger

This project features autumn leaves, rain and cloud-shaped animals which were placed into autumn landscapes. A total of 5 ad-campaign motifs were used in different formats at the point of sale in over 850 stores.

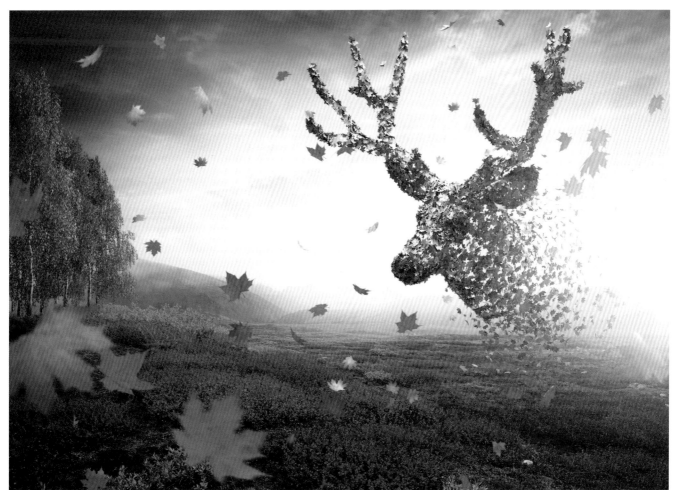

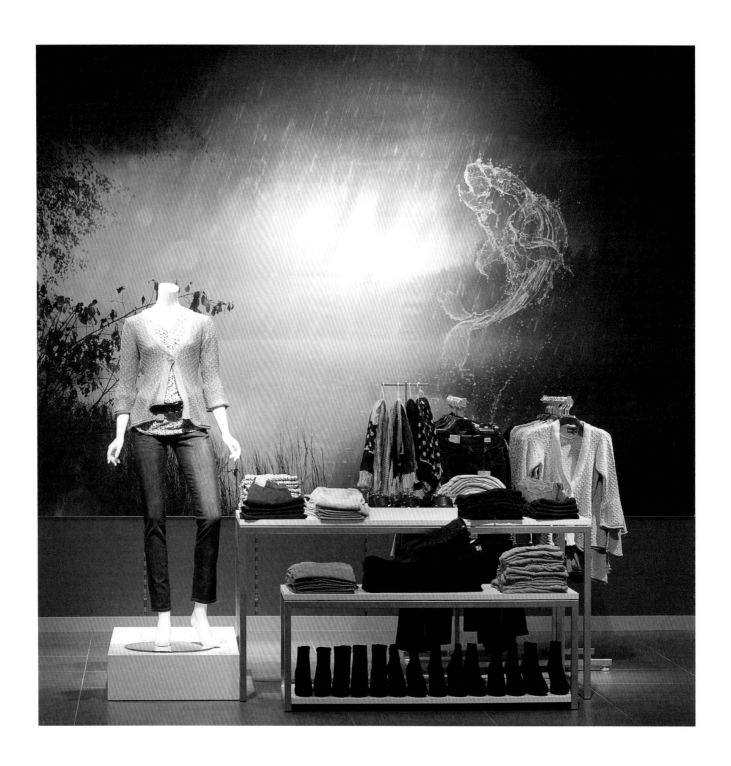

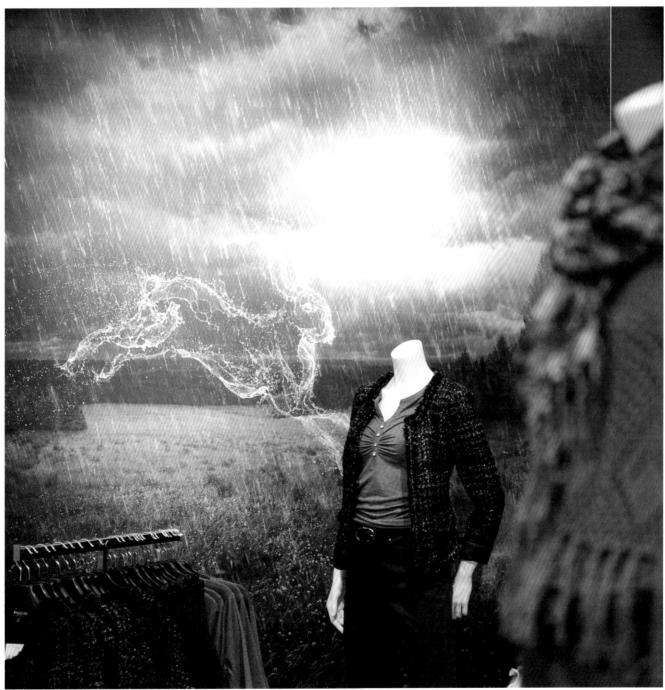

Mangoola

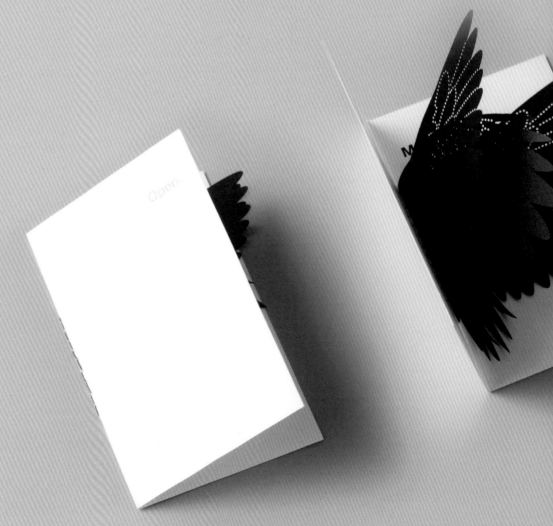

Australia

Design Agency
End of Work

Client
Xstrata Coal

This project for Xstrata's Mangoola Coal Mine challenges convention and creates something surprisingly subtle and delicate. The name Mangoola has indigenous Australian origins and is thought to mean "place of the black cockatoo." Intricate feather patterns laser cut into rich, black card emit an air of luxury. The gorgeous, black cockatoo flying out of the event invitation is striking.

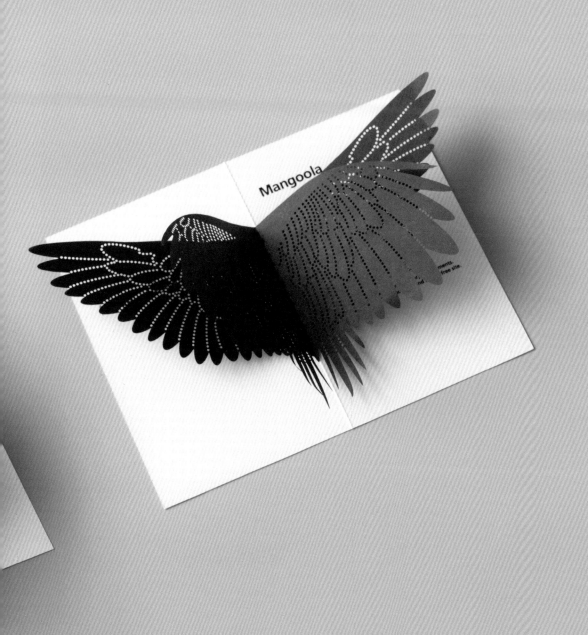

Mangoola

Many happy dragons of the year

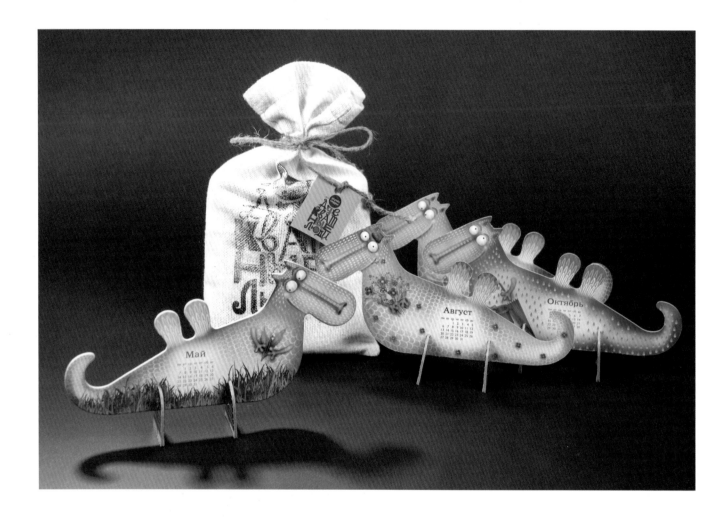

Russia

Design studio
Adequate people

Designer
Elina Zolotareva

This is a self-promo project of Adequate People. It's a common practice to give business-partners a calendar as New Year present. The idea was to show that something normal can be done in a different and joyful way.

The calendar is a set of 6 dragons (dragon is the symbol of the year 2012 in Chinese culture) and a base of two "legs", upon which the user can put the dragon with current month. In addition, each month has its own character. For example, in Russia, children go to school on first day of September, so the September dragon holds a book; Women's day in March is widely celebrated all over the country, so the dragon of March carries flowers.

The designer believed that a warm-hearted and inspirational calendar will transmit her enthusiasm and love for life to everyone else.

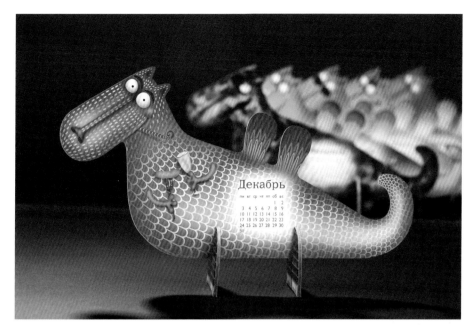

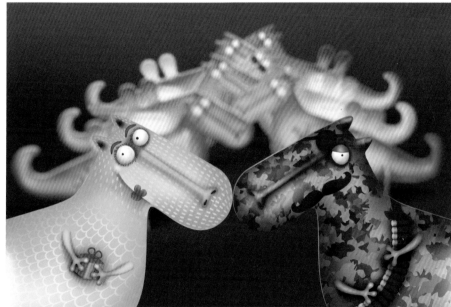

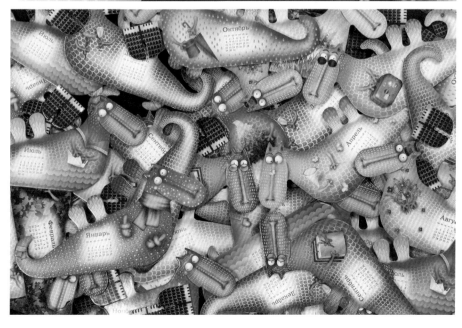

Beijing Buffet Fortunes

United States

Designer
Caroline Brickell

Each animal represents one of the twelve animals of Chinese Zodiac. Squeeze their cheeks and voilà, out pops your fortune. The innovative shape, cut from a single piece of cardstock for easy assembly, protects the cookie inside from breaking.

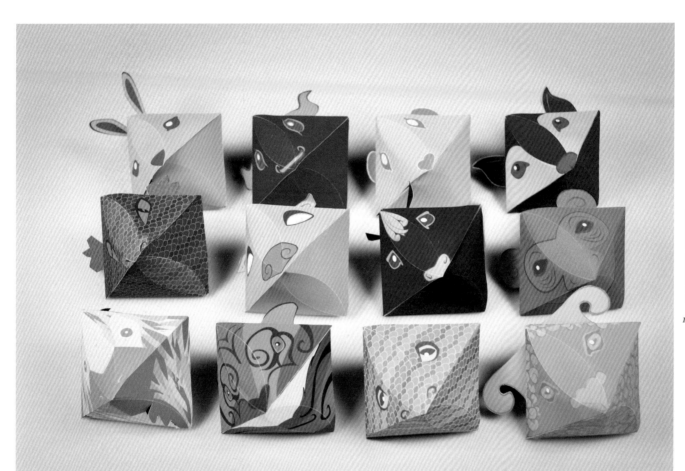

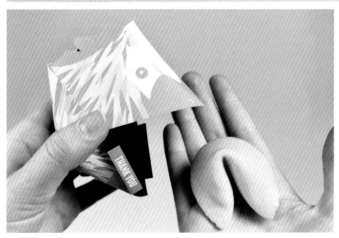

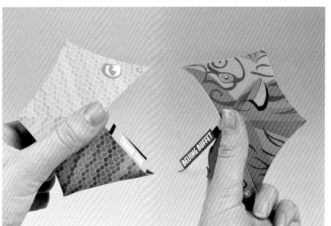

Pivot

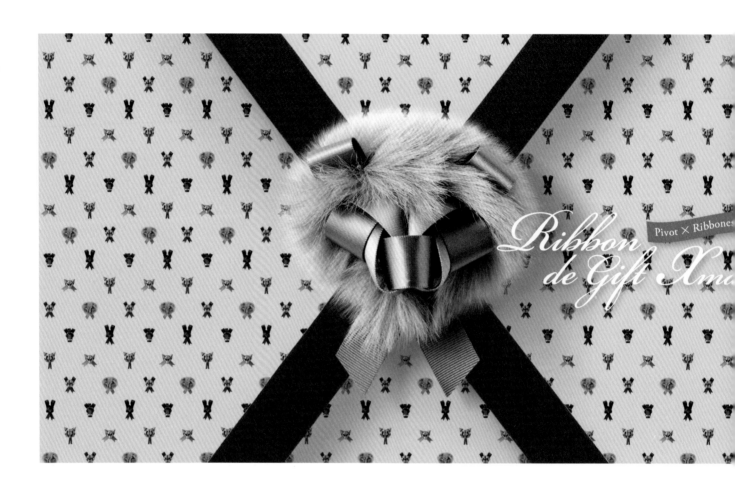

Japan

Design Agency
Ribbonesia

Artist
Baku Maeda

Creative Director
Toru Yoshikawa

Art Director
Ryo Ueda

Client
PIVOT Co.,Ltd.

Pivot is a department store in Sapporo, Japan. Ribbonesia was asked to create key thematic image and graphic spreads for their Christmas visual presentation.

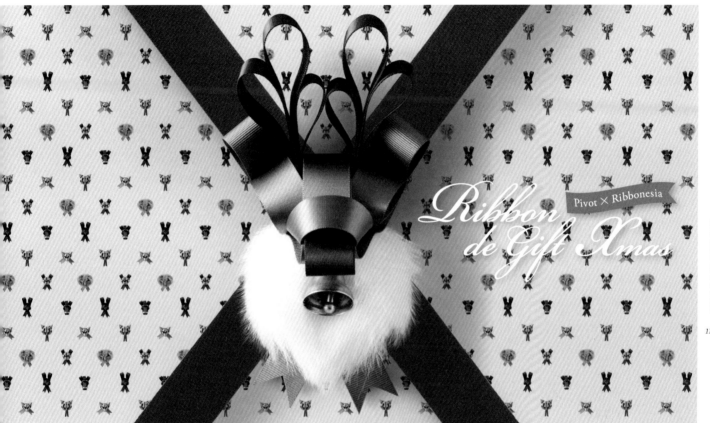

Ribbon
de Gift Xmas

Pivot × Ribbonesia

Ribbonesia Adornments

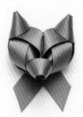
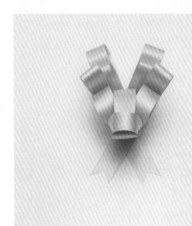
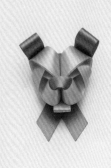
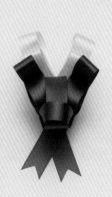

Japan

Design Agency
Ribbonesia

Artist
Baku Maeda

Creative Director
Toru Yoshikawa

Art Director
Ryo Ueda

Ribbonesia Adornments is an accessory series created for everyone to wear as part of their daily life. The artist, entranced by the often under-appreciated beauty and simplicity of ribbons, decided to launch a product line completely based around the image of the ribbon. Combining his love for animals, a "zoo" of colorful creatures was created.

Bench Fix Series

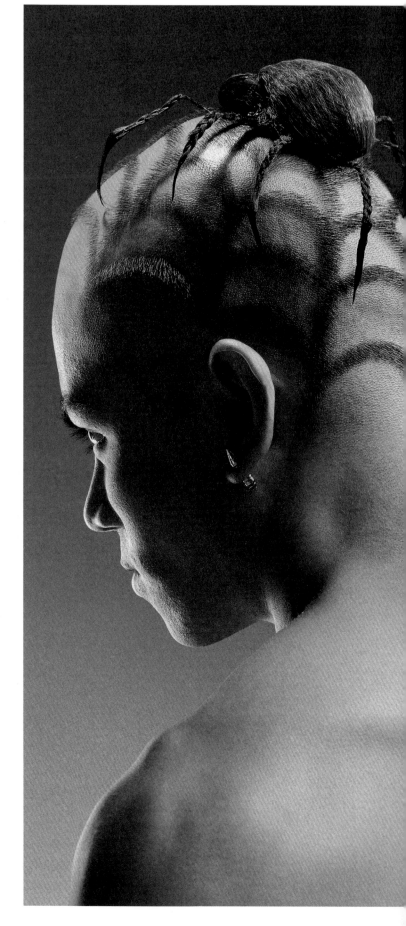

The Philippines

Design Agency
TBWA\Santiago Mangada Puno

Executive Creative Director
Melvin Mangada

Creative Director
Marci Reyes, **Ali Silao**

Client
Suyen Corporation

This project highlights the gripping abilities of Bench Fix products by featuring models with haircuts patterned after animals (gecko and spider) known for their great grip. The ad itself grips the viewer's attention with the hard-to-sculpt hairstyles.

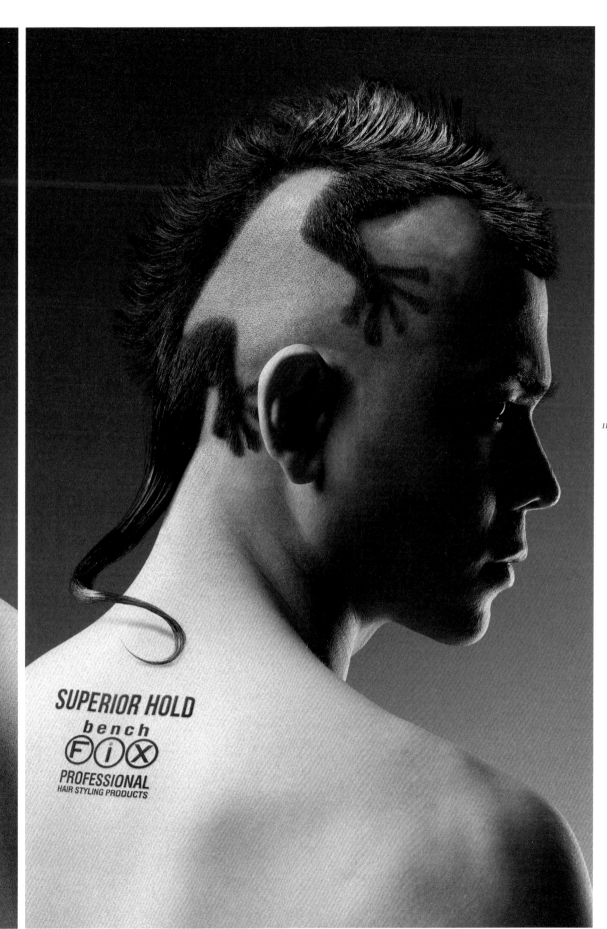

Mikrograph Campaign

Norway

Design Agency
Anti Bergen

Creative Director
Fabien Moullard(CLM BBDO)

Art Director
Mark Forgan(CLM BBDO)

Designer
Endre Berentzen, Robert Dalen

Ad agency
CLM BBDO

3D illustrations
Baptiste Massé / Mecanique Générale

Client
Tag Heuer

Tag Heuer is a world renowned Swiss watch brand known for its high precision watches. The European campaign for the Mikrograph used the images of animals that represented the same speed and precision as the Mikrograph, reflects the theme "Nature meets Swiss precision."

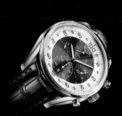

THE MIKROGRAPH. PRECISE TO 1/100TH OF A SECOND.

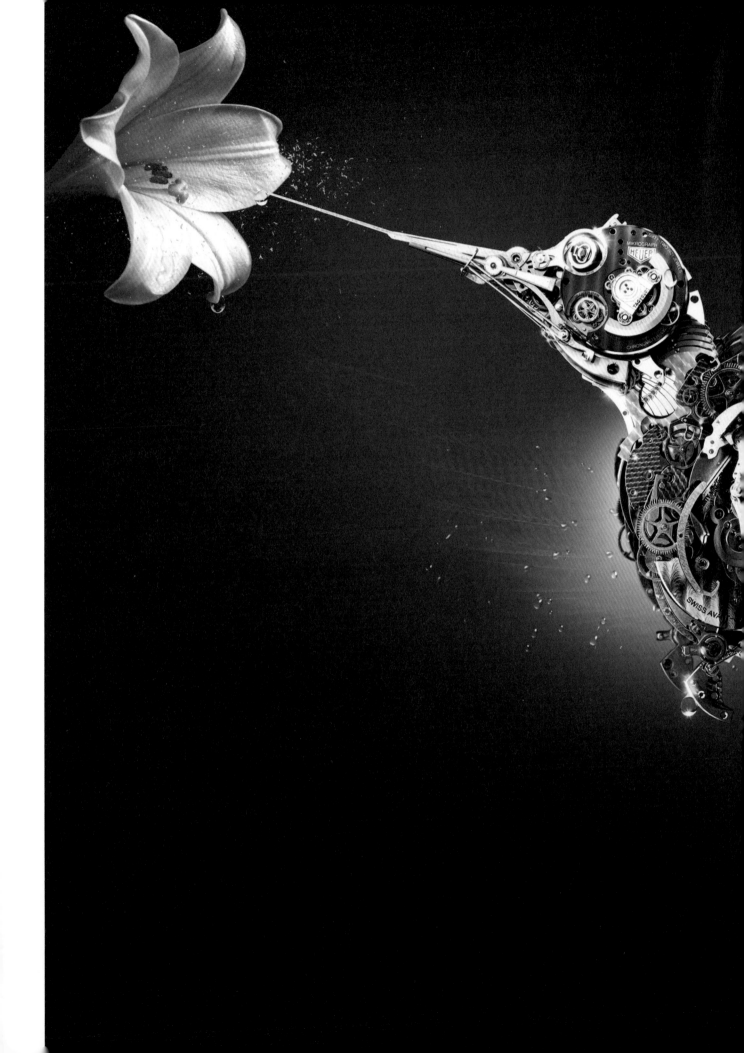

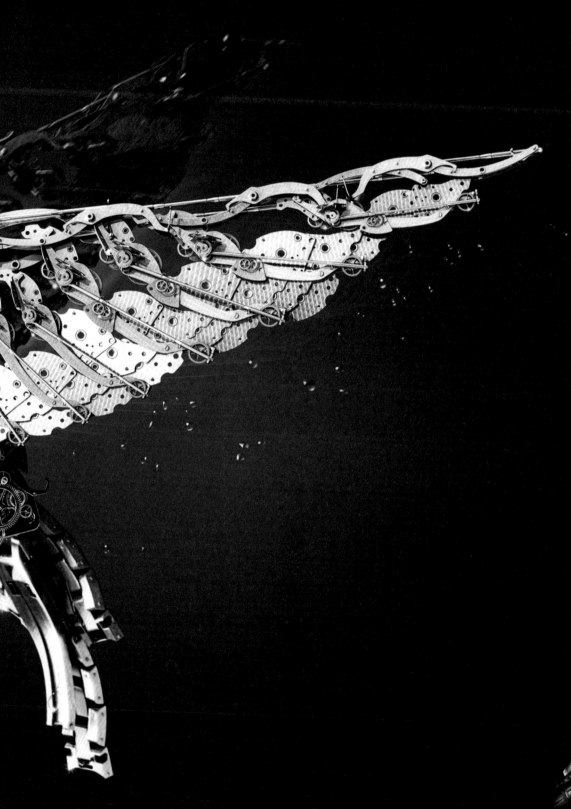

THE MIKROGRAPH. PRECISE TO 1/100TH OF A SECOND.

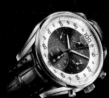

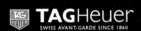

TAGHeuer

SWISS AVANT-GARDE SINCE 1860

Eternal Jungle

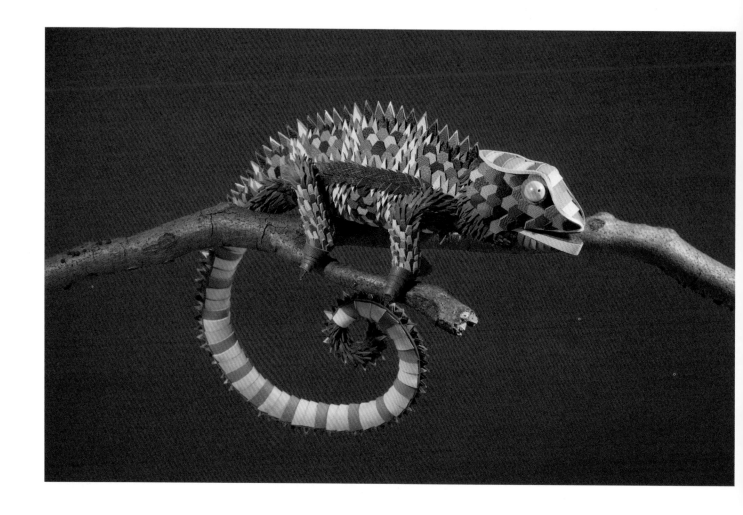

France

Design studio
Zim&Zou

Inspired by the contrast between the downtown Hong Kong and its surrounding mountains, the designers had decided to bring this contrast into the window display for Hermès shop which is located in Hong Kong's international airport.

They used paper for the whole jungle and leather scraps from Hermès workshops for the animals. It was a great idea to give a second life to the leather scraps which at the same time bring the sculptures to life.

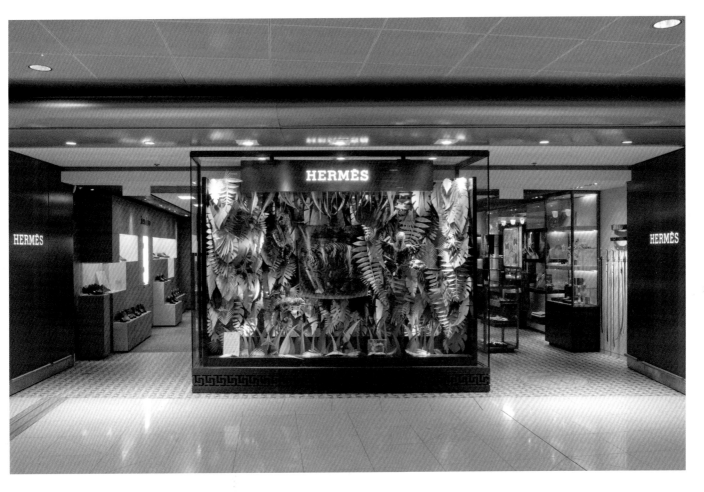

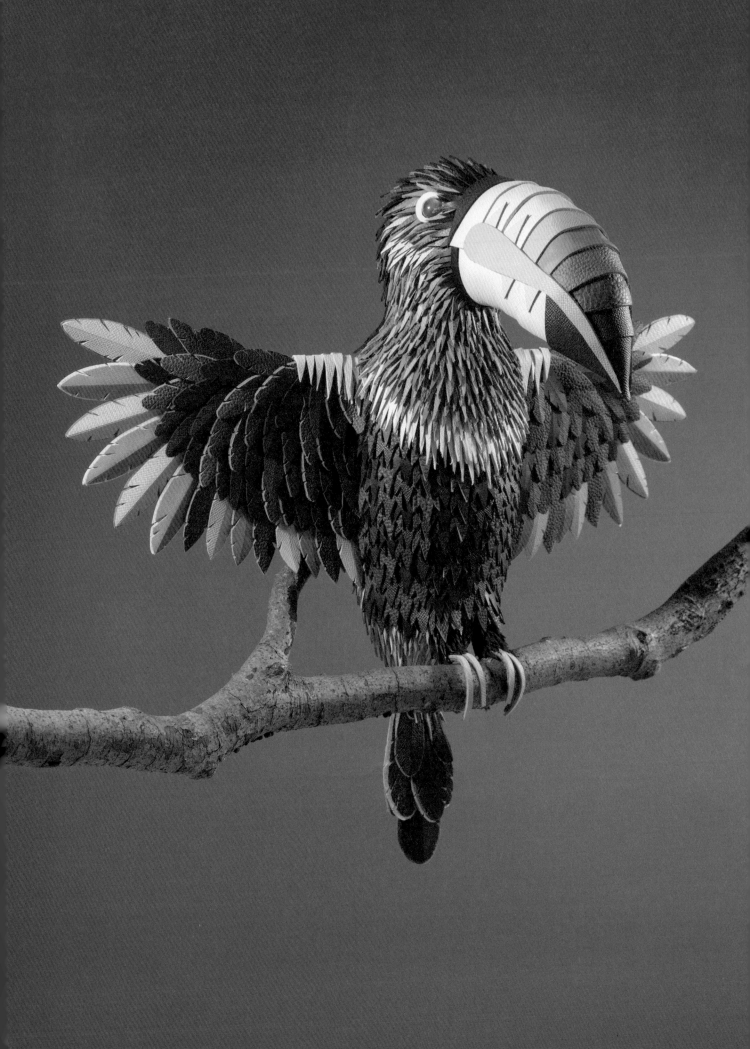

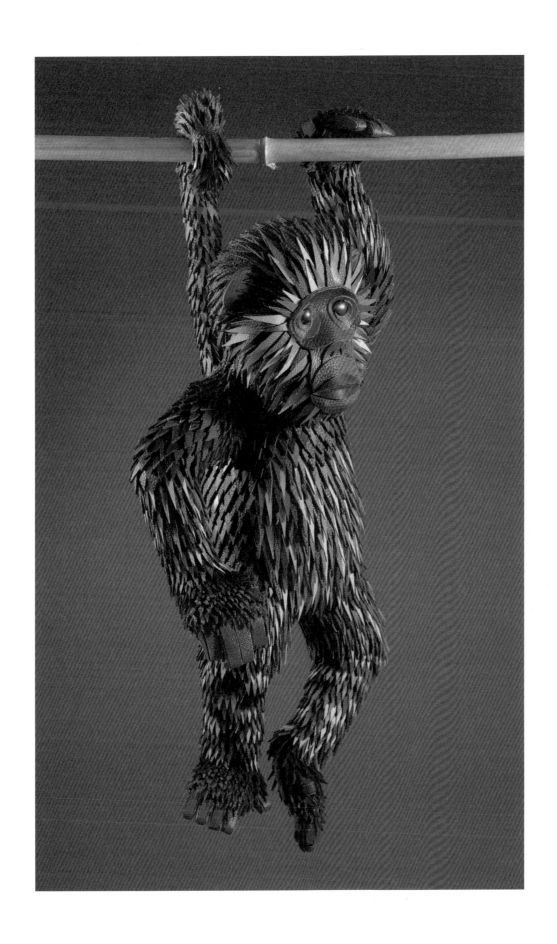

Receipt Lion

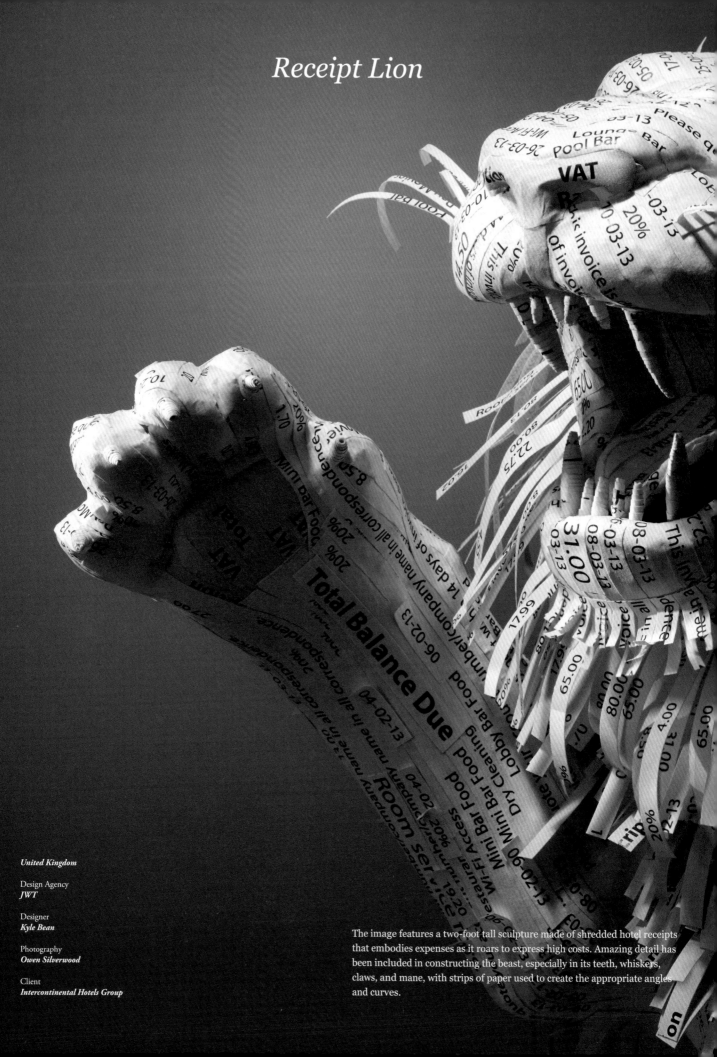

United Kingdom

Design Agency
JWT

Designer
Kyle Bean

Photography
Owen Silverwood

Client
Intercontinental Hotels Group

The image features a two-foot tall sculpture made of shredded hotel receipts that embodies expenses as it roars to express high costs. Amazing detail has been included in constructing the beast, especially in its teeth, whiskers, claws, and mane, with strips of paper used to create the appropriate angles and curves.

Skaap Wines

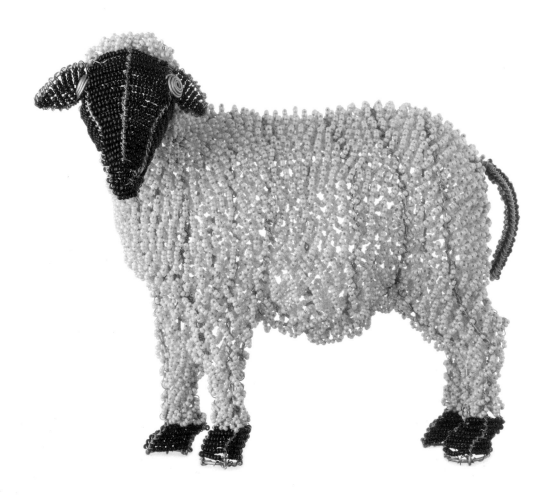

SKAAP
— WINES —

South Africa

Designer
Ian Whalley

Skaap is a South African wine from the Dutch Schaap family. Their vineyards are situated on Schaapenberg which means sheep mountain in Afrikaans. The designer wanted to use the label to showcase the works of the local township artists – with each wine featuring a sheep created by different artist. The artists' works were then sold at the vineyard as well as in the Schaap family store in Holland.

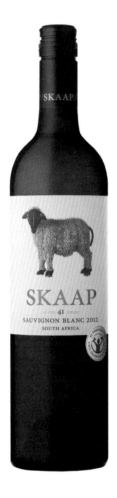

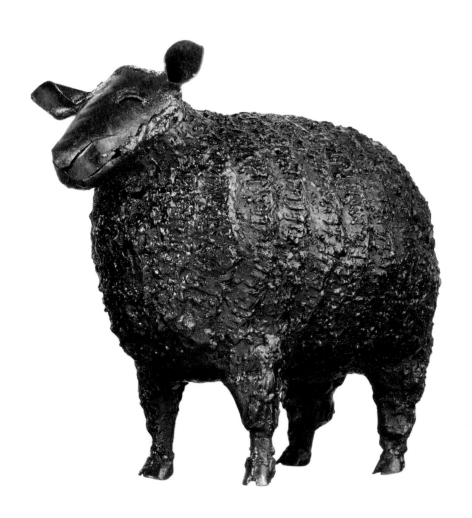

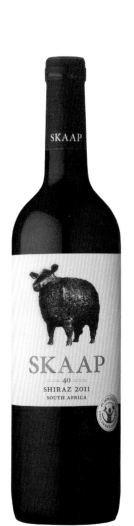

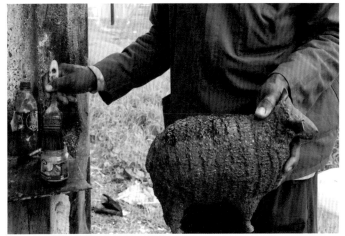

Victor Russo's Osteria

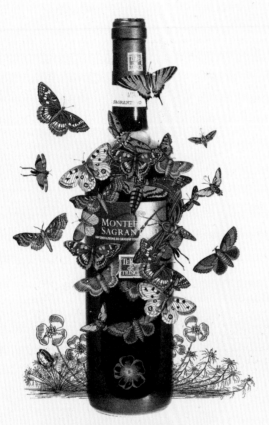

SAGRANTINO DI MONTEFALCO

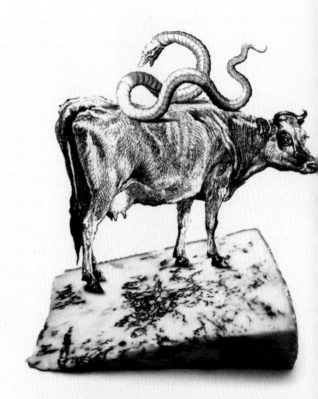

GORGONZOLA PICCANTE EXTRA AFFINATO

The Netherlands

Design Agency
TOTAL IDENTITY

Designer
Maarten Brandenburg

For this project, Total Identity developed an identity for an Italian osteria franchise in the Netherlands. A sense of ornamental symbolism has been built into the design. The representations by using the 18th-century engravings remind people of the fruit and vegetable portraits of the 16th-century Italian painter Arcimboldo.

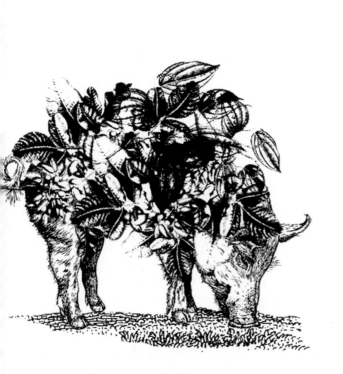

MORTADELLA

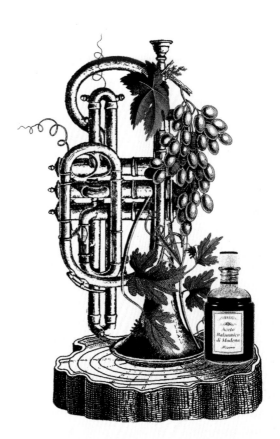

**ACETO BALSAMICO
TRADIZIONALE DI MODENA**

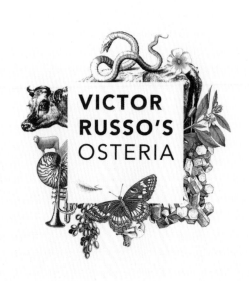

VICTOR
RUSSO'S
OSTERIA

DI GUSTO
IN GUSTI

OSTERIA DELLA
VICTOR RUSSO

STOCCAGIO
DI STORIA

OSTERIA DELLA
VICTOR RUSSO

NAME

OSTERIA DELLA
VICTOR RUSSO

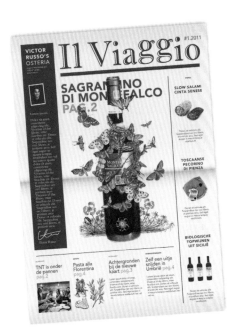

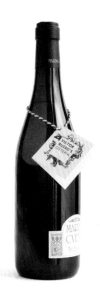

SAGRANTINO DI MONTEFALCO

GORGONZOLA PICCANTE EXTRA AFFINATO

PASTA BENEDETTRO CAVALIERI

MORTADELLA

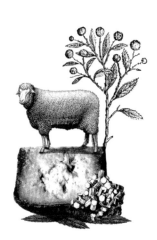

PECORINO FIORE SARDO DOP

ACETO BALSAMICO DI MODENA MANICARDI

Life in the Alphabet

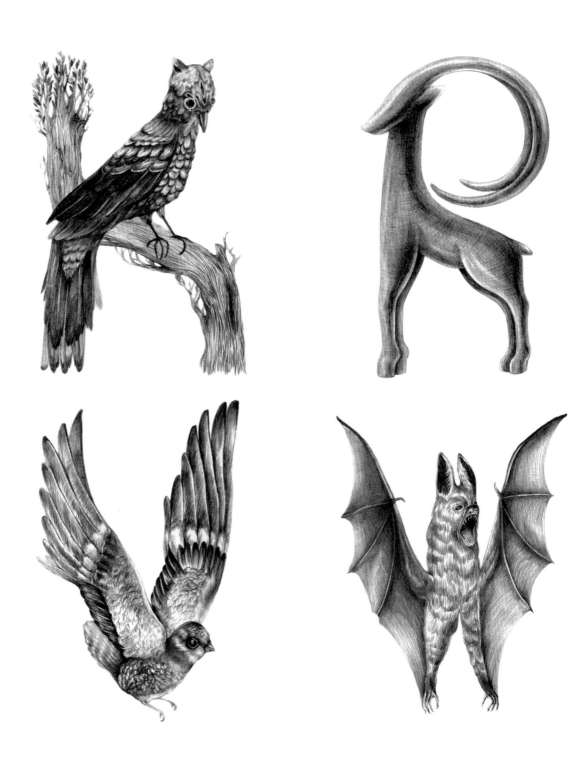

Austria

Designer
Eibatova Karina

The idea behind this project is to depict a letter in a natural form and appearance. As if something alive has turned into a letter. With certain letters it is possible to find symbolism, others are just an abstract form. In this alphabet you can find only one human: a woman in space. And one unreal creature: a dragon, which also acts as a very symbolical sign.

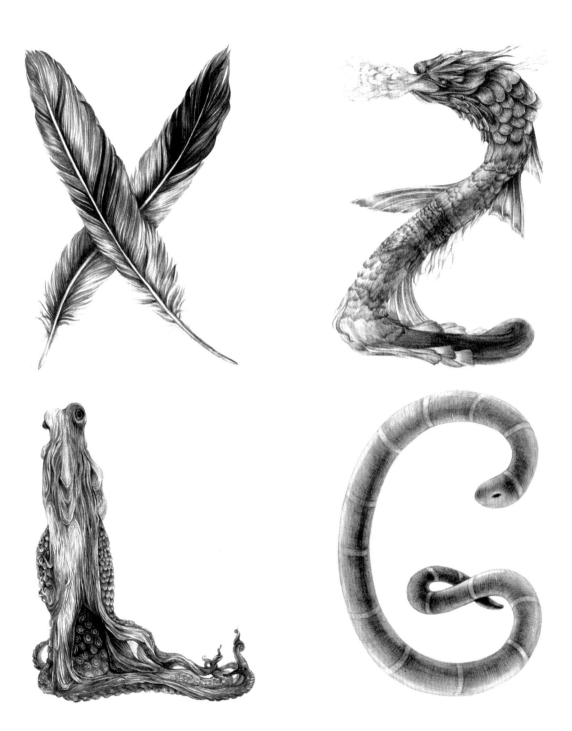

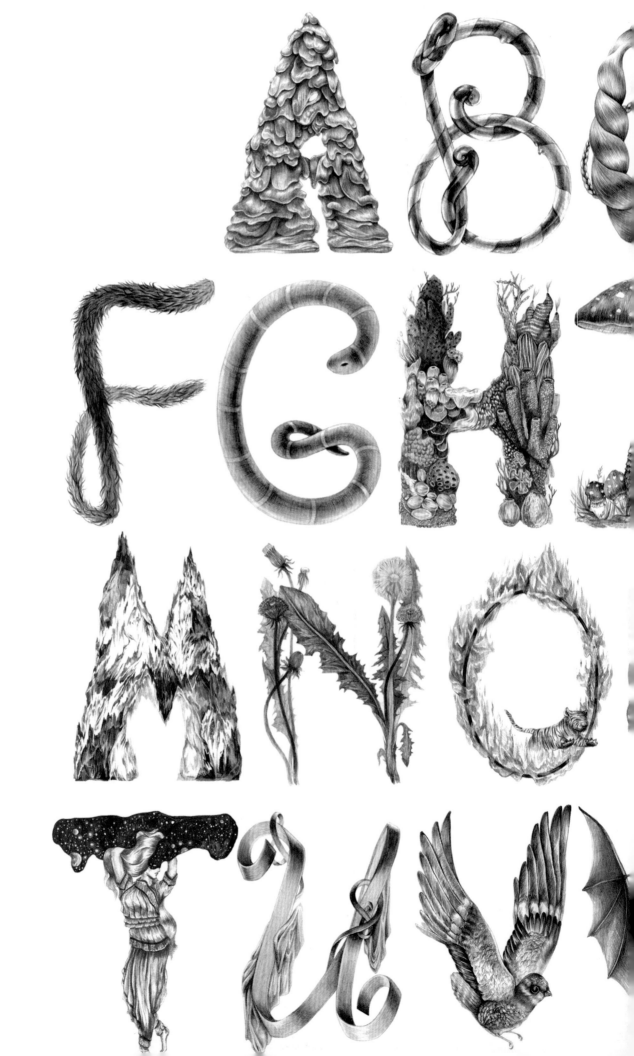

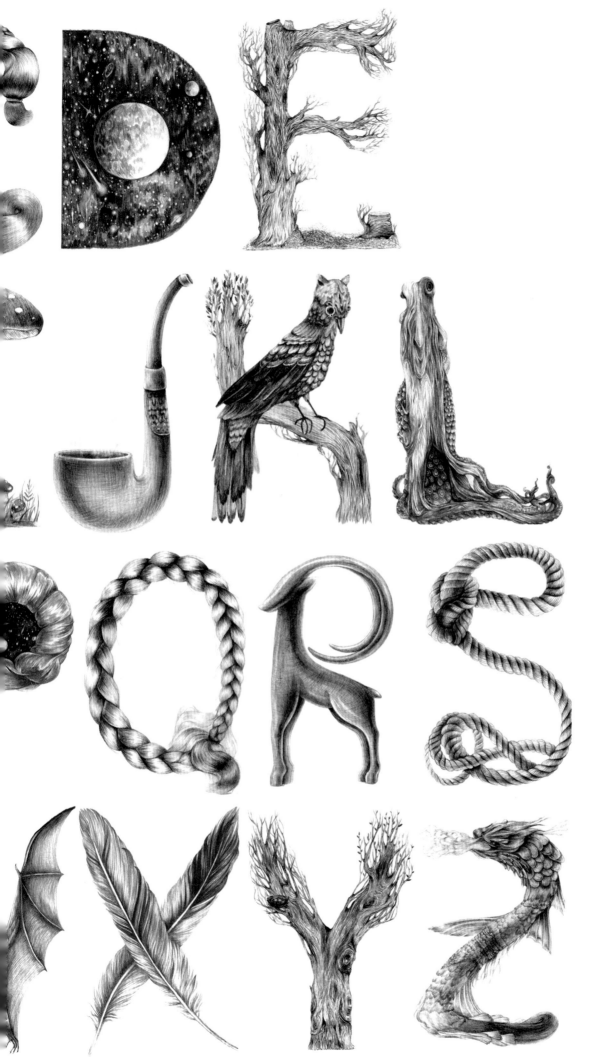

Don Belisario

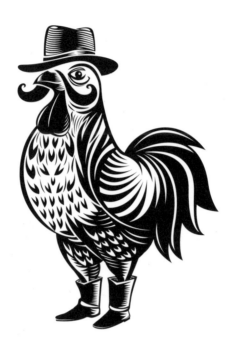

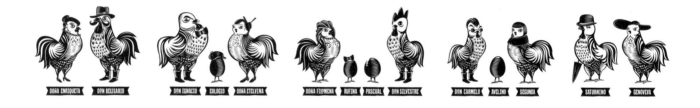

DOÑA ENRIQUETA · DON BELISARIO · DON IGNACIO · EULOGIO · DOÑA ETELVINA · DOÑA FILOMENA · RUFINA · PASCUAL · DON SILVESTRE · DON CARMELO · AVELINO · SEGUNDA · SATURNINO · GENOVEVA

Peru

Design Agency
Infinito

Creative Director
Afredo Burga

Designer
Paola Vecco

Illustration
Franco Zegovia

Client
NG Restaurants

Don Belisario is a chain of rotisserie chicken restaurants. The challenge was to create a fun concept for all ages and families that would stand out from the rest of the market, already saturated with similar gastronomic proposals. Don Belisario, a rooster was created to represent the patriarch of the plantation who inspires respect. The designers also created an entire family for him, a family of aristocratic characters who play a part in every meal in the restaurant. A playful, fun and entertaining idea gives the brand the opportunity to generate multiple storylines.

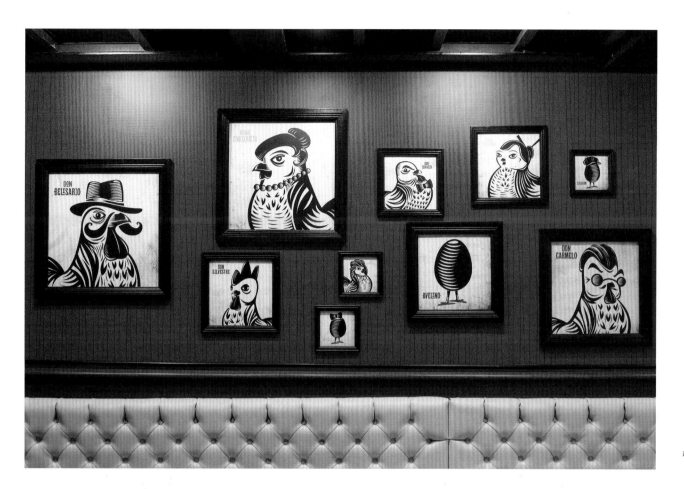

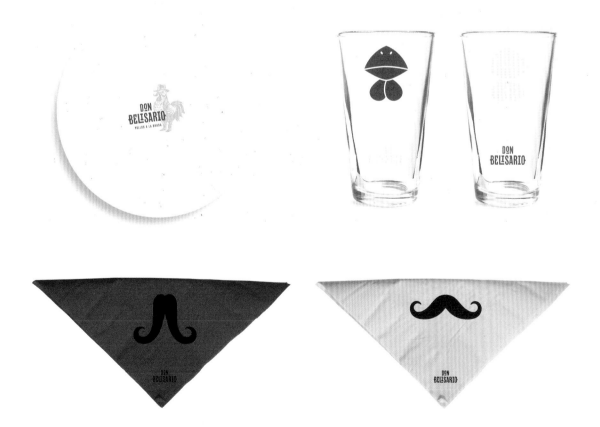

Cha Tzu Tang

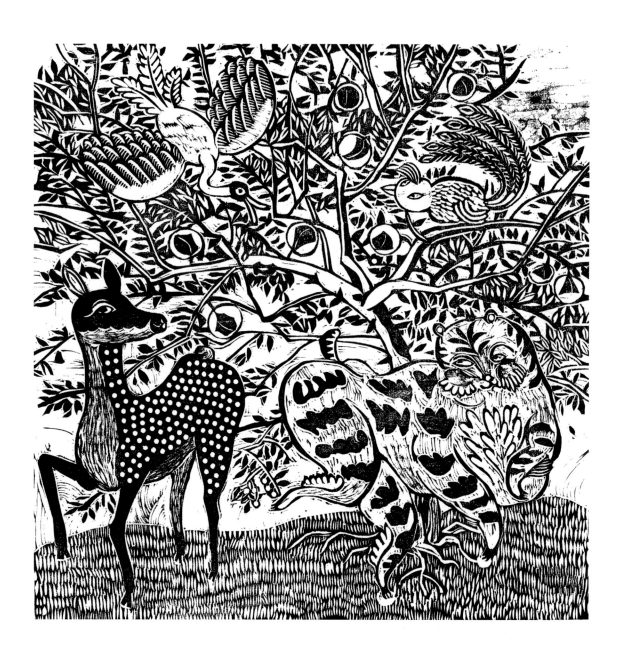

Chinese Taipei

Design Agency
Victor Branding Design Corp

Creative Director
Ying-Fa Wang, BB. Shee, Chung-Yuan Kuo

Art Director
Bee Liu

Client
Cha Tzu Tang

Seeking balance between nature and human, Cha Tzu Tang is a pioneering, green brand from Taiwan. By facilitating harmony between nature and life they hope that their aromatic, tea seeds can slow down people's daily pace. The four animals featured on the package are the tiger, deer, crane and magpie which represent joy, dreams, longevity and happiness. The use of traditional, monochrome prints and composite materials present the handmade texture of products in a combination of both modern and traditional thinking which represents the concept: "From Inside to outside, live a nature lifestyle."

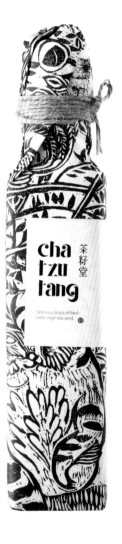
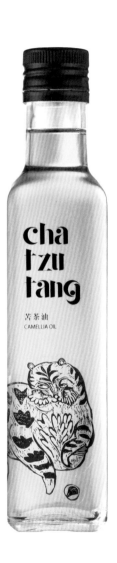
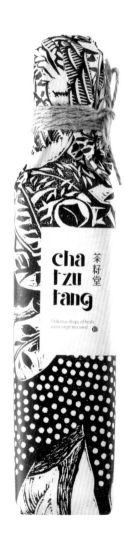
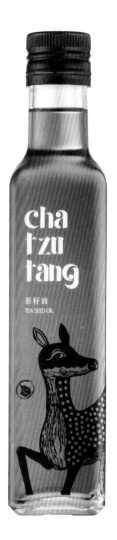

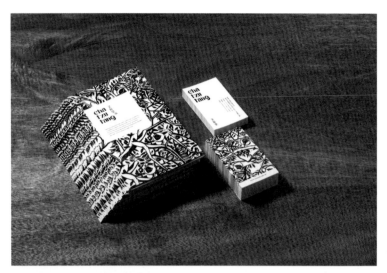

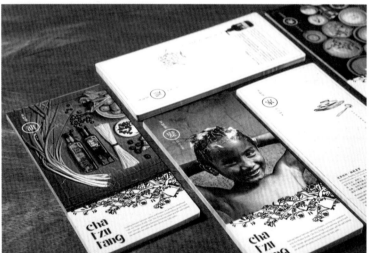

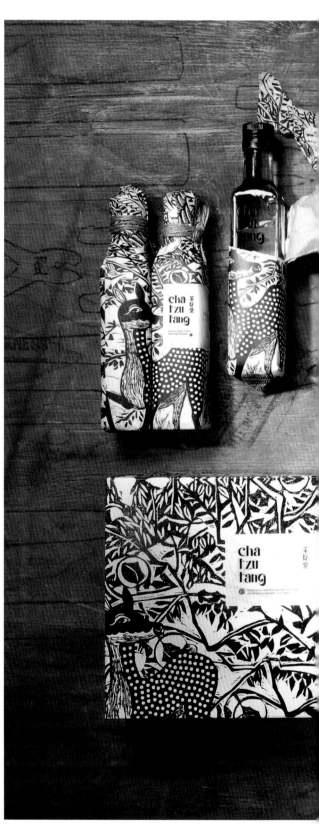

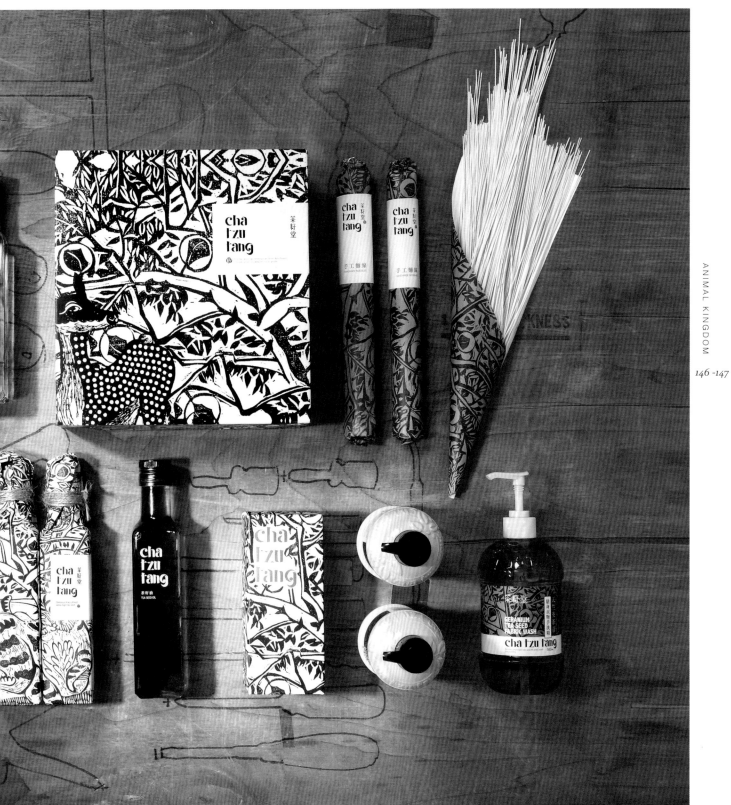

Puma Select Store Concept

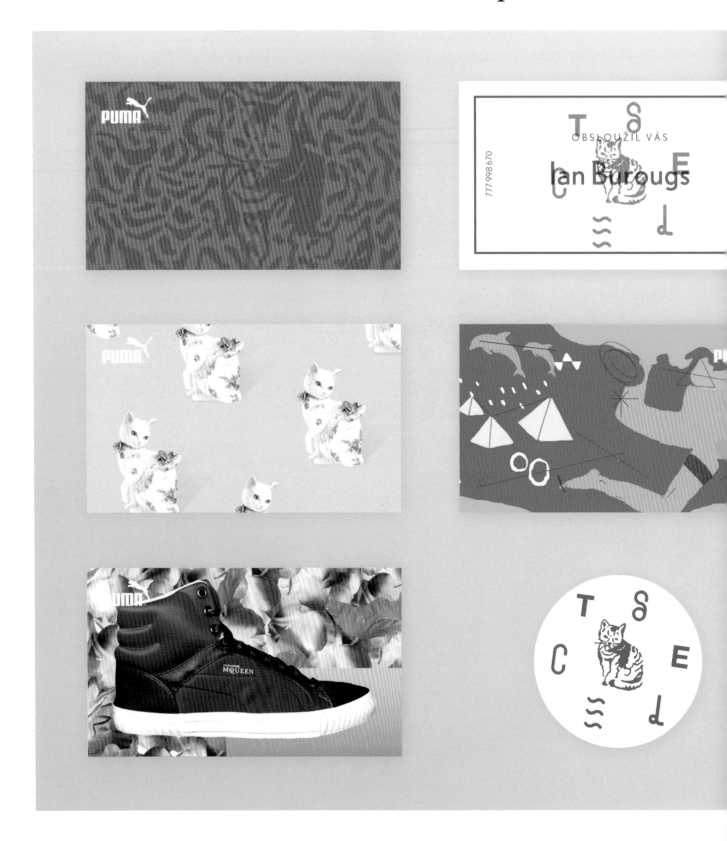

Czech Republic

Designer
Petr Kudláček / Lilkudley

This new branding image, a spoiled domestic kitty, is only interested in the best. She has a new home in the Prague Puma Select Store which features the most interesting products of limited Puma collections.

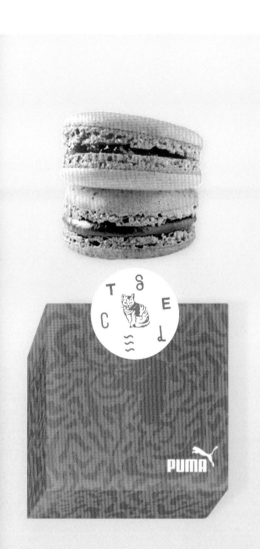

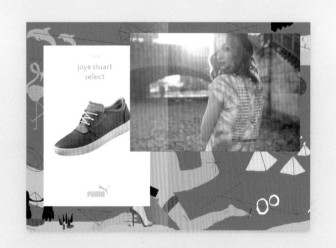

joye stuart
select

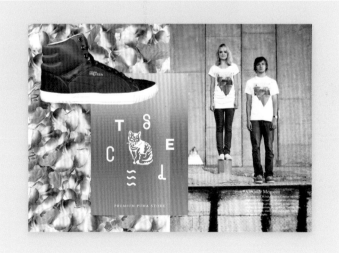

PREMIUM PUMA STORE

Songwriters' Label Identity

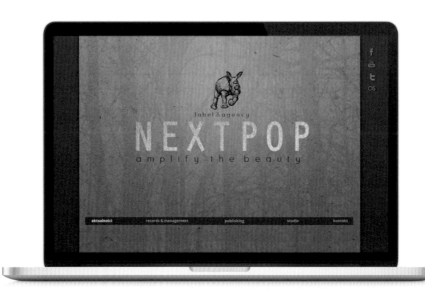

Poland

Designer
Gabriela Jordan

Nextpop is a small specialized record label focusing on young debuting singers and songwriters with the mission to find them and support their vision of music. A young rhinoceros was used as the icon to bring out the unique character of this label, for the young rhinoceros is a symbol of strength, self-confidence, dynamic, sensitivity, and courage.

It was also very important to choose a massive, powerful creature, but not a predator kind; and make a sketch-like, delicate and filigree illustration to present the animal as a positive figure of energy, future power and limitless potential.

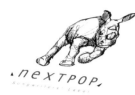

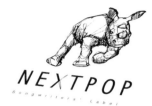

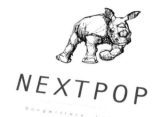

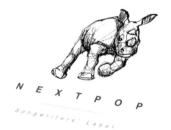

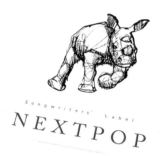

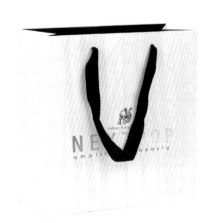

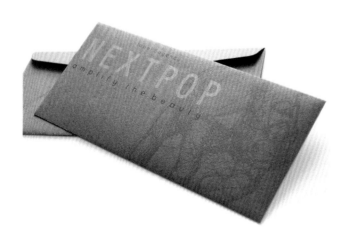

Bar Noire

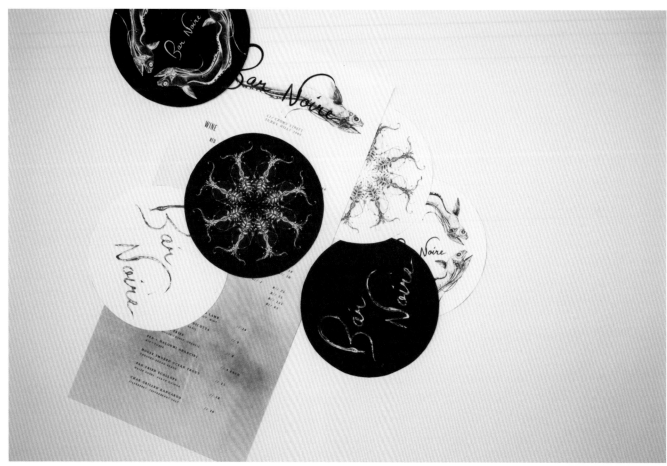

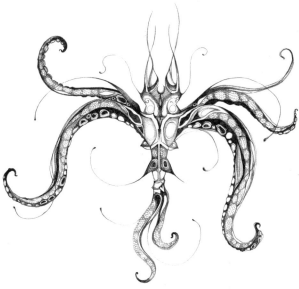

Australia

Designer
Bec Kilpatrick

Bar Noire is a new wine bar in Surry Hills, Australia. The concept of Bar Noire was inspired by the designer's fascination with the weird and wonderful creatures of the deep. The creatures in this project are inspired by old scientific diagrams and are a mix of visual representations of existing creatures as well as the designer's own imagination. This creates a creepy and sinister tone that can be catchy for the after-dark bar scene.

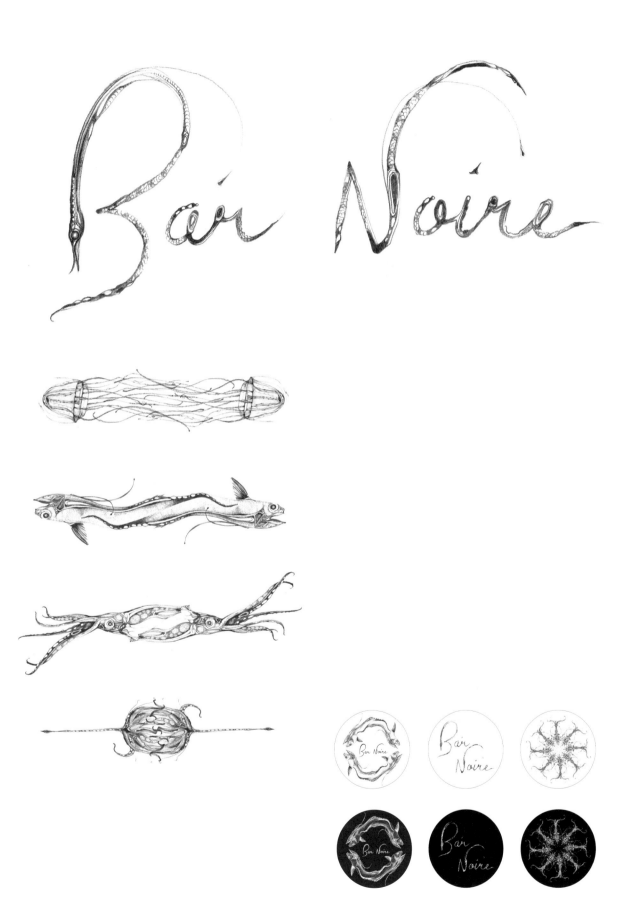

Leder Wimmer

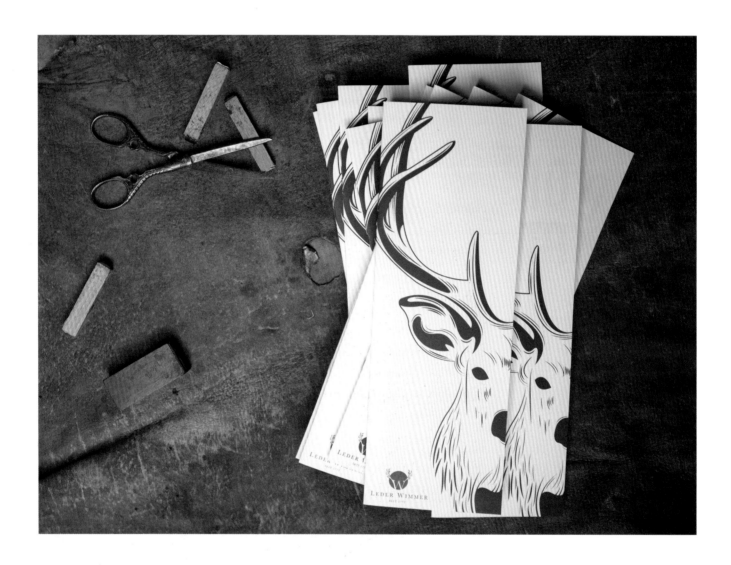

Austria

Designer
Lukas Nöckler, Patrick Musil

Leder Wimmer is a leather goods producer in the centre of Lienz, Austria. This re-branding is to strengthen Leder Wimmer's visual appearance in the leather goods industries. The core competence of Leder Wimmer is the manufacturing of deerskin. So the designers decided to bring the focus on the deer.

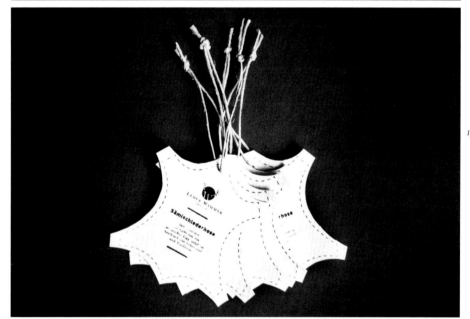

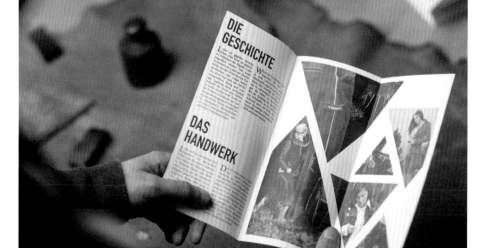

THE STORY

Vom Hirsch zur Hose

1
ERLEGEN DES TIERES
[Neuseelandhirsch, Rothirsch]

2
VERARBEITUNG ZUM LEDER
[Velour, Sämisch, Nubuk]

3
HERSTELLUNG DER LEDERHOSE
[Kurz, Kniebund, Lang]

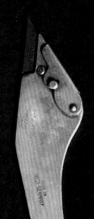

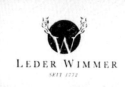

LEDER WIMMER
SEIT 1772

Josef Wimmer
GERBERMEISTER

Schweizergasse 12
9900 Lienz
+43 664 303 46 65

office@leder-wimmer.at
www.leder-wimmer.at

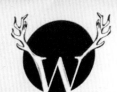

LEDER WIMMER
SEIT 1772

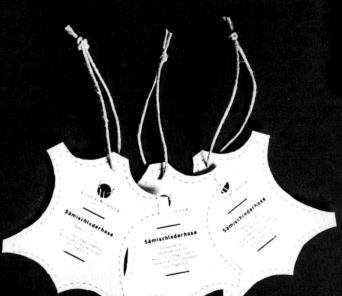

Tarantino Brewery

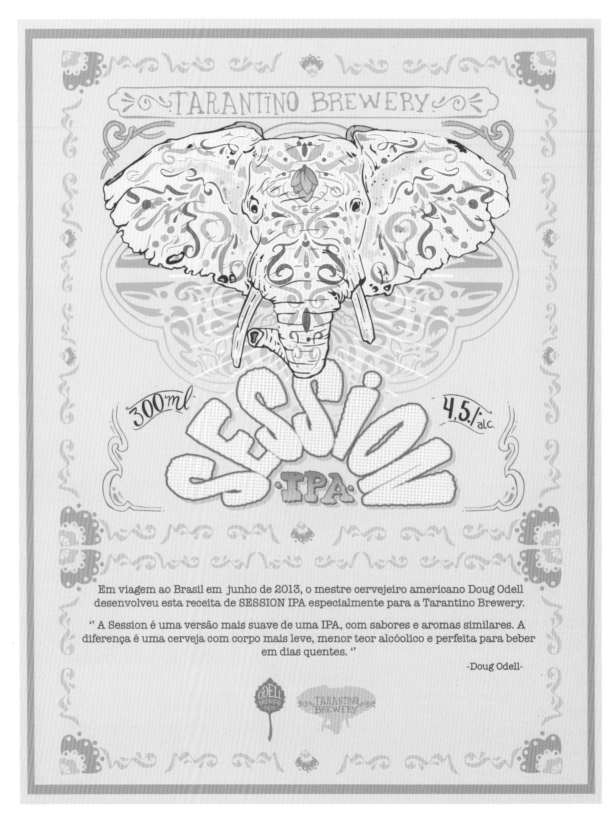

Em viagem ao Brasil em junho de 2013, o mestre cervejeiro americano Doug Odell desenvolveu esta receita de SESSION IPA especialmente para a Tarantino Brewery.

" A Session é uma versão mais suave de uma IPA, com sabores e aromas similares. A diferença é uma cerveja com corpo mais leve, menor teor alcóolico e perfeita para beber em dias quentes. "

-Doug Odell-

Brazil

Designer
Ciro Bicudo

Traveling to Brazil in June 2013, the American brew master Doug Odell developed this recipe SESSION IPA especially for Tarantino Brewery. This is actually a lighter version of an IPS with similar flavor and aroma characteristics. The difference is this beer is lighter in body, lower in alcohol, and perfect for a hot day. The designer used an elephant with bright colors in the package to reflect the character of the beer.

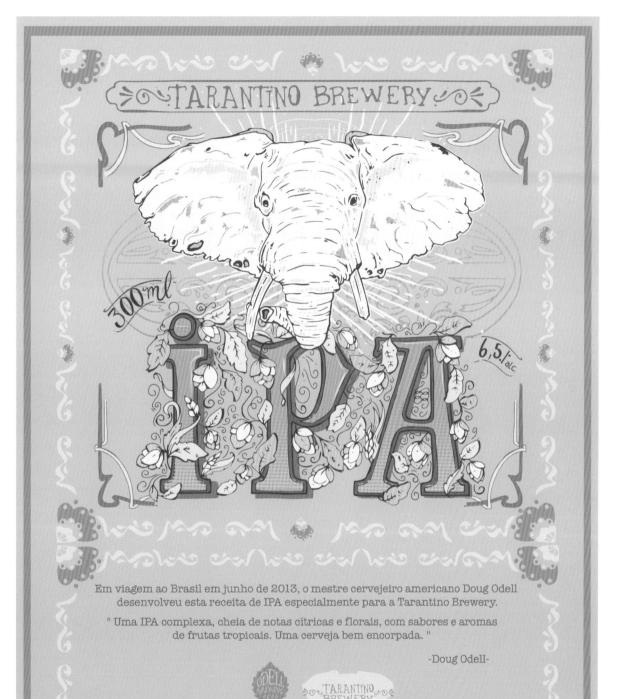

Em viagem ao Brasil em junho de 2013, o mestre cervejeiro americano Doug Odell desenvolveu esta receita de IPA especialmente para a Tarantino Brewery.

" Uma IPA complexa, cheia de notas cítricas e florais, com sabores e aromas de frutas tropicais. Uma cerveja bem encorpada. "

-Doug Odell-

Celebrating Marriage

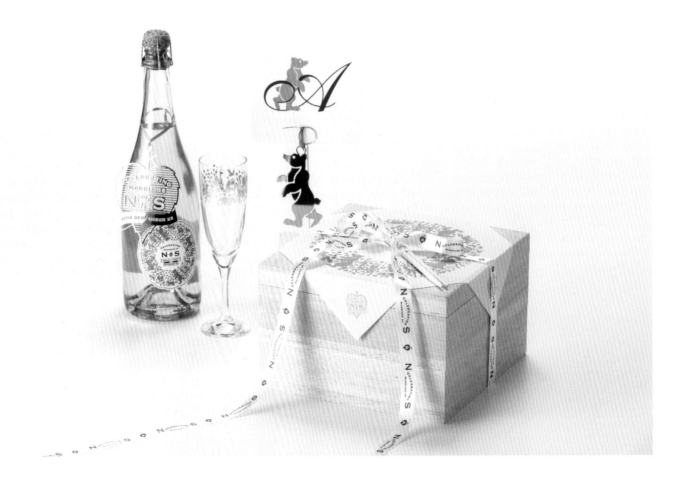

Japan

Design Agency
ANONIWA

Designer
Naoto Kitaguchi

This logo was created using a leaf motif, in order to reflect part of an old mansion surrounded by greenery. Various forest animals were chosen as key visuals for the design. The warm atmosphere is perfect for the special wedding day.

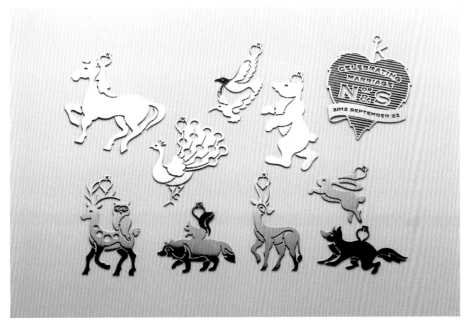

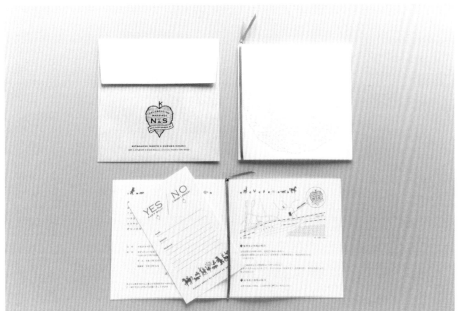

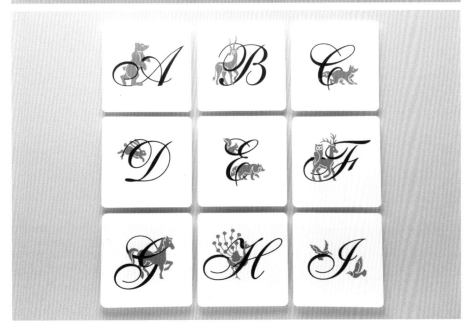

EP Packaging

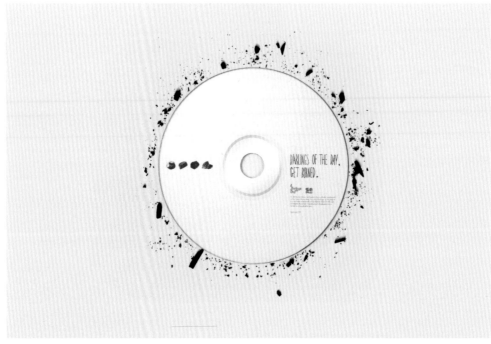

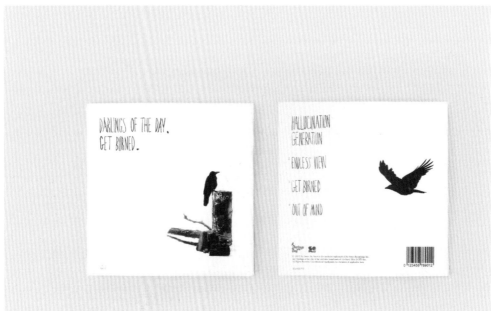

The 8-page, double gatefold CD cover was designed for a Hollywood-based alternative rock band's debut EP.

The artwork features a photographic narrative inspired by the title: "Get Burned." Four pieces of wood on the front cover represent the four tracks. Each piece is revealed in a burnt state as the cover unfolds. Hand-drawn typography was also created using charcoal from the burnt pieces.

The silhouette of a crow is a key element in the band's eclectic, Victoriana inspired identity. Often regarded as a bad omen, the image of the crow perched on the front and then in flight on the back adds mystery and intrigue to the narrative.

United Kingdom

Design Agency
Believe in

Creative Director
Blair Thomson

Designer
Tom Dabner

Client
Darlings of the Day

DARLINGS OF THE DAY.
GET BURNED.

¹ HALLUCINATION
GENERATION

² ENDLESS VIEW

³ GET BURNED

⁴ OUT OF MIND

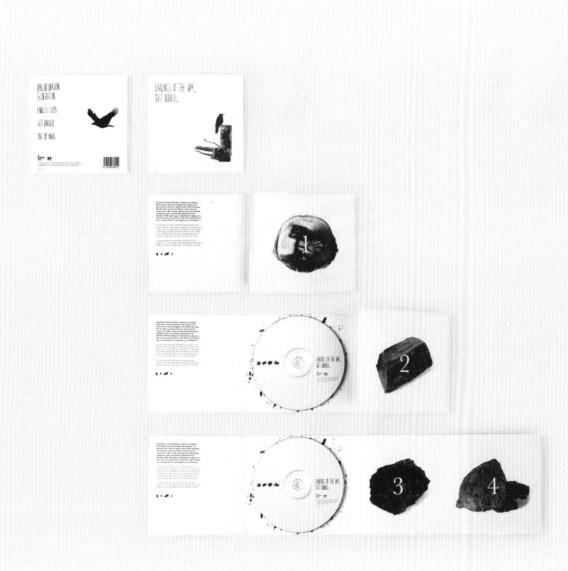

Zebra Event Management

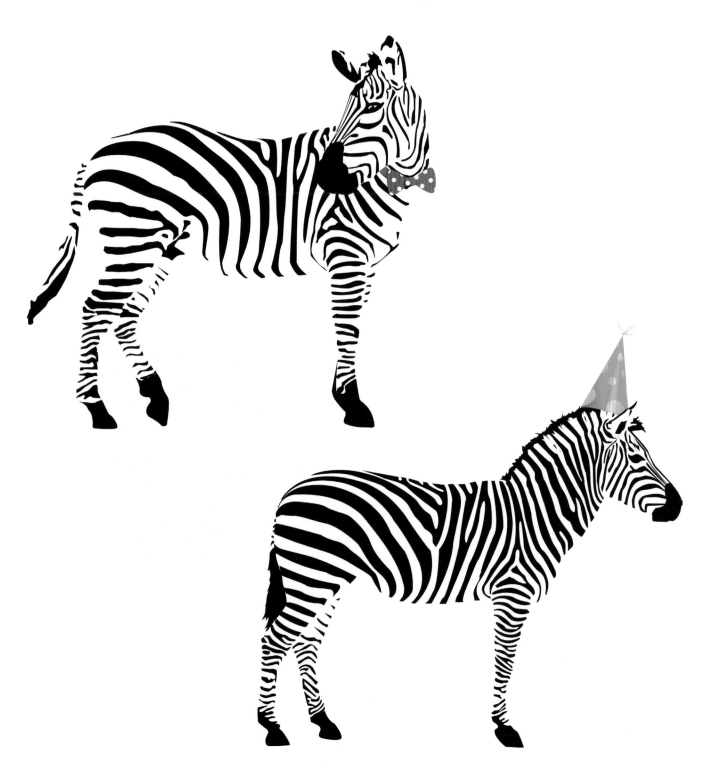

United Kingdom

Design Agency
Gareth Procter Studio

Designer
Gareth Procter

Client
Zebra Event Management

Zebra Event Management is a small company that organizes and manages events for clients of all kinds. They needed a distinctive new brand identity that would represent the playful nature of the company as well as differentiate them "from the herd."

Well-known as a highly social animal the zebra seemed like the perfect choice to create a distinctive brand mascot. Cue Roger, a somewhat flamboyant and rather charismatic zebra. Often described as a bit of a party animal, he has an outfit for every occasion!

Zebra
Event Management

Zebra Event Management
Park Studio
19A St Thomas's Road
London, N4 2QH

t: 020 7690 6889
m: '44 (0)7767 847 276
e: sue@zebraeventmanagement.com
www.zebraeventmanagement.com

Cheers.

Zebra
Event Management

Style guide.

Zebra
Event Management

Sue Brodie
Managing Director

Zebra Event Management t: 020 7690 6889
Park Studio m: '44 (0)7767 847 276
19A St Thomas's Road e: sue.brodie@zem.uk.com
London, N4 2QH www.zem.uk.com

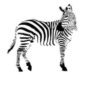

Fena Imagine More Campaigns

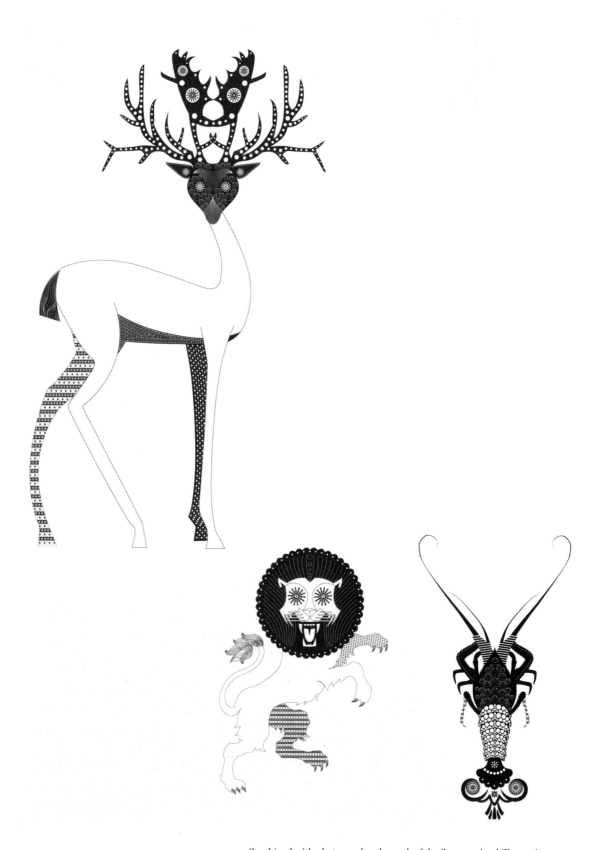

Greece

Design Agency
BeetRoot Design Group

Client
Fena Fashion Stores

Combined with photography, these playful, vibrant animal illustrations create a positive feeling in various parts of the Fena Fashion Stores.

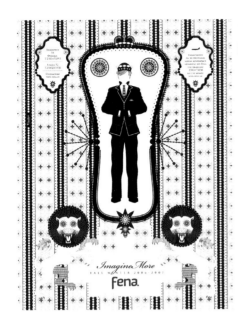

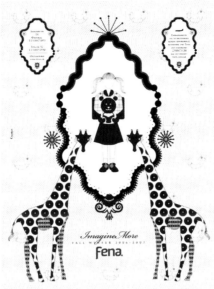

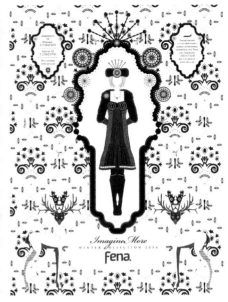

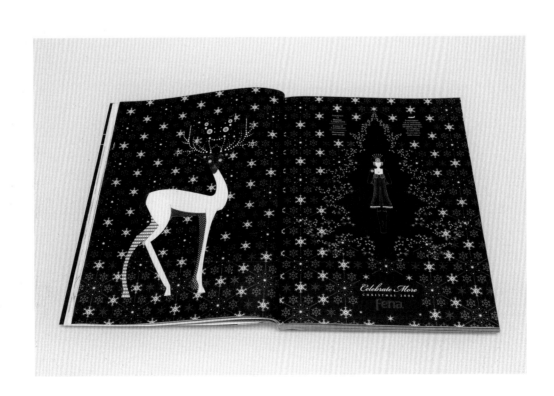

fena.

SPRING SUMMER 2006

IMAGINE
MORE

01 Δημοκρίτου 14, Φοίνικας, Τ: 2310 471 093
02 Εγνατία 52, Τ: 2310 253930
 Θεσσαλονίκη, www.fena.gr

* Ενημερωθείτε για το πρόγραμμα δωρεάν αεροπορικής μεταφοράς
 της Fena στο τηλέφωνο 2310 473138 και στο website www.fena.gr

Feпɑ.

SPRING SUMMER 2006

IMAGINE
MORE

Moomah

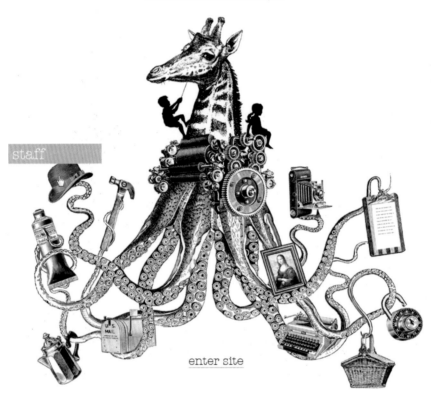

United States

Design Agency
Apartment One

Creative Director
Spencer Bagley

Client
Moomah

Moomah is a creative arts café for parents, children and friends in Tribeca, New York. The designers developed a visual brand language that would convey those ideals, designing variations of the logo with everyday objects that represented the values. They pushed the boundaries of traditional identity development by extending the brand's identity beyond the logo and name and creating an ownable graphic vernacular that encapsulated the whimsy, wonder and heart of the brand.

moomah

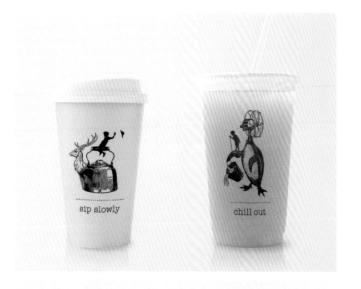

sip slowly

chill out

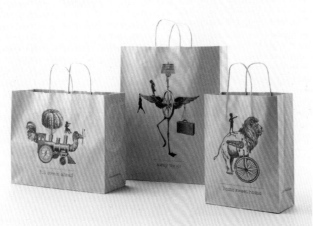

connect

discover

nourish

create

art and nature class

Every semester children explore the natural world through printmaking, collage, sculpting, painting, bookmaking, sewing, felting, storytelling, music, imaginative play, and dance. Each class, the students are introduced to a new topic, given a tutorial with the materials and then offered a creative space in which to explore their own unique experience. Something as simple as a leaf rubbing or building a nest can be a wonderful way to help a child connect with nature and the world around them.

AGES 2 TO 7 YEARS OLD
FOR SCHEDULES AND MORE INFO PLEASE VISIT MOOMAH.COM

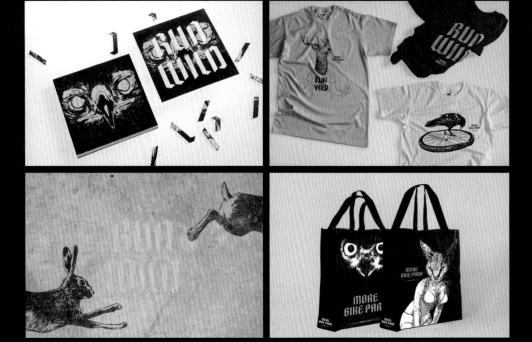

Portugal

Design Agency
FIBA Design + FEB Design

Designer
Miguel Batista, Marta Fragata

Illustrator
Pedro Lourenço

Client
Esquio Mountain Reserve

Esquio Mountain Reserve used wild animals as the main objects to portray the essence of the experiences available, as a supplier of extreme bicycling events. It was important for the credibility of the message to mirror certain emotions such as freedom, instinct and danger. The tiger represented fearlessness and the eagle speed.

MORE BLACKLETTER

ABCDEFGHIJKL
MNOPQRSTUVWXYZ
1234567890

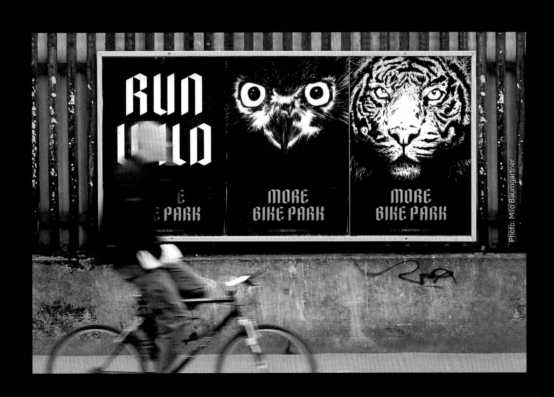

Photo: Milo Baumgartner

Oveja Negra Lowe

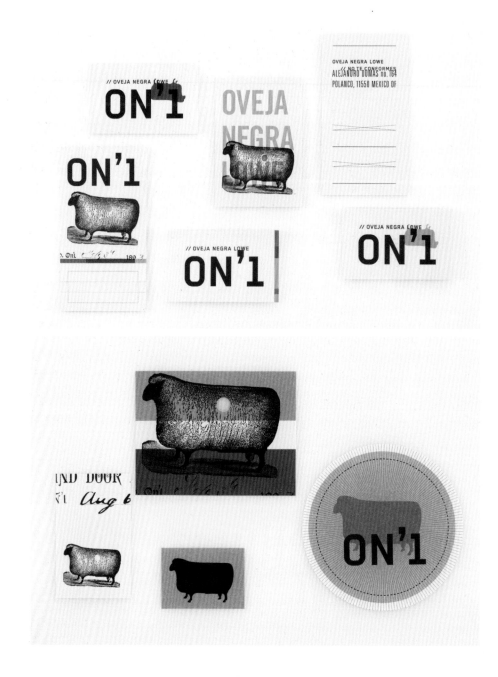

Mexico / Canada

Design Agency
Blok Design

Designer
Vanessa Eckstein, Patricia Kleeberg

Client
Oveja Negra Lowe

This logo and identity design expresses the merging of two companies, one of which is international, one of which is local. An acronym of both company's letters was created to communicate the idea of two becoming one, with the number 1 doubling as a lower-case "l". The witty character of the local company is represented by a "black sheep". It plays a starring role in the identity, changing locations and colors randomly to continually surprise and engage.

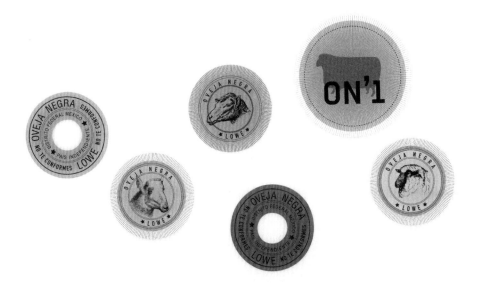

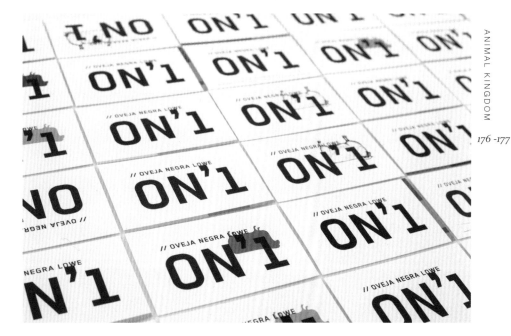

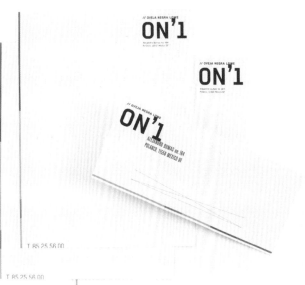

The Deep

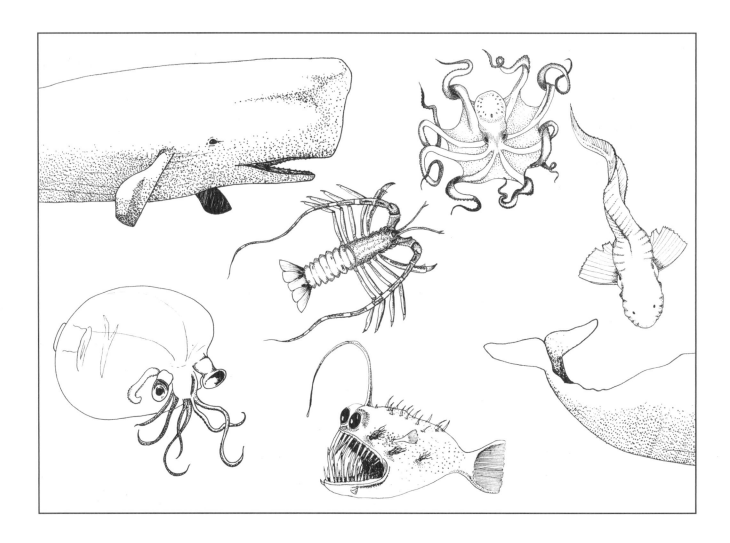

United Kingdom

Designer
Rebecca Tarran

These cups and saucers are pretty to look at from the outside but as their contents are consumed the reality of what lurks beneath is discovered. Four deep-sea creatures: the octopus, shrimp, anglerfish and snail fish emerge from their previous concealment. The illustrations used traditional ceramic Cobalt blue which links the idea to traditional china patterns.

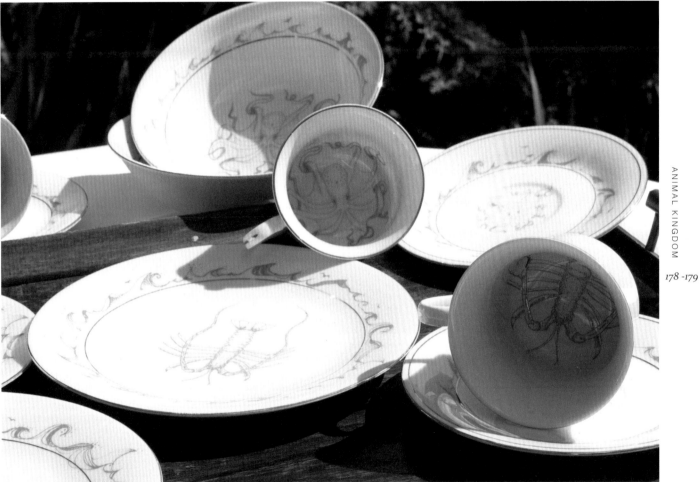

Tattoos

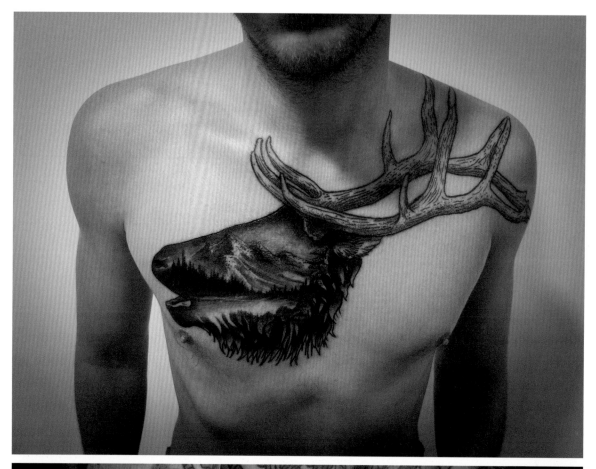

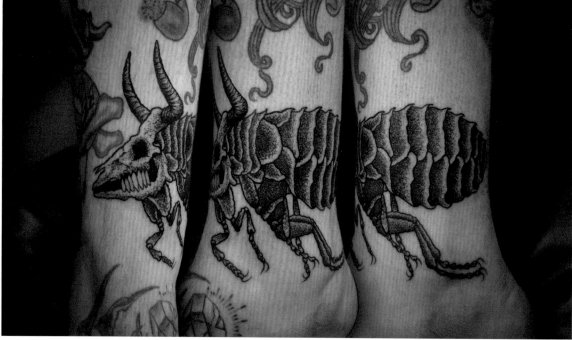

Ukraine

Artist
Ien Levin

Animals are one of tattoo artists' favorite themes to work with. Their simplicity, rawness, honesty and beauty speak for themselves. As one of the tools of the trade for designers of any kind, animals are immortal and timeless.

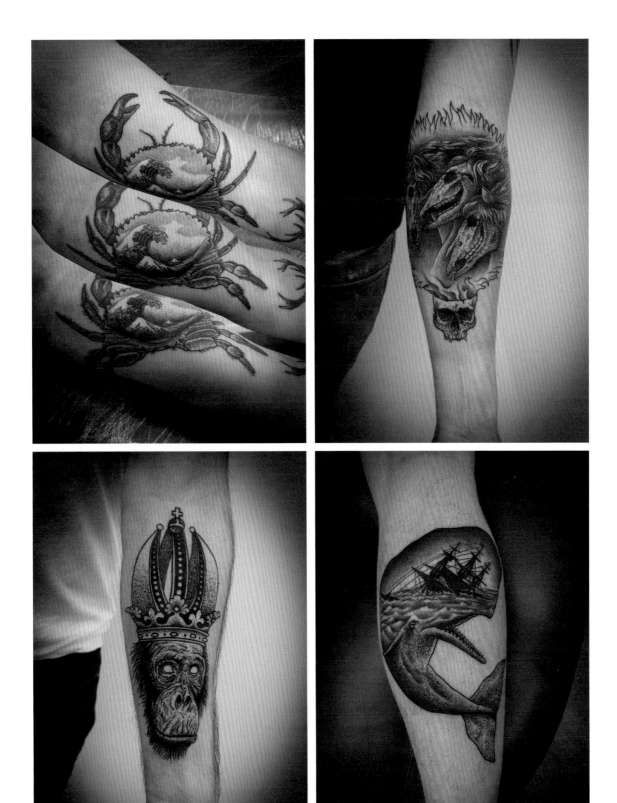

World · Barcode

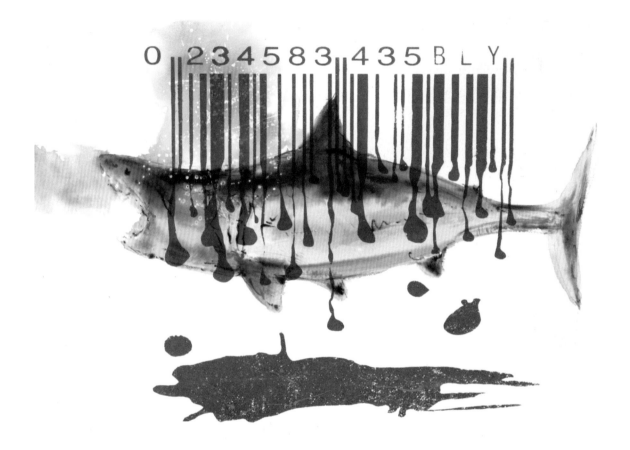

China

Designer
Luyang Bai

In this project, colorful barcodes bar in silk-screened animals, which include species near extinction, like the Tibetan antelope, giant pandas, rhinos and etc. Barcodes here symbolize commercialism and profit, each with a line of numbers at the top or bottom indicating the sum of the animal still surviving on the earth. The artist is trying to visually depict the statement: "In an age imbued with materialism, we should make right decisions."

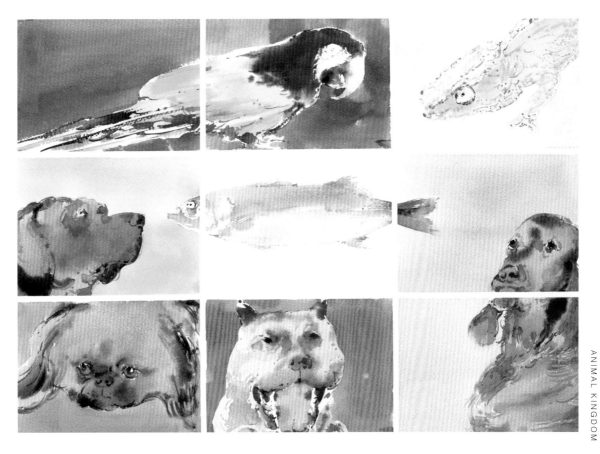

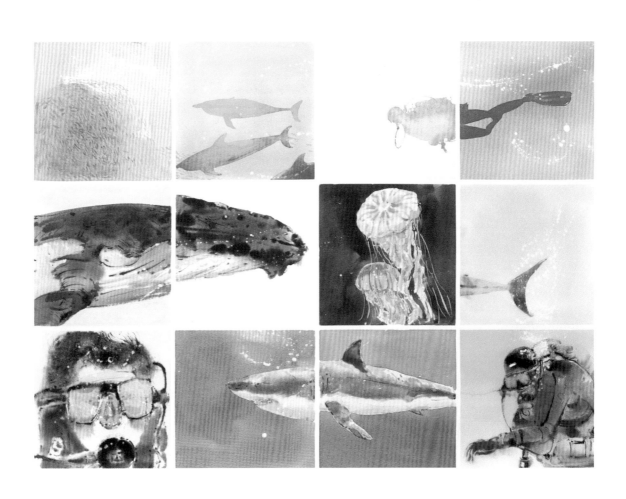

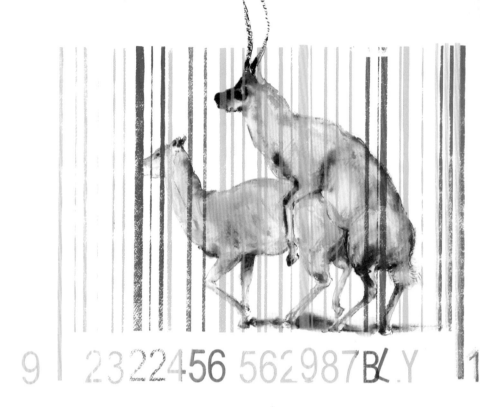

9 | 2322456 562987BLY 1

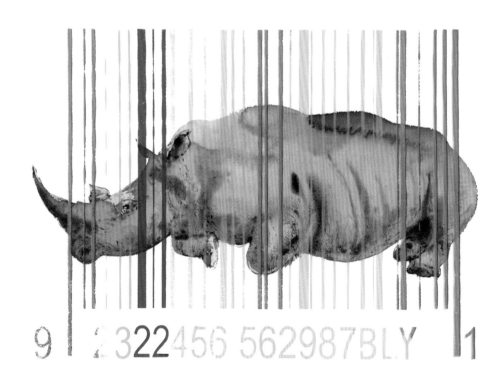

9 | 2322456 562987BLY 1

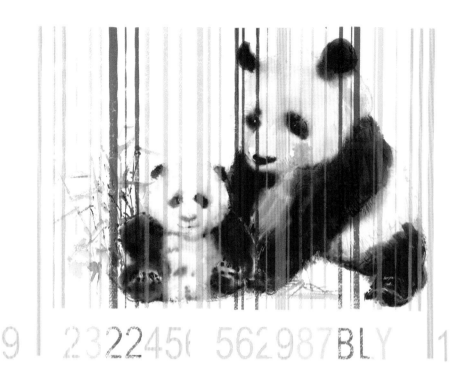

9 | 23224 5(562987BLY | 1

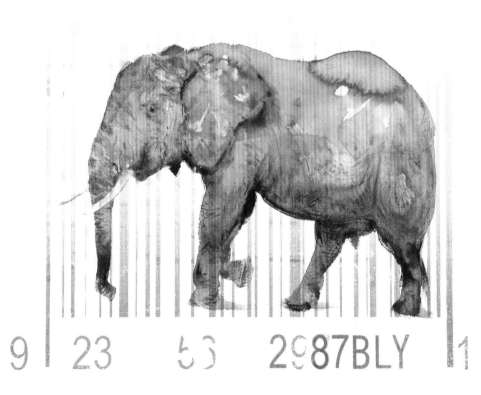

9 | 23 5 5 2 87BLY | 1

Agenda CCEC

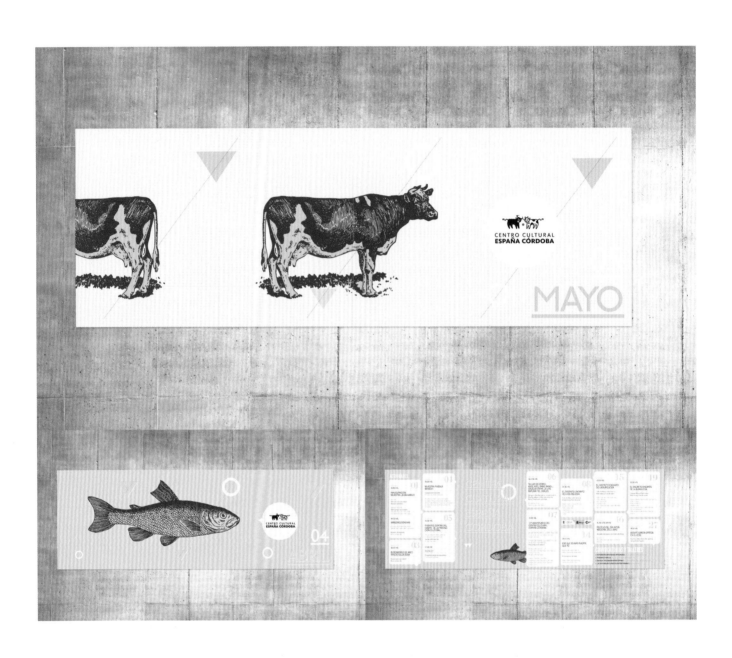

Argentina

Designer
Ramiro Lozada

Client
CCEC

Each front cover in the special monthly brochure is represented by an animal that relates to the artistic activities scheduled during a given month. This data is presented using a colorful scheme to create a powerful graphic work.

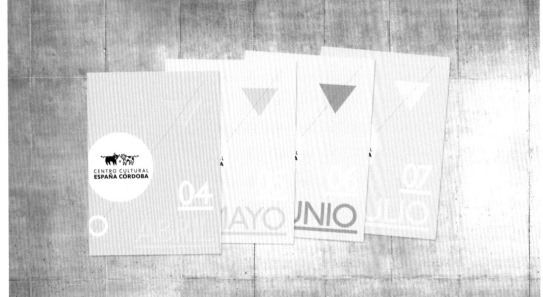

Feather & Fish

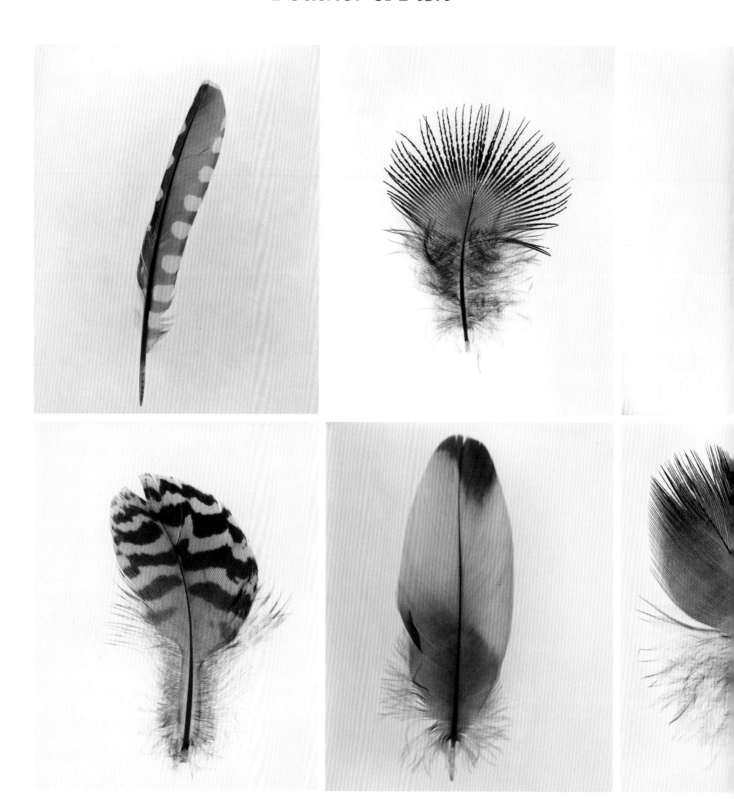

United States

Photographer
Taylor Curry

These photographs are a camera-less exploration of the object as well as the medium of photography. The items are placed directly onto a 4x5 or 8x10 glass plate. Using the color enlarger, the photographer projects the specimen onto 8x10 color film. Color paper or Polaroid film can also capture the image. By enlarging the item it allows people to look closer at the details not seen by the naked eye.

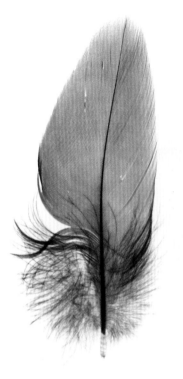

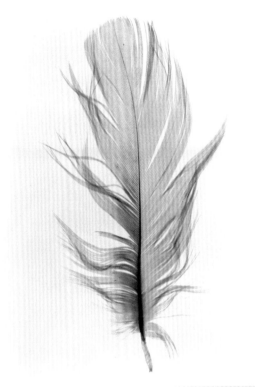

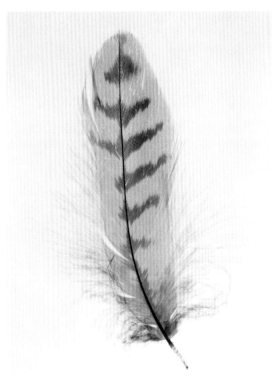

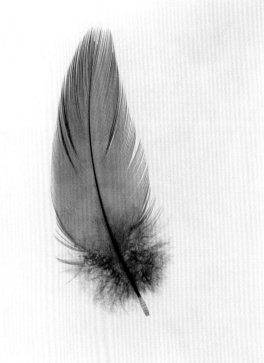

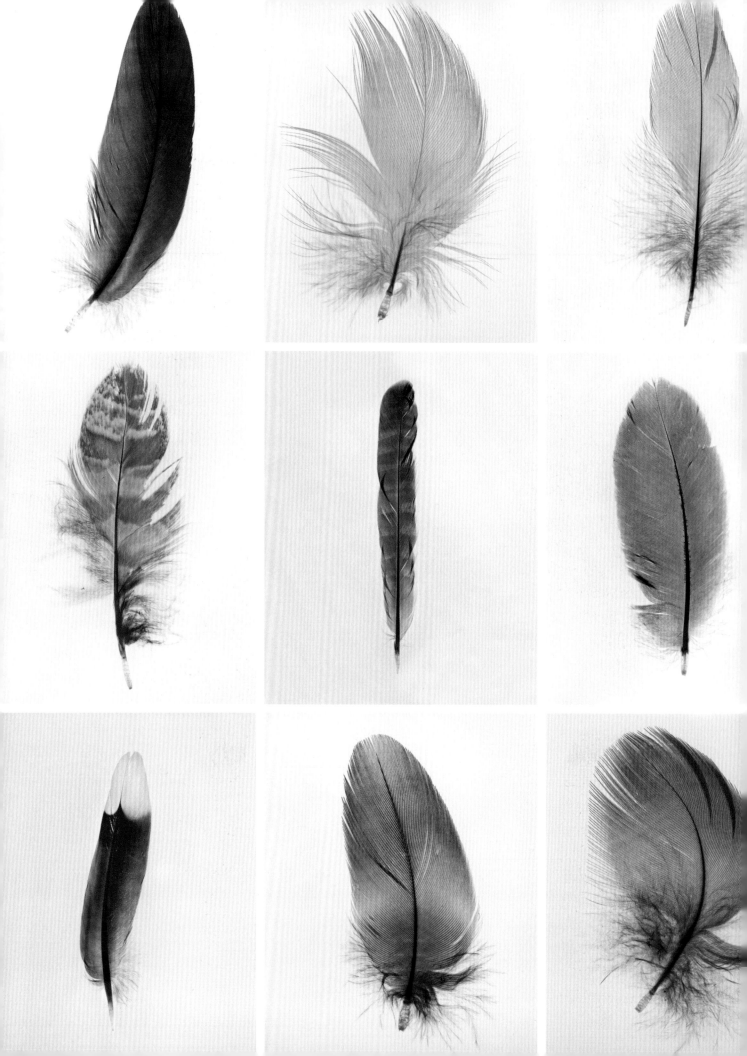

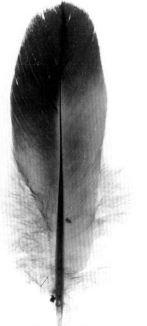
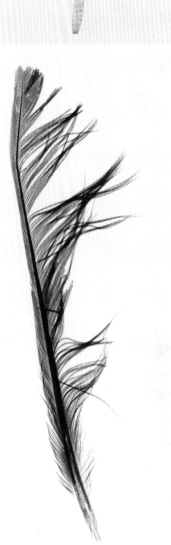

Crows' Nest

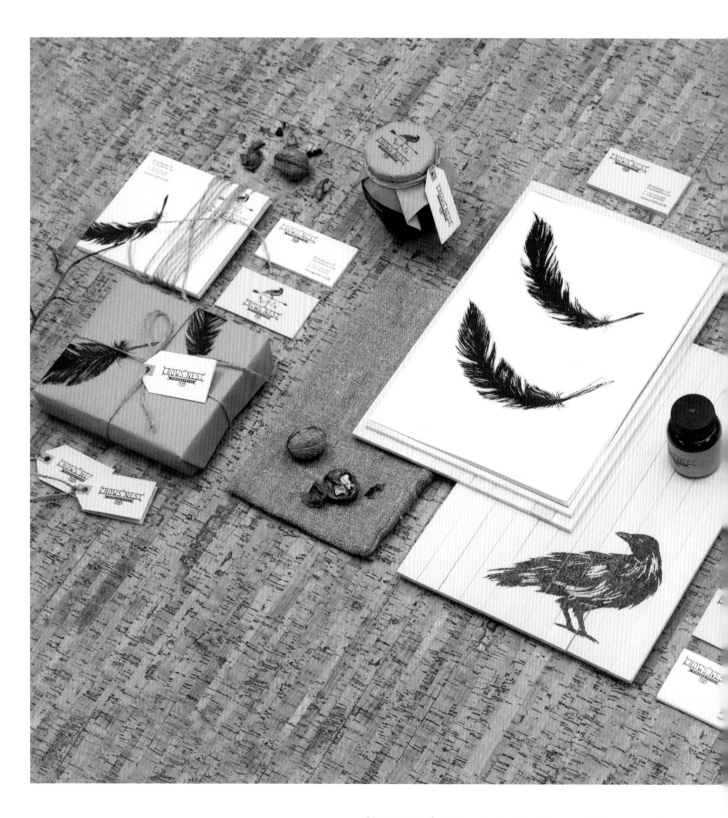

Russia

Designer
Pavel Emelyanov

Client
Crows' Nest

This corporate identity was inspired by vintage wrought-iron signs and weather vanes. Black crows are chosen for the graphic illustration because of their intelligent character. Crow's nests are built of dry wood twigs and lined with fur, grass, feathers. Some natural materials, textured and Kraft paper are reproduced in a vintage style while the monochrome black printing supplements warm shades of stationery.

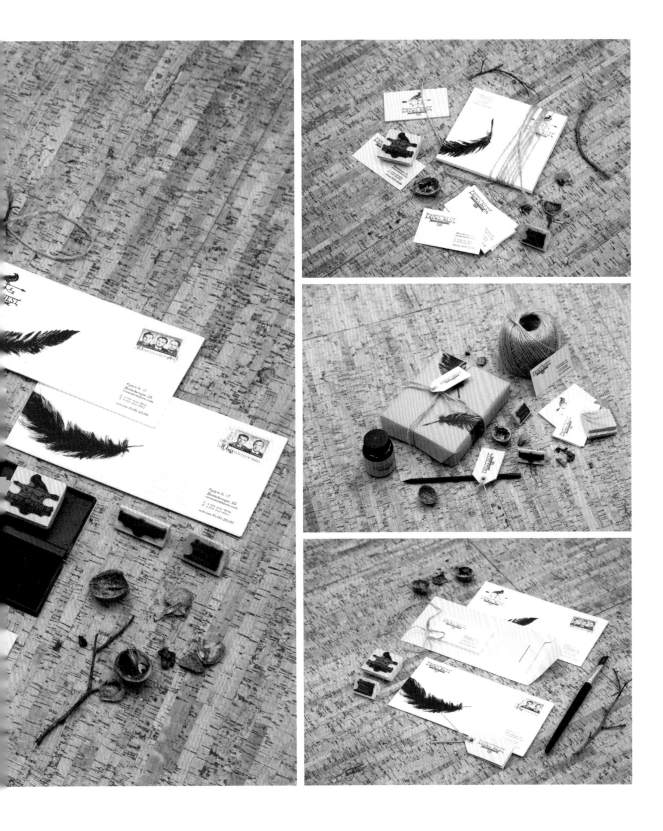

The Perfect Dead Thing

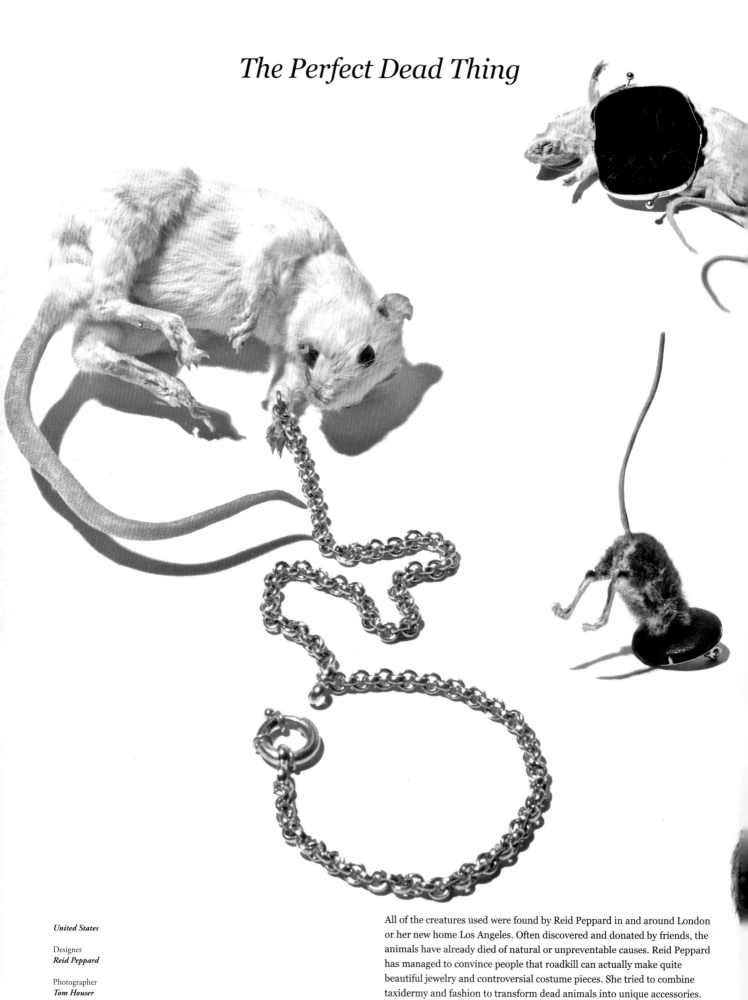

United States

Designer
Reid Peppard

Photographer
Tom Houser

All of the creatures used were found by Reid Peppard in and around London or her new home Los Angeles. Often discovered and donated by friends, the animals have already died of natural or unpreventable causes. Reid Peppard has managed to convince people that roadkill can actually make quite beautiful jewelry and controversial costume pieces. She tried to combine taxidermy and fashion to transform dead animals into unique accessories.

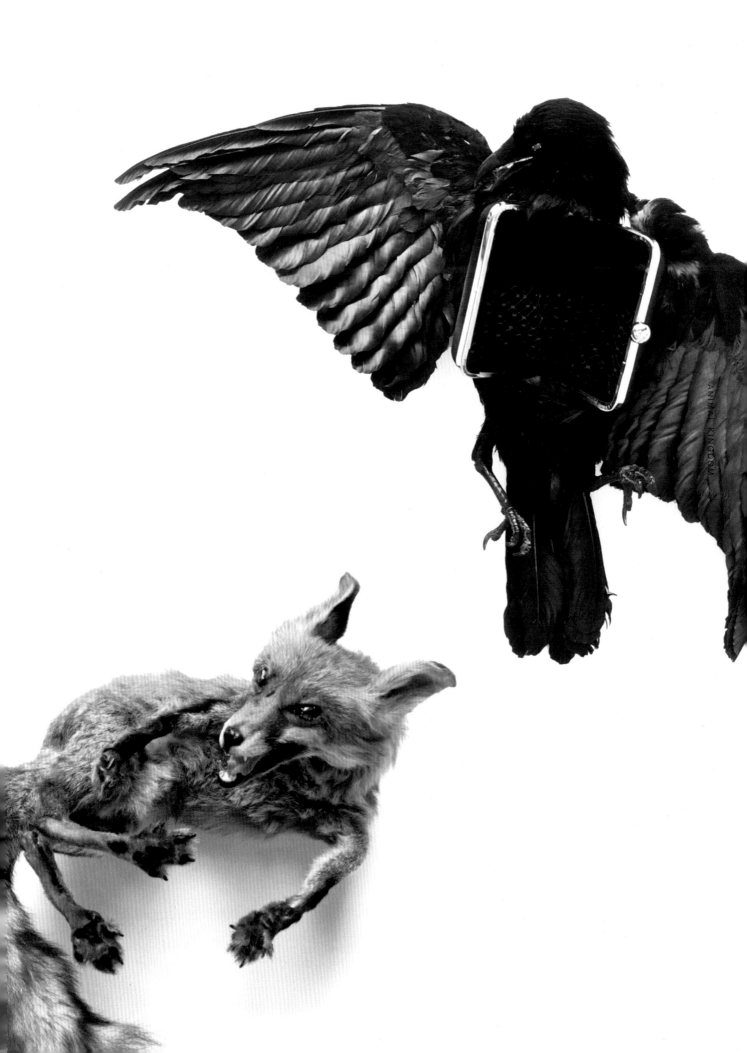

Fat & Furry

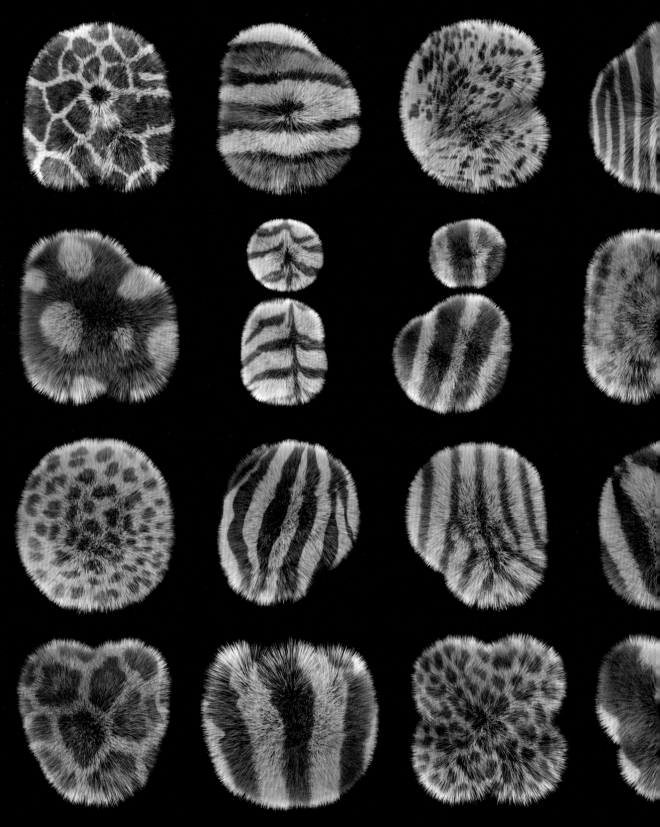

United Kingdom

Design & Art Direction
Sean Freeman

Design Firm
THERE IS Studio

Mix-media alphabet created as an experimental personal project based on animal furs.

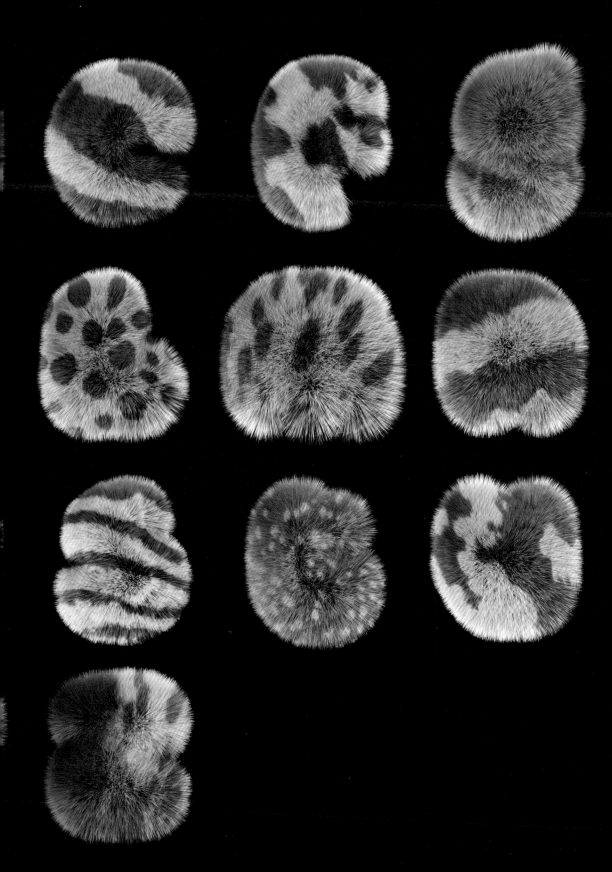

Kreopoleio Restaurant

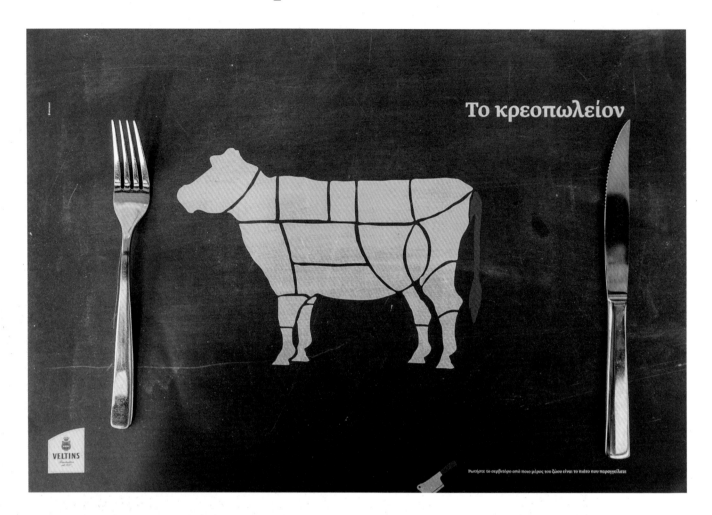

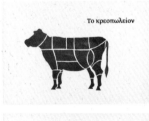

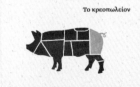

Greece

Design Agency
BeetRoot Design Group

Client
Kreopoleio Restaurant

The design of Kreopoleio's visual identity was based on visual and cultural references from a traditional, Greek butcher shops. A number of butcher shop icons were incorporated in the identity including the beef chart table, the butcher's knife, the old blackboard and chalk advertisement and notes together with a fine touch of color and a sense of humor. The last piece in the chart or the one with the tail is the only one colored against the austere black of the other parts in baby pink for pork or passion red for beef. The design identity was completed with a simple and elegant inscription of the restaurant's name.

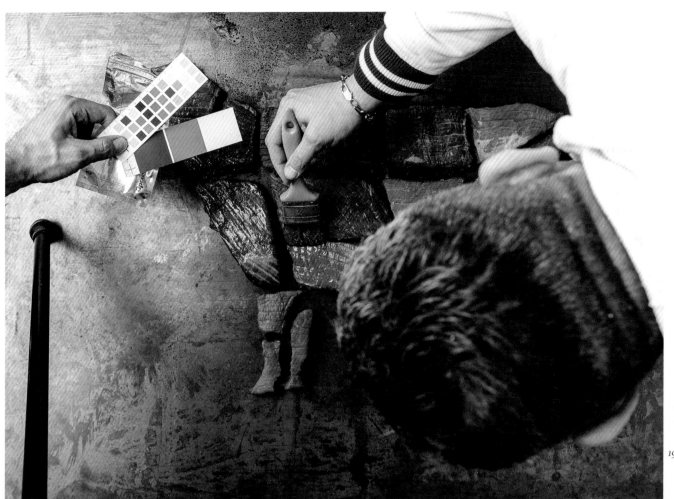

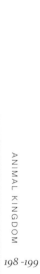

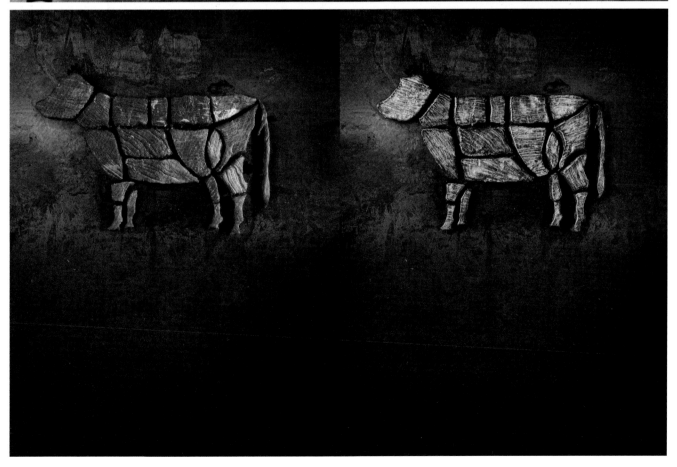

A Tribute to Budgie

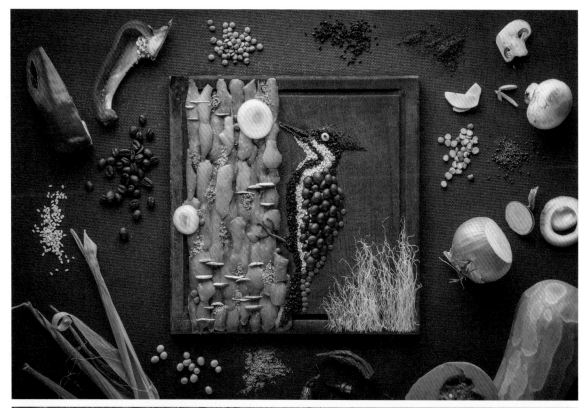

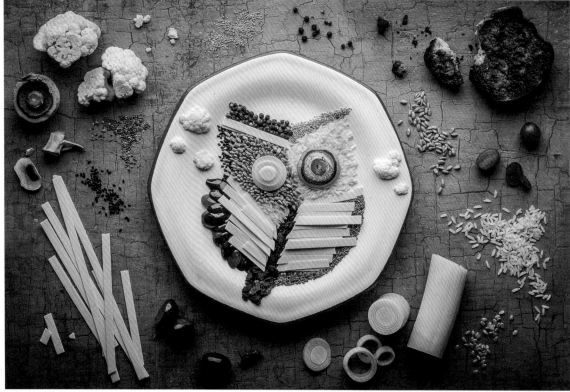

Argentina

Designer
Anna Keville Joyce

Photographer
Agustín Nieto

As a professional Food Stylist and Illustrator for commercial photography and film, food is Anna's strong point. The colors, shapes and textures are where the inspiration comes from. "A Tribute to Budgie" is a series of bird interpretations, highlighting the unique humor in their designs and vivid physical characteristics.

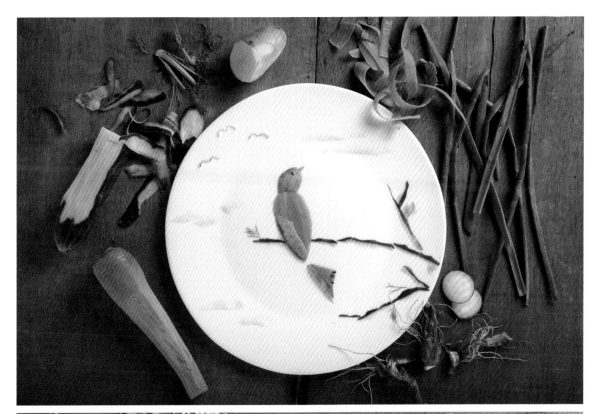

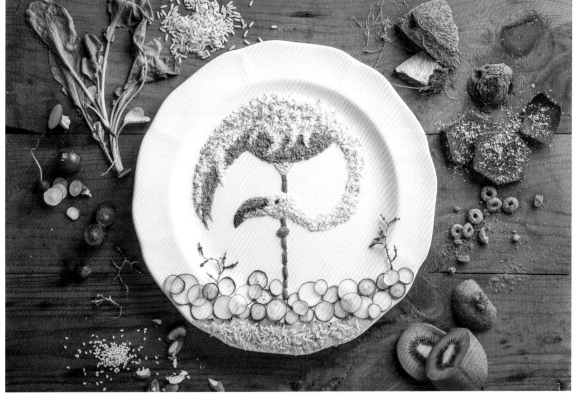

Insect Definer

Israel

Designer
Yael Cohen

This is an interactive, insect field guide app for the iPad, which allows digital text reading, a transformation from physically printed content to digital media. The app will allow exploring and experiencing the world of insects in a new interactive way. The core advantage of the app is its search possibilities, which use new search values that the printed book cannot provide us with. Through this new way of exploring, departing from the existing catalog conventions new intersections and contexts will be revealed among different insects.

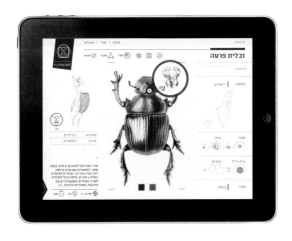

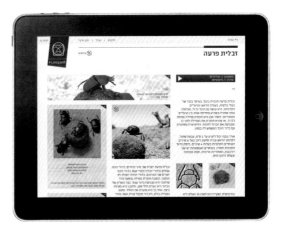

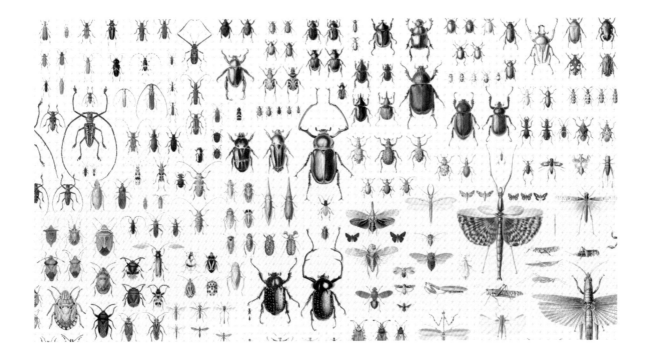

Fly on the Moon

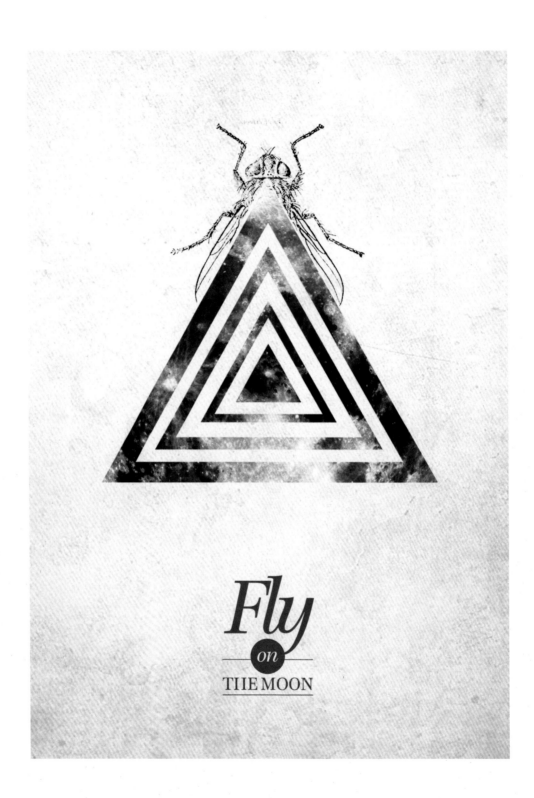

Peru

Design Agency
Brandlab

Creative Director
Alfonso Fernández

Art Director
Iván Alemán

Client
Arcadia Mediatica

"Fly on the Moon" was born from an amusing situation that gave birth to the idea of flies being the protagonists of an adventure. The designer wanted to send annoying flies away as far as they could possibly go. The moon seemed like an ideal destination. The project includes a series of five illustrations and as a series of postcards and merchandising products.

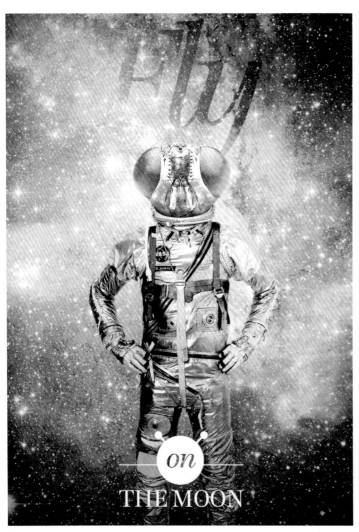

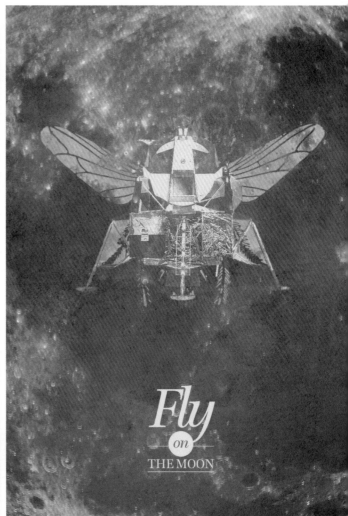

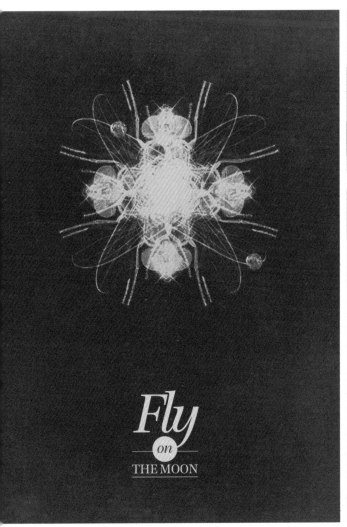

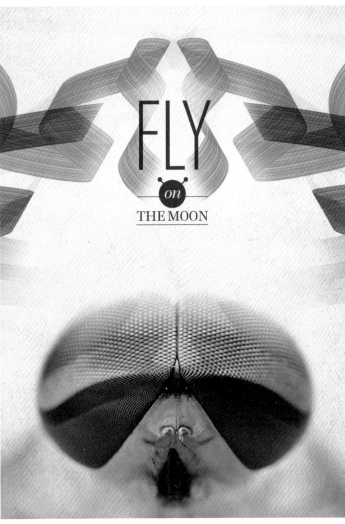

Personal Branding

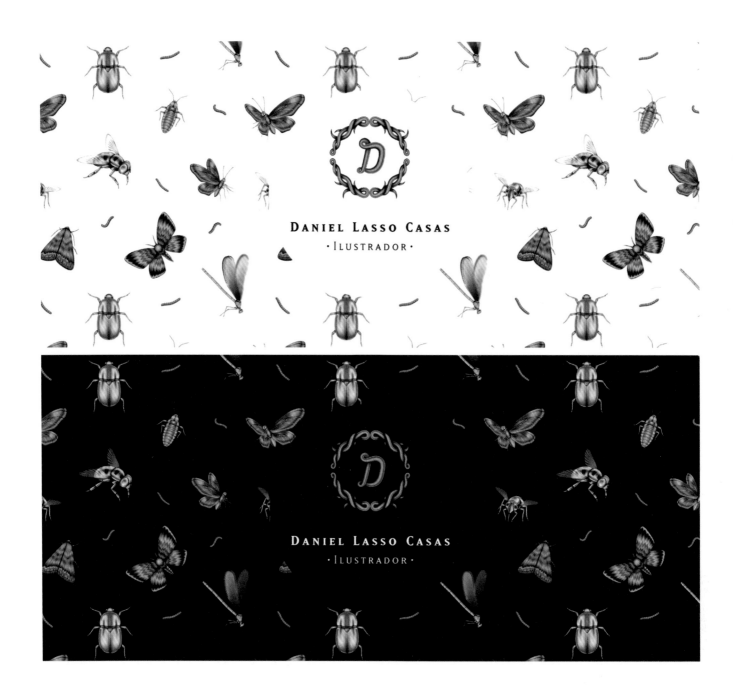

Daniel Lasso Casas
·Ilustrador·

Colombia

Designer
Daniel Lasso Casas

This is a personal branding project that the designer created to highlight his work as an illustrator and graphic designer through various printed and digital applications. His inspiration came from all the insects and bugs he has drawn in his illustrations in the past 3 years.

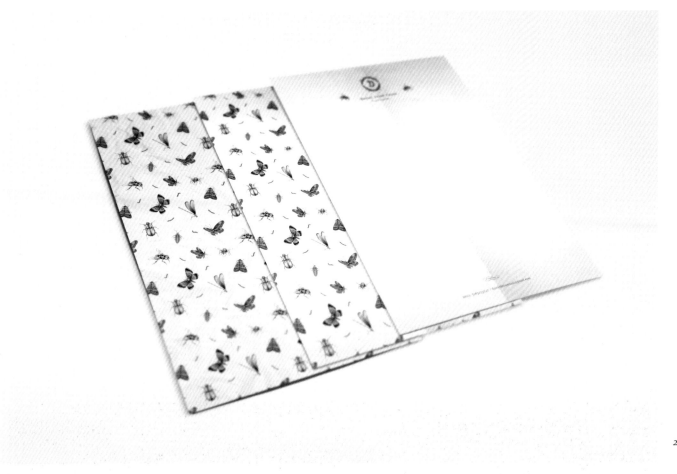

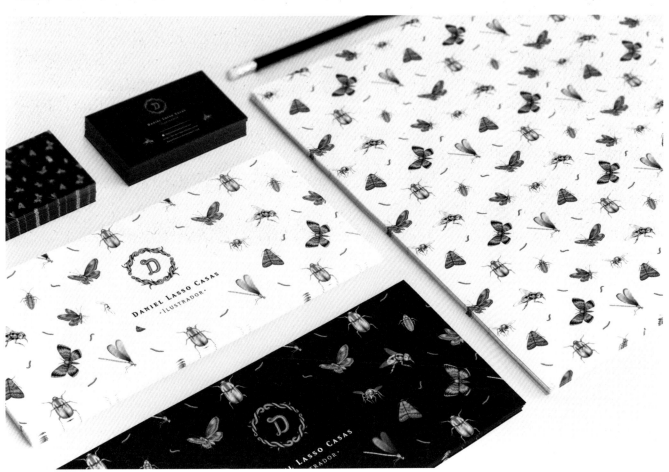

Idea + Communications Branding Identity

SHOW OFF!

BETTER SMOKED, THAN JUST SALMON!

WHY HOP, WHEN YOU CAN HOP, HOP, HULA HOOP!

WHY RUN WHEN YOU CAN ROLL!

BE YOURSELF. UNLESS YOU CAN BE A UNICORN.

JUST BE FABULOUS!

Macedonia

Designer
Tabi Aziri

Client
Idea + Communications

Idea + Communications is one of the oldest ad agencies in Macedonia. The new company branding had to include the company's tradition and at the same time present the youthful spirit of its employees. This was a relatively strict art direction and resulted in the ancient-looking engravings and playful catch phrases accompanying them.

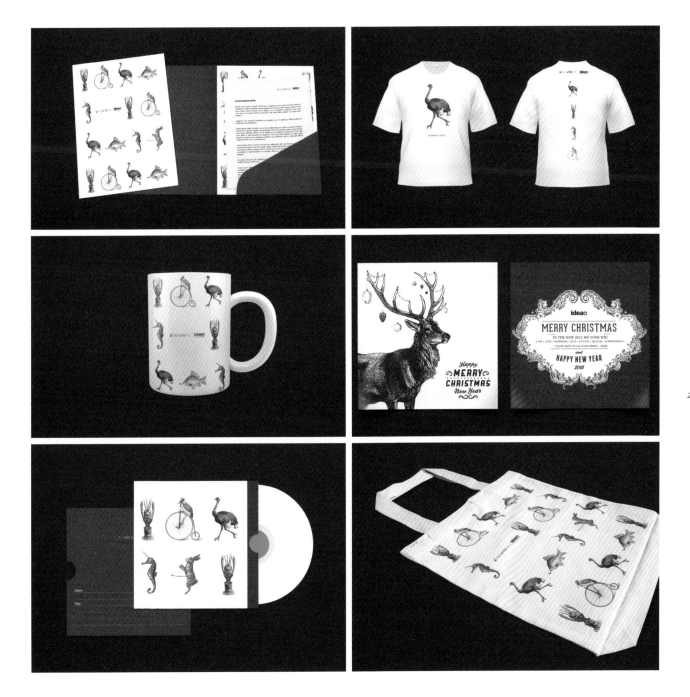

Orpheus & Eurydice

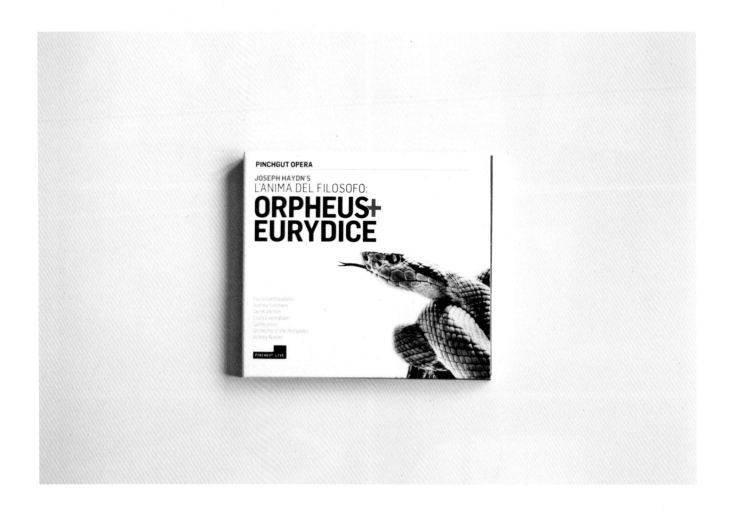

Australia

Design Agency
Alphabet Studio

Creative Director
Tim Kliendienst, Paul Clark

Designers
Lara Juriansz

Client
Pinchgut Opera

With associations linked to the underworld, temptation, poison and death, the snake is a symbolic character that expresses these themes all in the one image. It also serves to communicate the dark and sinister mood of the opera, inspiring a visceral response from the viewer.

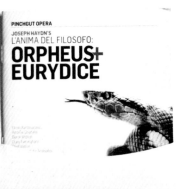
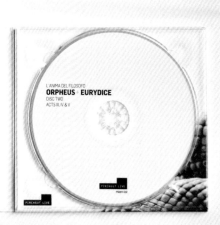

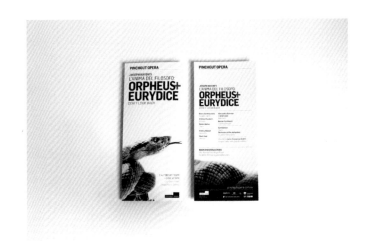

Roar

United Kingdom

Design studio
ORB

Designer
Sanj Sahota

Through enlightening brainstorming sessions, the design team hit upon the name "ROAR," which was the first step to embodying the company's personality and attitude: "small and ferocious." The design team wanted a different feel for the logo of ROAR, so they chose to create it in Indian ink, which shows the collision of strength and sentiment.

They used traditionally timid animals in the imagery which was a continuation of the contrast between small and loud, which also works well for a very local British feel. By using animals indigenous to each international market, this local spirit could be retained as the company grows.

ROAR.

Burning Hearts - Extinctions

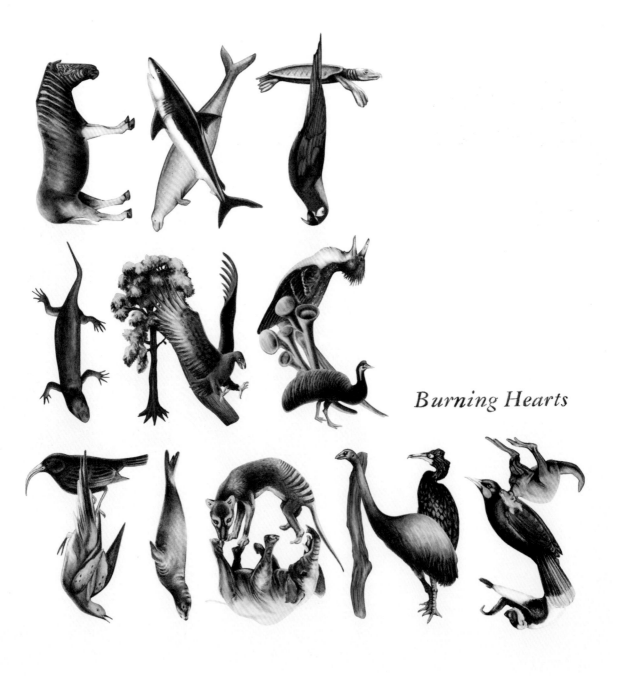

Finland

Designer
Emil Bertell & Kea Bertell

Client
Burning Hearts

The illustration presented on the album cover is for a Finnish band. The name of this album consists of extinct animals.

Almost Extinct

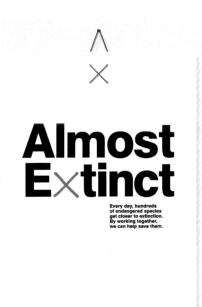

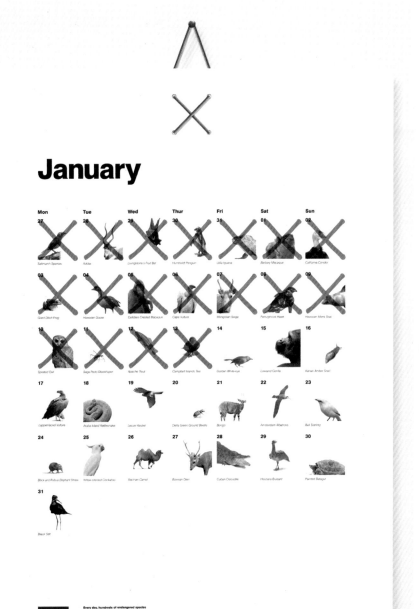

UK

Studio
The Chase

Designers
Chris Challinor, Rebecca Low,
Dulcie Cowling, Adam Cartwright

Client
BBC Wildlife Fund

The BBC Wildlife Fund aims to raise awareness and funds to save threatened wildlife around the world. The Chase was asked to develop an awareness campaign that could convey the ongoing serious issue of the large variety of species which become extinct each year.
A calendar was developed to keep the fund at front of stakeholders' minds each day, whilst also directly showing the effect mankind is having on the planet.

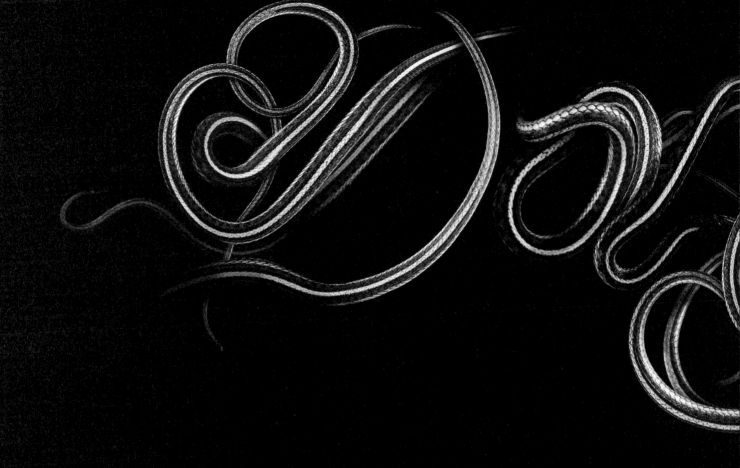

United Kingdom

Design & Art Direction
Sean Freeman

Design Firm
THERE IS Studio

Photography
Atton Conrad

Client
Jack Du Rose

The title treatment for luxury jeweller Jack Du Rose's solo collection
featuring unique creations is inspired by dangerous wild creatures.

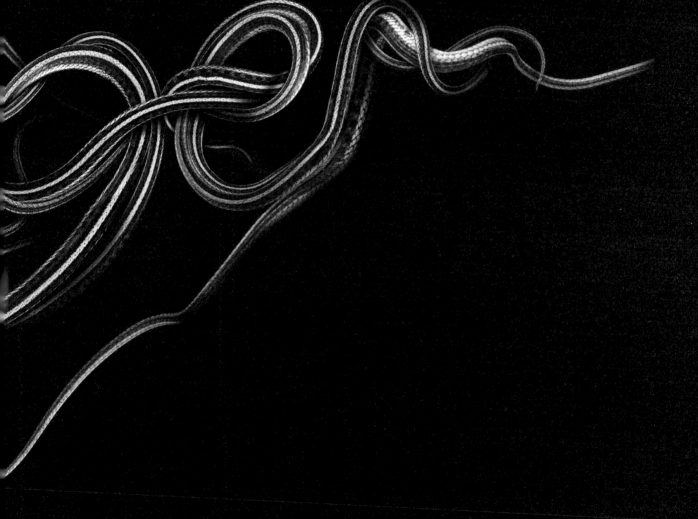

Truly Deeply

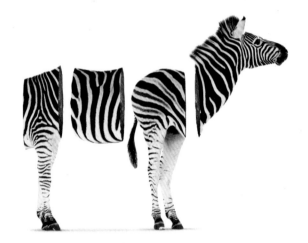

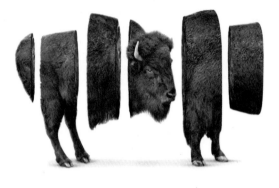

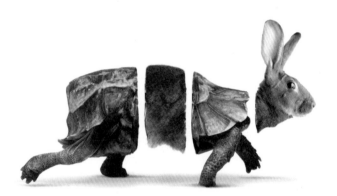

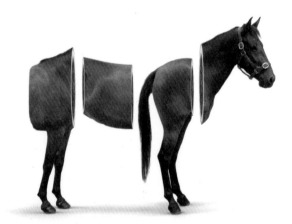

Australia

Design Agency
Truly Deeply

Creative Director
David Ansett

Designer
David Ansett, Derek Carroll, Cassandra Gill,

Tim Wood, Lachlan McDougall

Truly Deeply is the re-branding of Storm Design and Brand DNA. The illustrations and designs were created to express the brand essence "Re-imaging Brands". The delivery is magical and thoughtful. The sliced animals represent a new way of thinking about brand to create new and unique brands to take to market.

Truly Deeply ®

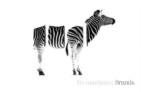

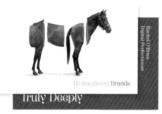

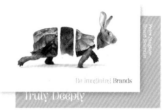

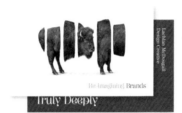

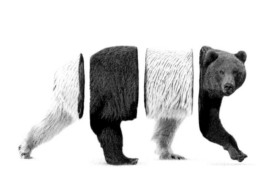

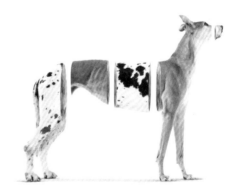

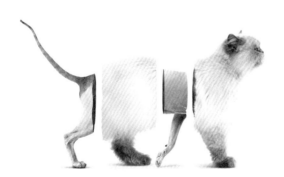

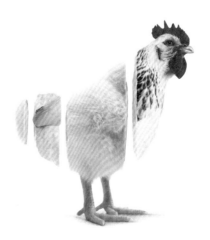

Eva Solo

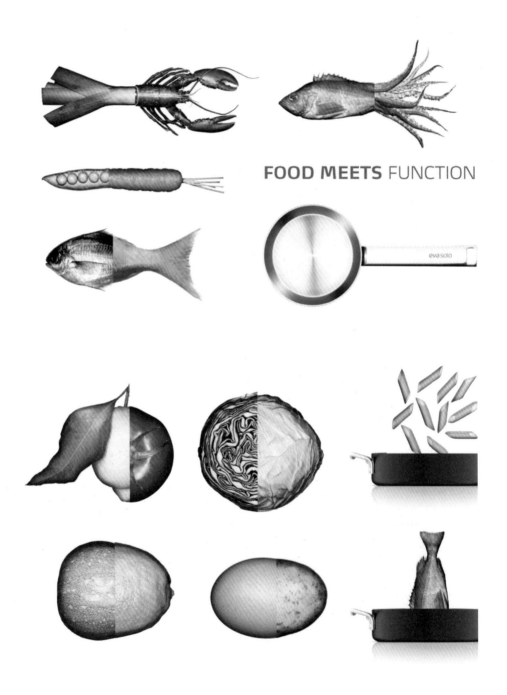

FOOD **MEETS** FUNCTION

Denmark

Design Agency
Bessermachen

Creative Director
Kristin Brandt

Client
Eva Solo

In 2012 Eva Solo launched a kitchenware set that combined professional, chef-level quality with Eva Solo's uncompromising design quality. A visual design was created for them that united these two worlds. The concept was to use the product itself as a strict design element to naturally feature its aesthetic qualities. This project is a case of form meeting function in the gastronomical realm.

COOKING
GOOD
TASTE

eva solo XO COLLECTION

I 2010 skulle Eva Solo lancere en serie køkkenredskaber, der kombinerede professionel køkkekvalitet med Eva Solos kompromisløse design.

Der blev skabt et udtryk, der formede de to verdener.

Idéen var at bruge ikonerne som et stramt designelement – udnytte æstetikken i det naturlige – og sidestille det med XO-produkterne.

Form møder funktion på den gastronomiske måde.

Fishmen & The Rice Wine

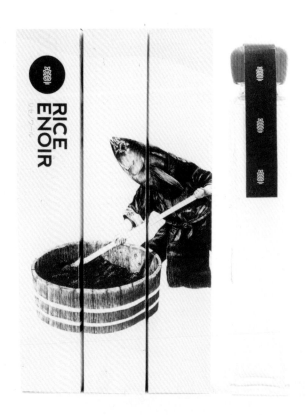

Indonesia

Design Agency
Sciencewerk

Designer
Danis Sie

Illustrator
Roby Dwi Antono

Client
Rice Enoir

The identity and drawing of the packaging in this project is inspired by both the fishing and brewing industries. The design also promotes the Japanese town "Setouchi" which is well-known and popular in the fishing business. For this reason, fish are chosen to be the portrayal of the fishmen who sails the seas to bring prosperity into the town. The illustration creates a surreal feeling of a fisherman who magically brews the best sake in the world.

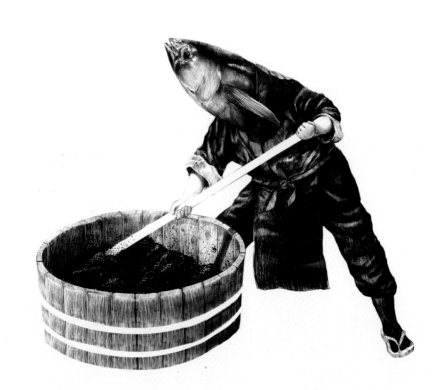

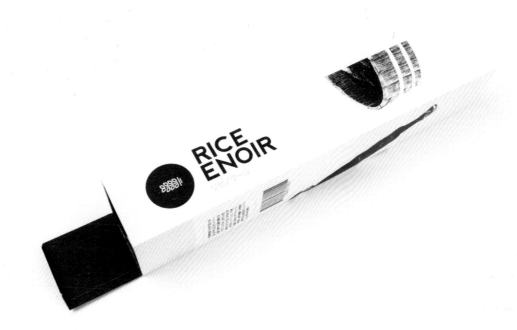

RICE
ENOIR

Whitebites

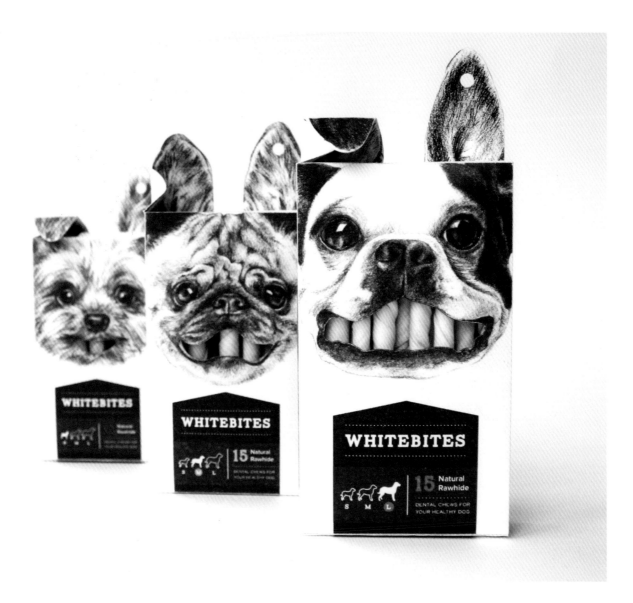

Canada

Designer
Cecilia Uhr

Cecilia Uhr chose to illustrate a set of dogs of different breeds because she is a dog lover. Her dog is a white Maltese who provided the inspiration for Cecilia to take on this project. Cecilia did not like the way pet supply stores packaged the rawhide sticks they sold, so she decided to fix that problem in her own way.

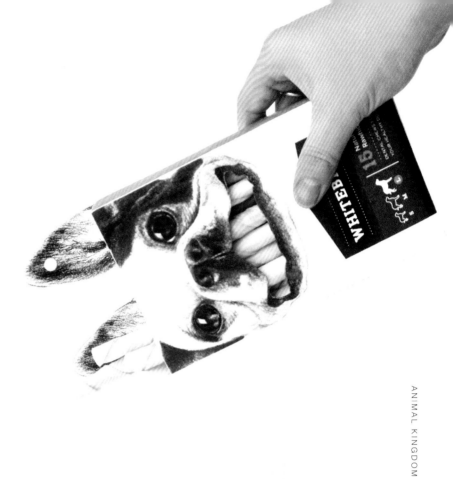

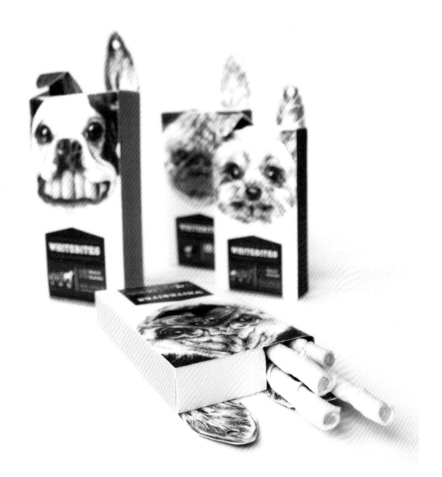

Butterfly Kingdom Taiwan Tea

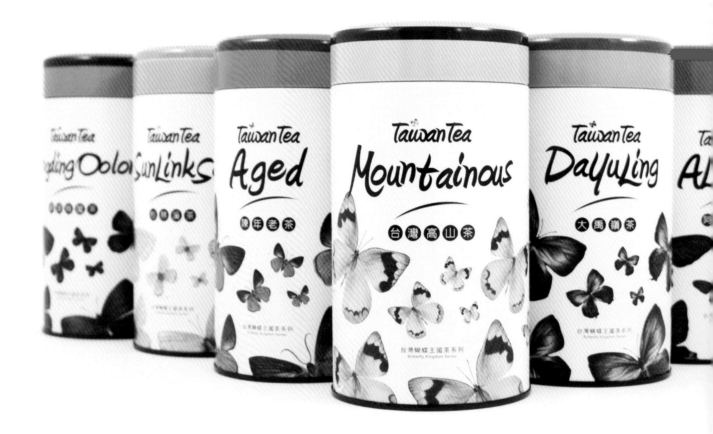

Chinese Taipei

Design Agency
TROONIONDesign

Creative Director
Xie Yauzer

Art Director
Xie Xiauyu

Client
Shumeei International Co., Ltd

One of the most beautiful insects that designers are inspired by is the butterfly. Butterflies feature fantastic visual designs and move through spectacular backgrounds, from flowers to mountainsides. When contemplating butterflies that designers are reminded of the carefree times in childhood when they chased after them and tried to catch them. Now they're taking on the heavy responsibility of Taiwanese tea with a similar approach.

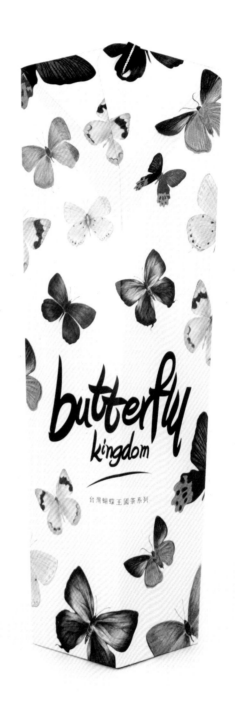

The Furry Tails

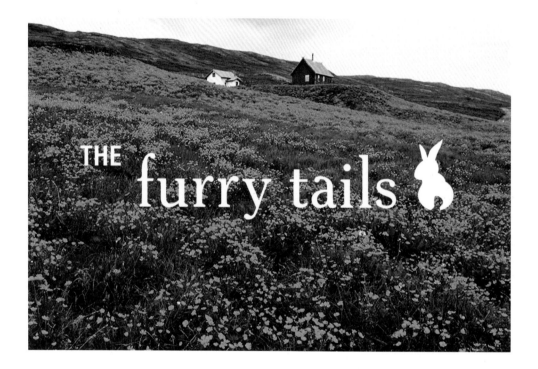

Chinese Taipei

Design Agency:
AM Creative

Designer
Marissa Cheung

Client
The Furry Tails

The Furry Tails, created with the love for the owner's pet rabbit, specializes in hand-made cushions for pets and animals. The name was developed from the word play "Furry Tails", it reminds people of pets and gives a whimsical feel as it has a similar sound as "Fairy Tales". Inspired by the playful minds of animals, the word mark is featured by the customized r and a as if they are interacting with each other. A tactile feel is incorporated into the brand with the use of textured paper and stamping.

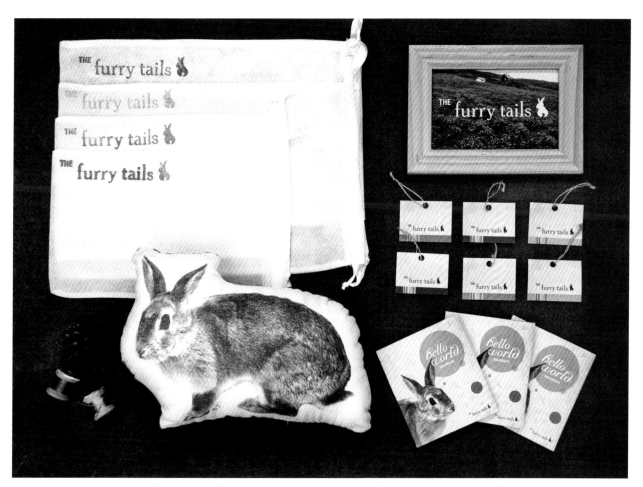

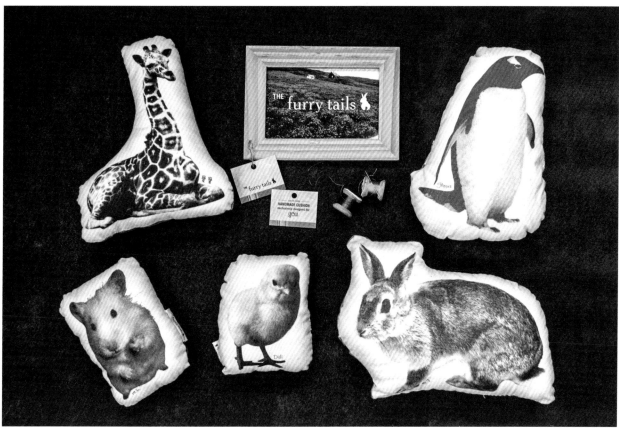

Painting on Photography

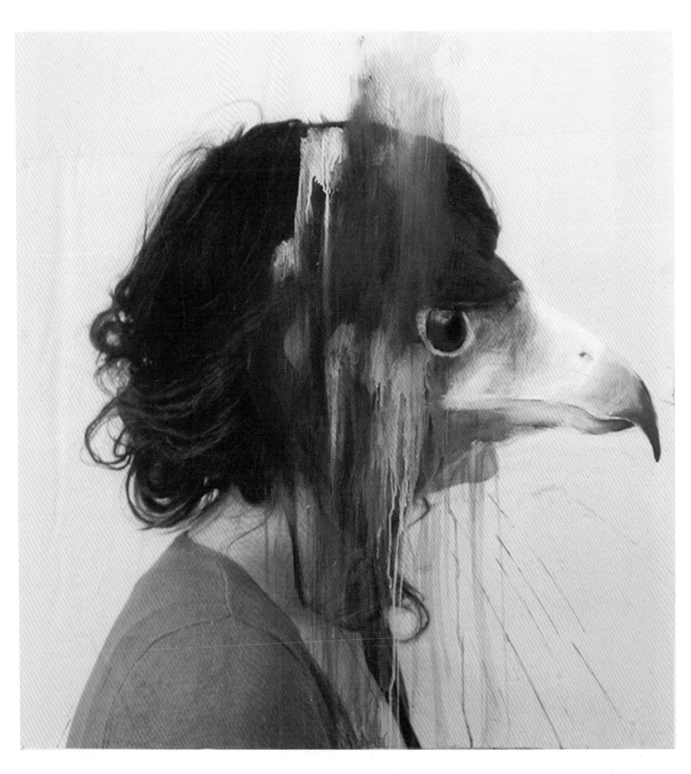

France

Designer
Charlotte Caron

The paintings explore both the ancient tendency to humanize animals and some people's dreams of transforming into animals. The acrylic paintings of animal faces are set on the photographed portraits of people as if they were masks. The people of the photographs not only assume the appearance of the animals, but nearly seem to exude corresponding personalities. The hawk seems harsh, the fox mischievous, the deer gentle. The literal anthropomorphizing of animals in the paintings depicts a creative way how this takes place.

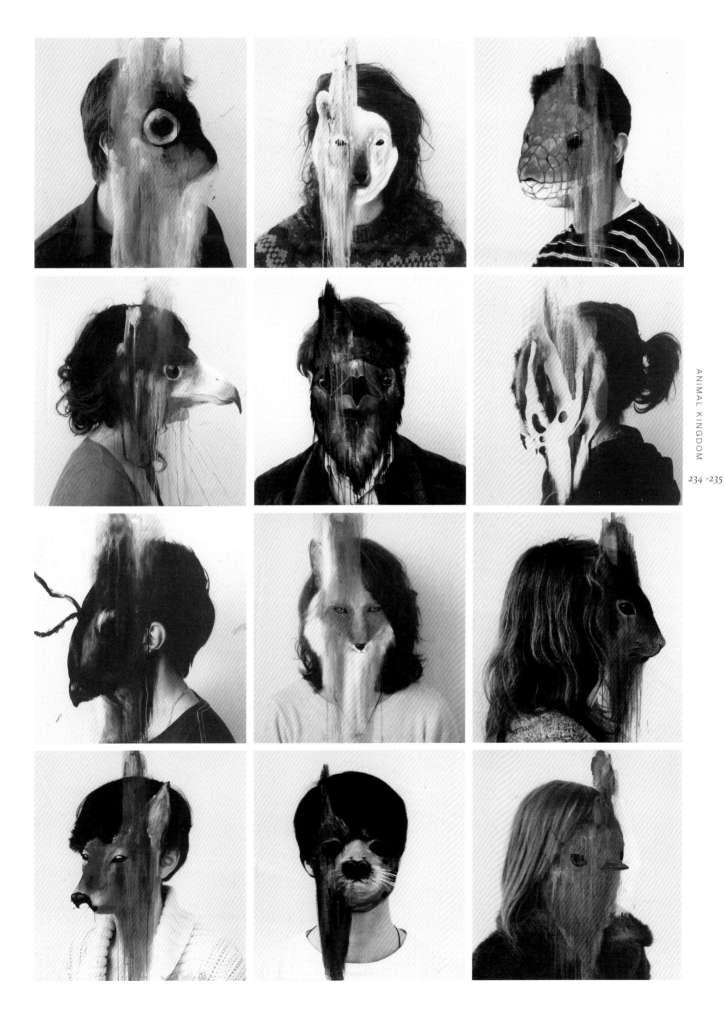

The Vault

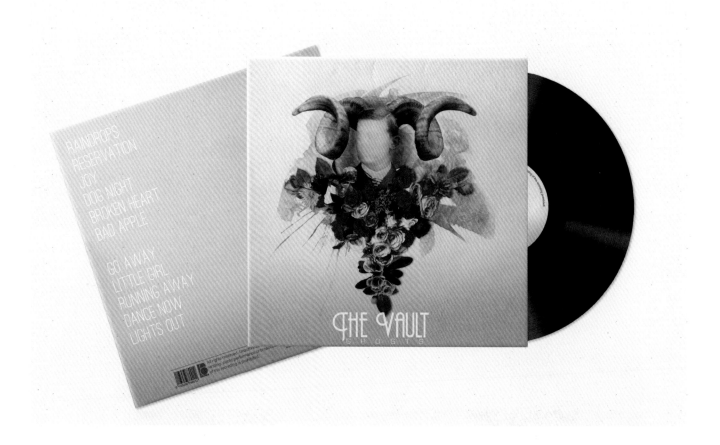

Brazil

Designer
Antonio Rodrigues Jr

This album design, which was originally commissioned by a pop band, has been developed as a personal project. The images are about grief and confusion, as each faceless character's head is decorated with antelope horns like the hanging trophy.

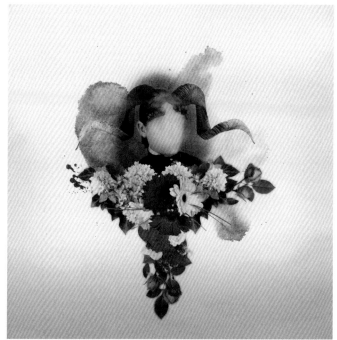
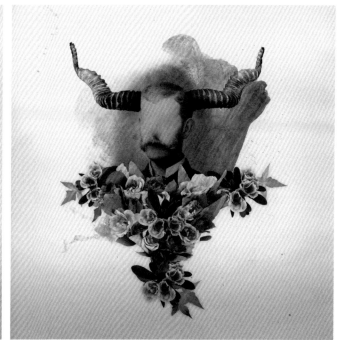

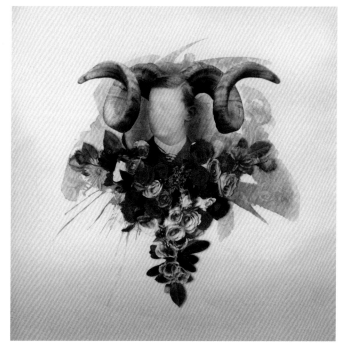
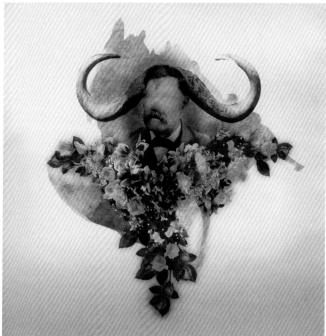

Fish

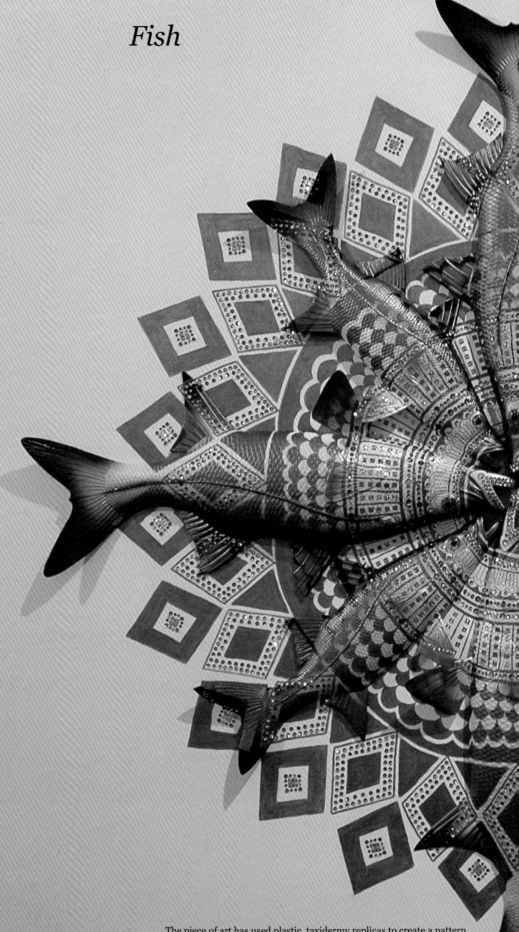

United States

Designer
Cassandra Smith

The piece of art has used plastic, taxidermy replicas to create a pattern out of animal bodies. Then the designer overlaid a synthetic camouflage of sequins and paint in contrast to the natural shapes of the fish.

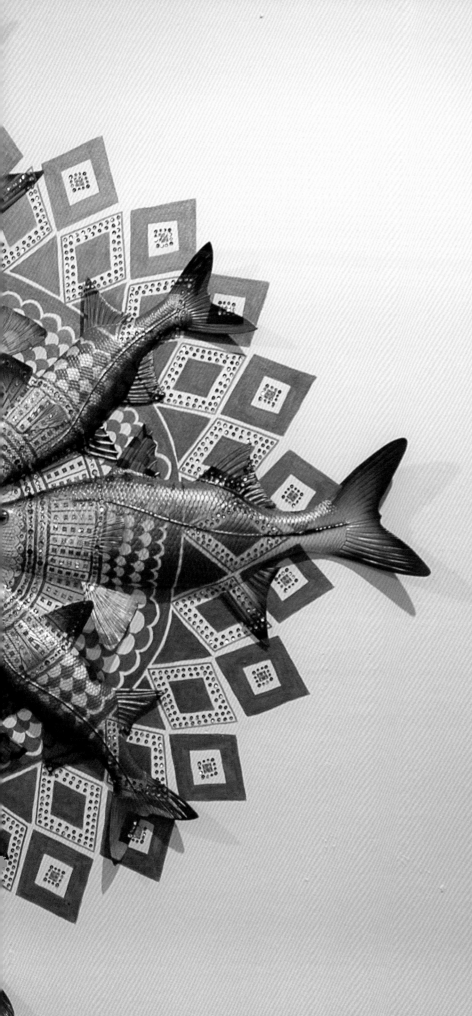

Dream's Bud Album Cover Design

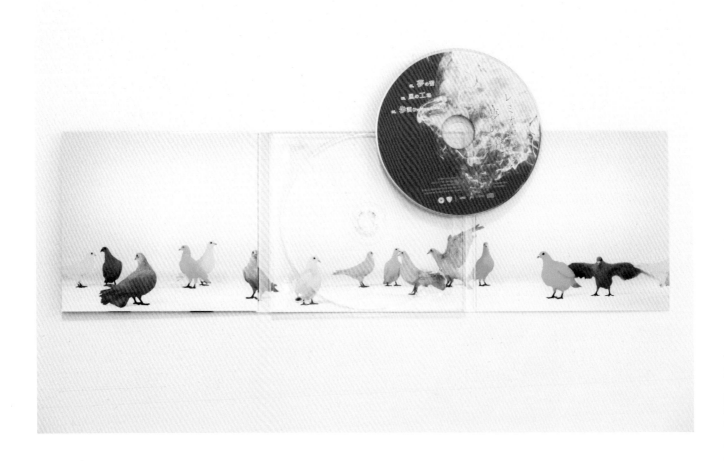

Japan

Design Agency
Ouwn

Designer
Atsushi Ihisguro

Client
OORONG-SHA

This album cover design is for a Japanese singer Remioromen. In order to connect the title of the album (Dream's Bud) more closely with the design, some flowers with a flock of colorful birds are depicted in the graphic motif.

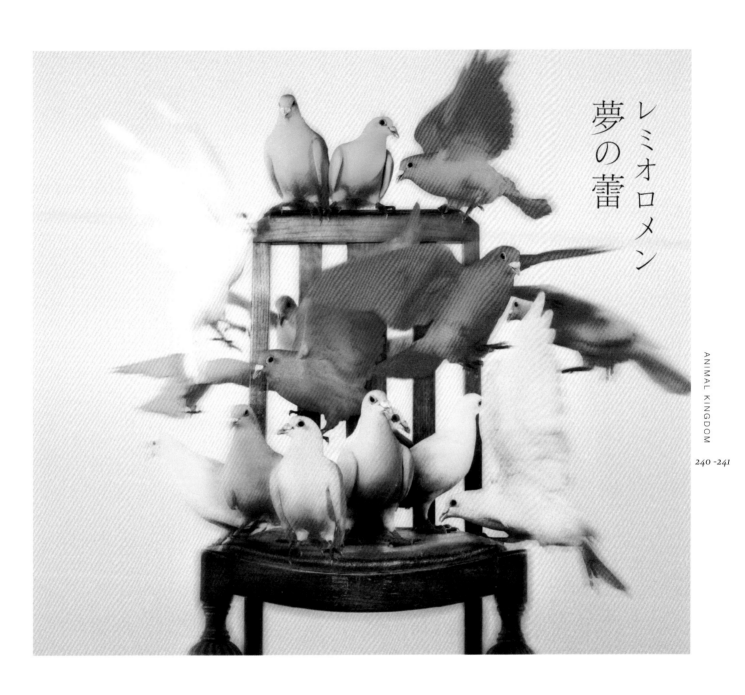

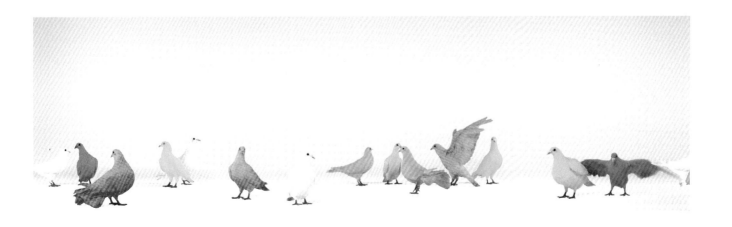

Hand-Painted Antler Sheds

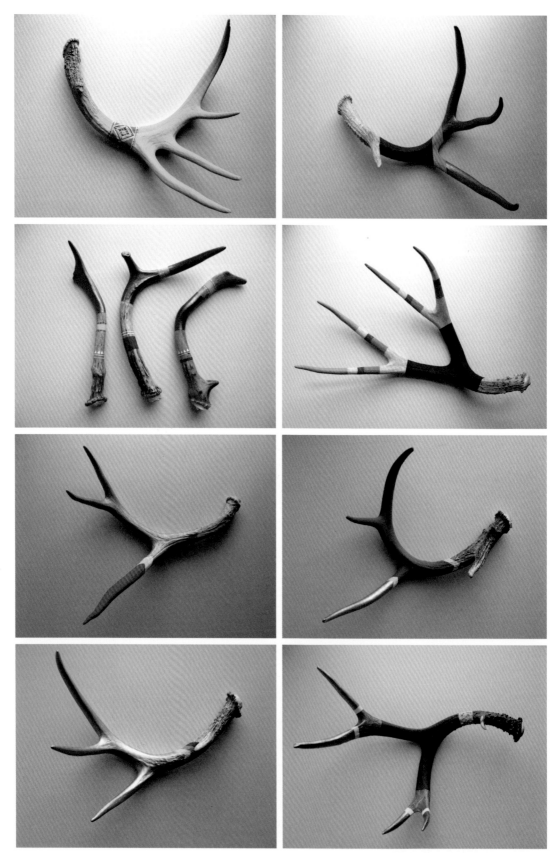

United States

Designer
Cassandra Smith

The designer came up with the idea of painting antlers which had been shed by deer as a way to work on something smaller and quicker than her normal, large-scale installations. Shed antlers are also 100% humane because deer shed their antlers every year naturally.

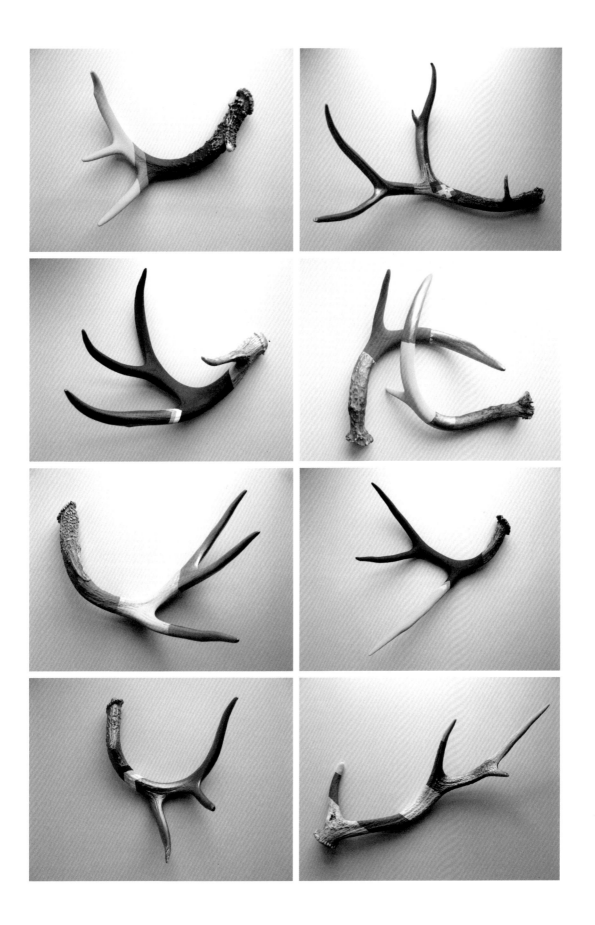

Arla Baby & Me Organic

Finland

Design Agency
Kuudes Kerros Helsinki Oy

Designer
Piëtke Visser

Client
Arla Foods

Arla Baby & Me's organic, baby food range was launched in Finland and
Denmark in the autumn of 2012. The range of 100% natural, 100% organic
dairy products are specially formulated for babies' growth and development.
For the packaging the designer crocheted a lovely set of animal characters.
The design communicates the brand values: pureness, openness and
trustworthiness.

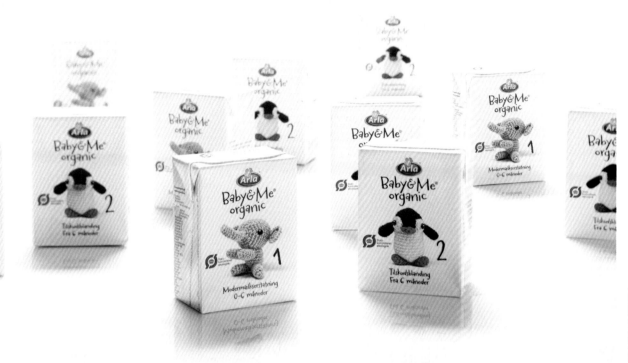

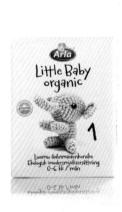

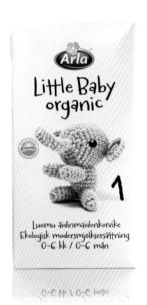

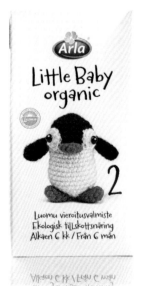

Macro Photography of Insects

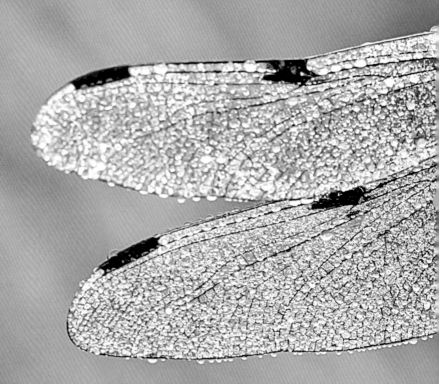

France

Photographer
David Chambon

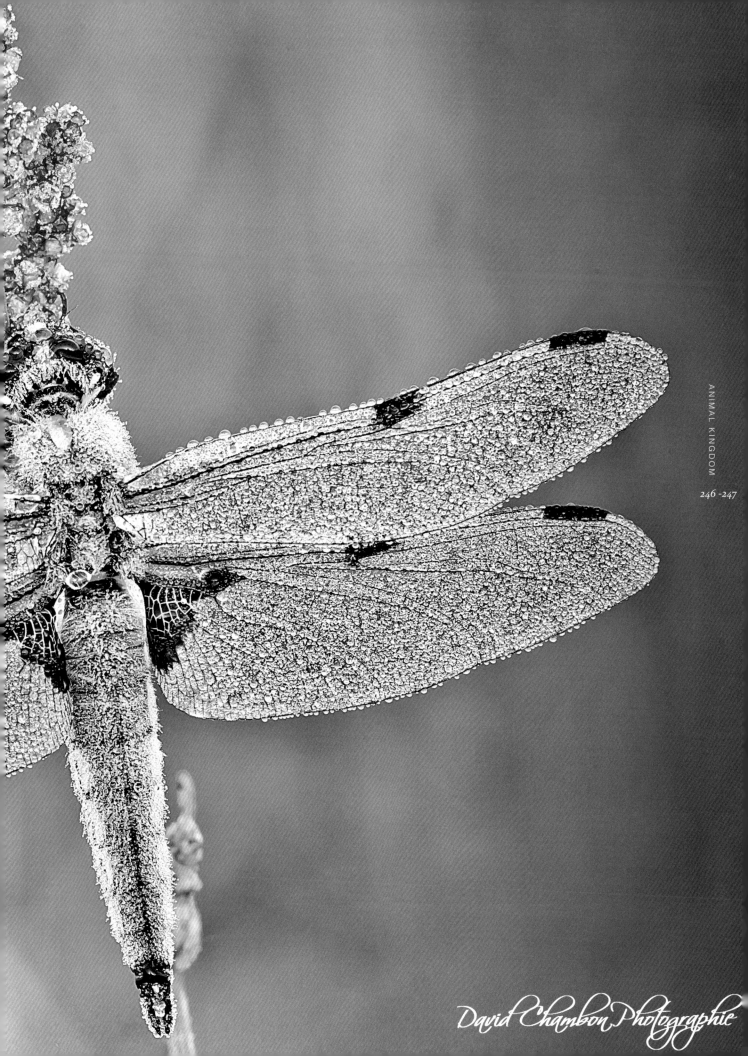

David Chambon Photographie

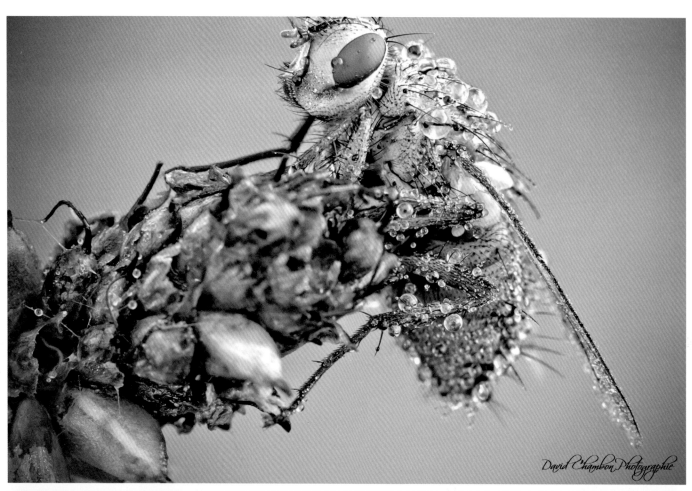

David Chambon Photographie

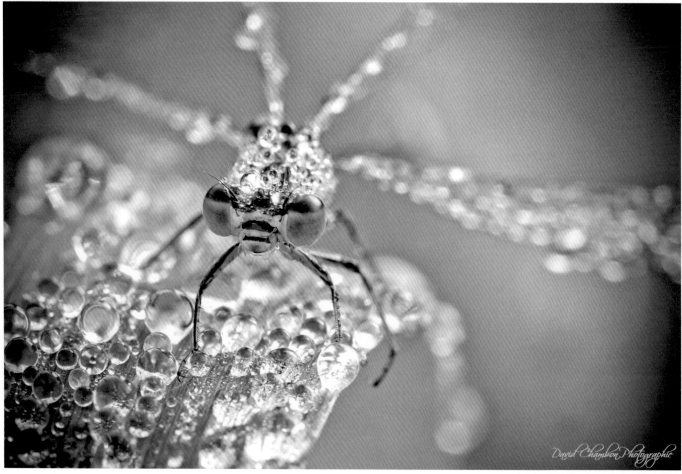

David Chambon Photographie

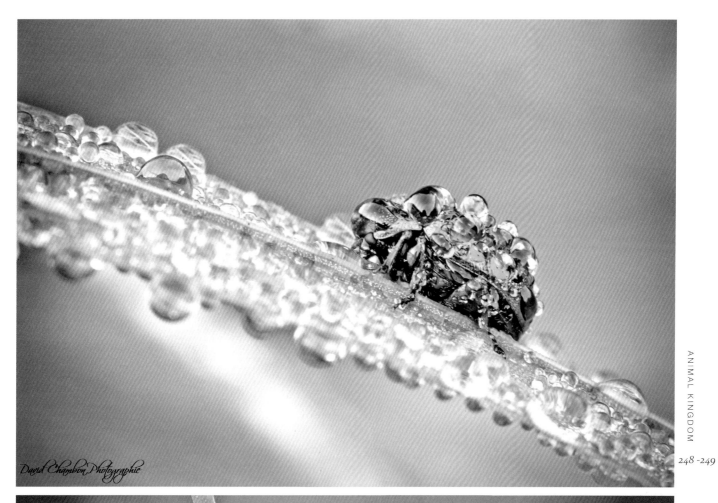

David Chambon Photographie

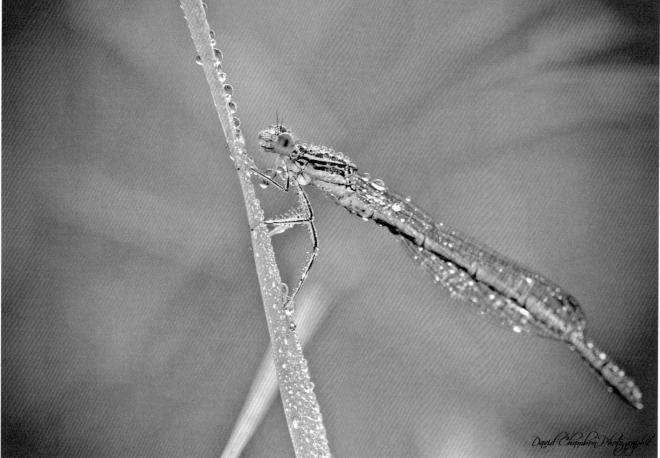

David Chambon Photographie

Audi Tails Campaign

Audi Q5. Rearview camera standard.

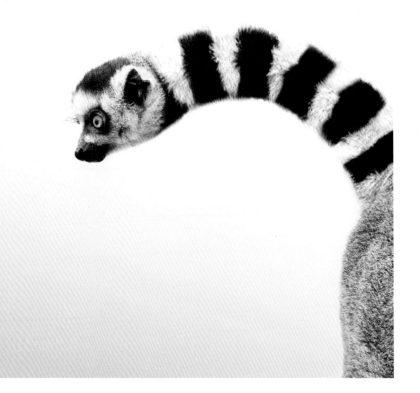

Germany

Creative Director
Karpat Polat

Art Director
Canhür Aktuğlu

Copywritter
Tolga Mutlu

Client
Audi

In order to showcase the rearview camera Standard of Audi Q5, this advertisement used monkey, skunk and lizard's tails as its main inspiration.

Audi Q5. Rearview camera standard.

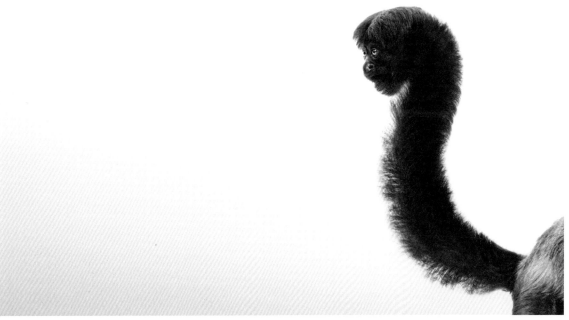

Audi Q5. Rearview camera standard.

Audi
Vorsprung durch Technik

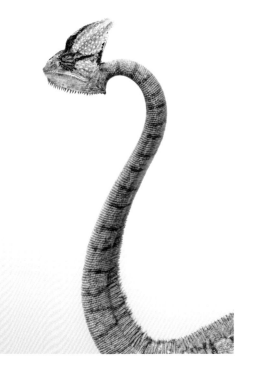

INDEX

L

N

K

O

M

P

ACKNOWLEDGEMENTS

We would like to thank all the designers and contributers who have been involved in the production of this book. Their contribution is indispensable in the compilation of this book. We would also like to express our gratitude to all the producers for their invaluable opinions and assistance throughout this project. And to the many others whose names are not credited but have aided in the production of this book, we thank you for your continuous support.